Exploring Religious
Community Online

Steve Jones
General Editor

Vol. 24

PETER LANG
New York • Washington, D.C./Baltimore • Bern
Frankfurt am Main • Berlin • Brussels • Vienna • Oxford

Heidi Campbell

Exploring Religious Community Online

We are One in the Network

PETER LANG
New York • Washington, D.C./Baltimore • Bern
Frankfurt am Main • Berlin • Brussels • Vienna • Oxford

Library of Congress Cataloging-in-Publication Data

Campbell, Heidi.
Exploring religious community online: we are one in the network /
Heidi Campbell.
p. cm. —— (Digital formations; v. 24)
Includes bibliographical references (p.) and index.
1. Religion——Computer networks. 2. Religion——Computer network resources.
3. Internet——Religious aspects. 4. Cyberspace——Religious aspects.
I. Title. II. Series.
BL37.C36 200'.285'4678——dc22 2005006767
ISBN 978-0-8204-7105-1
ISSN 1526-3169

Bibliographic information published by **Die Deutsche Bibliothek**.
Die Deutsche Bibliothek lists this publication in the "Deutsche
Nationalbibliografie"; detailed bibliographic data is available
on the Internet at http://dnb.ddb.de/.

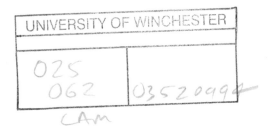

Cover design by Joni Holst
Cover photo by Robb Elmatti & Heidi Campbell
Author photo by Bryan N. Schulman

The paper in this book meets the guidelines for permanence and durability
of the Committee on Production Guidelines for Book Longevity
of the Council of Library Resources.

© 2005, 2010 Peter Lang Publishing, Inc., New York
29 Broadway, 18th Floor, New York, NY 10006
www.peterlang.com

Printed in the United States of America

For Heather

...and our online/offline journey of 687 emails
and 4000 interstate miles together...

to find community and a place to call home.

contents

acknowledgments

This book is the result of a seven-year journey exploring images and ideas of community both online and offline. I am grateful for several groups of individuals from around the world who have encouraged and guided me over the course of this project.

This work is rooted in my PhD work at the University of Edinburgh. I am thankful for the supervision of Joylon Mitchell and Hamish Macleod, along with the online/offline mentorship of several scholars who have been foundational in forming my thinking related to internet, community and religion, namely: Clifford Christians, Stewart Hoover, and Barry Wellman. This research was graciously backed by a University of Edinburgh Faculty of Arts Group and the International Study Commission on Media, Religion, and Culture, which provided funding support for my PhD fieldwork.

I would like to thank the Institute for Advanced Studies in the Humanities at the University of Edinburgh for providing space and a grant in 2003–2004 that allowed me to transform my research into this text. During my time at IASH I was privileged to interact with a wonderful group of international scholars (from Hungary, Italy, Holland, Canada, Germany, Australia, India, UK, and US) coming from diverse disciplines (History, Philosophy, Literature, Communications, and Cultural Studies) who challenged and sharpened my thinking over the course of this project. I am also grateful to Anthea Taylor and Donald Ferguson for creating such a wonderful working environment.

Special thanks to friends and scholars who provided valuable input on versions of this text, including Thomas Ball, Christopher Helland, and Lisa Pitt

Lee, as well as the oversight of the Digital Formation series editor Steve Jones, commissioning editor Damon Zucca, and the Peter Lang staff.

Also, I could not have completed this project without my international support network who have cheered me on during the writing process. I am grateful especially for my family—John and Vivian Campbell, Heather and Robb Elmatti—and such great friends as Sylvia Klauser, Linda and Billy Lindsay, Mia Lövheim, Katie and Mark McKean, Louise McPake, John & Sally Stuart, Ina Steyn and Kate and Simon Yates.

preface

It was late September 1999 when with nervous curiosity I found myself making my way up the steps of a large Anglican church in downtown Toronto. Inside I was greeted with organized chaos: people arranging chairs and preparing the high altar, a makeshift choir practicing, and a dozen others milling around chatting. It was a feeling of strange familiarity; here I was surrounded by a crowd of known people with unknown faces.

This was the "The Great Anglican Online Listmeet," a weekend gathering organized by members of an international email list for Anglicans around the world. For a year I had observed, recorded, interviewed, and interacted with its members online. Tonight we would celebrate Mass together, face to face, many of us meeting online friends and contacts for the first time. I was known on the list as a "professional lurker," and I came looking forward to the opportunity to meet a large cross section of my research subjects, hoping to gain their confidence about my work by answering their questions.

I was welcomed with a big smile and hug by the first person I introduced myself to and presented with a name badge bearing the community's logo and motto, "via media via modem." "Put your name or your online tag or both on this and come find a seat," she said. Around me at the front of the church the nervous excitement was evident. Some people shyly scanned the name badges of those seated, while others quietly greeted one another. It was the feeling one might have at a family reunion, when you know you are family, related to everyone in the room, yet these bonds seem a bit strained, because you've never met before.

In a few minutes the service began. About 37 of the then 450 list members had come. The Eucharist program read,

> This "list meet" in Toronto is an opportunity for many to celebrate together face to face but in our hearts, in our prayers, and over the electrons, our beloved community worldwide celebrates this holy meal with us.

The Mass was an attempt to weave together the different styles and liturgical backgrounds of the community members. A dozen people took lay and pastoral roles in the service, which included seven practicing priests and ordinands. The music ranged from Taizé chants and Negro spirituals to folk rock and traditional hymns. It was an emotional and symbolic event. Just before the gospel reading, while the group sang "Shall we gather at the river," a man from New York started a chain reaction by grabbing the hands of the people next to him. Soon the whole group was standing in a circle swaying back and forth, many with eyes closed and tears running down their faces. It was a moving experience, and I was struck by the high level of care and emotion the people surrounding me were expressing for what some would call their "virtual community" of friends.

The value members placed on this community was stressed in the homily given by a priest, whose email two months earlier about wanting to connect with "list sibs" in Toronto had instigated this meeting. ("List sibs" is short for "list siblings," or "brothers and sisters in Christ.") His message was personal, stressing the importance he placed on this community as it provided him with friendship and support, especially as he lived and worked in an isolated island parish in Canada with little opportunity for fellowship with other Anglicans. He described the list's prayer ministry as a special gift that "list sibs" give one another. The group responded to his openness by coming alive. During the "passing of the peace," instead of the reserved greetings that had been exchanged when I entered the church, there were instead loud laughter, kisses, and hugs. At communion the celebrant emphasized that the group was being transformed from a virtual group to members of the global body of Christ. It was understood that through our physical presence and partaking of the bread and the wine together that we were cementing our connections to one another. We were becoming one in the spirit, as we were already one in the network.

introduction

We are One in The Spirit; We are One in The Lord.
And we pray that all unity may one day be restored.
And they'll know we are Christians by our love.
("We are One in The Spirit," Peter Scholte, 1966, licensed F.E.L.)

In the twenty-first century community is a term that is being debated and redefined. Community can be used to denote a forced social gathering of those who live in a given region, or a chosen partnering of people for a common purpose. Discussion about the nature of community may recognize our global interconnectedness or describe separation of people into selective relationships that affirm personal beliefs and values. Yet, increasingly community is seen as something people choose, rather than something that chooses them.

The trend toward selective, specialized relationships, which may be used to negotiate through an increasingly depersonalized world, has a certain resonance with ideas of community coming out of 1960s hippie communal culture. Reacting against the perceived controlling "establishment," and advocating peace, love, and unity, groups of people broke through traditional boundaries to experiment with new forms of community. At this time a religious counterculture also emerged. The "Jesus People" movement similarly was characterized by its pulling away from mainstream society to create new living spaces of faith. Communal living challenged traditional views of community, in some case invoking fear about the effects of "turning on" and "dropping out." Around campfires across the United States in the 1960s, along with the echoes of "Kumbaya," these experimental social groups sang songs about their expectations and visions: "We are one in the spirit... And we pray that all unity

may one day be restored." By walking side by side in new ways, they hoped to transform their world. By the way they lived, they hoped to mark themselves as unique, representing something new.

Four decades later another revolution has taken place, an information revolution that has spurred a new generation of social gatherings. The internet has become the campfire around which people gather to tell their stories, meet people, and form relationships. Through the network of the internet, people are seeking to build social groups that challenge traditional ideas of community. But can people really experience community online? Can we really become one through a computer network?

Community Online?

In this "congregation" we can't hide much. We don't stay isolated in our bubbles with our own burdens and struggles. We get stripped of our masks (they don't work well by email). Although we are from all over the world, all different from each other, our distinctiveness from each other has lost its separateness.... Can anything else live this out more than an email "congregation" where we know nothing about each other than the common bond of Christ—the bond of LOVE? (Email sent to Community of Prophecy, 24 Mar 1998, Subject: school feedback)

At hundreds of computer screens all over the globe, individuals are logging on to their email accounts, and sorting through a myriad of messages: junk email, correspondence from friends, work-related email, and the daily postings of an email list. Many email users would consider themselves members of an "online community," a group formed though online communication. Email discussion lists take many different forms: self-help advice groups, fan clubs, friendship networks, political discussions, religious prayer groups. They attract people from different backgrounds and with different agendas.

Some discussion list members are "lurkers," staying in the virtual shadows of the groups, reading but not posting, their names only known to the computer that facilitates subscriptions to the list. Some members become well-known characters on the lists, as frequent posters. Others are infrequent posters with degrees of participation depending on time and interest in current discussion. There are also members who moderate or guide group discussions and look after the technical running of these communities. All of these are members of a community joined through computer wires. They gather in different places, at different times—separate, but together. This community is drawn together for a common, specialized interest, and sustained through the internet. But can a group of people, who gather solely through email, truly be regarded as a community? Can online relationships be as authentic as interactions taking place in a local church? What is community? What is church?

The emergence of online communities raises these and many other questions. Online communities provide meeting places for people not linked to a physical space. Rather, they are created through the technology of email lists, World Wide Web (WWW), and chat rooms. These electronic tools connect people to others in their local area or around the world. Yet just as attending a church does not make one part of the Christian community, being part of a Christian email list does not mean the group is a community, either. As the number of Christian websites and electronic discussion groups increases, the link between what is the church and what is Christian community needs to be reevaluated. For some, the personal relationships occurring in the online context can become more intimate and valued than those occurring in the local church. When this takes place, individuals may see their Christian community as coming from the online context rather than the place where they "physically" locate themselves for worship each week. Some critics argue that disembodied gatherings and worship online create a false form of community. Still, online socialization and religious pursuits continue to flourish, and research demonstrates that they invigorate the social sphere (Katz and Rice, 2002; Larsen, 2001; Barna, 2001).

The internet has introduced a new terrain needing to be defined and contextualized as well as explored. The term "internet" is used to identify the vast array of wires and computer network connections, and is what most people use when referring to the World Wide Web as they navigate their way through websites and access their email. It is the "network of all networks." Cyberspace is often used synonymously to refer to the internet. It is seen as a "virtual" world where technology and fantasy meet somewhere beyond the user's computer screen. In his science fiction novel *Neuromancer*, William Gibson uses the term "cyberspace" to describe the realm the story's hero enters when he connects a computer directly to his brain. Gibson describes cyberspace as "a consensual hallucination... a graphic representation of data abstracted from the banks of every computer in the human system... lines of light ranged in the non space of the mind" (Gibson, 1984: 51). This poetic image illustrates how cyberspace and the internet are seen to bring together the real and the virtual in a technological world. The description envisions a mystical realm where people do not simply use technology; they become part of the network.

Virtual reality discussions and images dominated the beginnings of the internet's proliferation into mainstream culture in the early 1990s, and by the mid-1990s "virtual community" emerged as the newest internet buzzword, describing the group relationships many computer users were forming online. These internet-based communities were seen as new social spaces enabling human interaction in the digital world. Starting as grassroots communities on newsgroups or electronic bulletin boards, virtual communities soon became

facilitated and promoted by commercial websites and e-businesses. By encouraging users to form interest groups around specialized topics they hoped to attract more traffic to their websites. Later the term "virtual community" was dropped in favor of the label "online communities," as virtual community seemed to infer something false about the relationships that were emerging.

Throughout the 1990s increasing numbers of people sought out and created online communities, ranging from such diverse topics as stamp collecting to African politics or single parenting. Online communities combine traditional traits of community in a new setting. They occur as individuals assemble through internet technology to form networks of interdependent relationships based on common vision, care, and communication. At the same time as community online emerged, the internet became seen as a social sphere as much as an information-gathering tool.

As internet use and digital social interaction increase, researchers have found making the distinction between "online" and the "offline" context or "real world" crucial in order to describe this phenomenon and compare these with manifestations of community offline. "Online" is applied to that which takes place in a computer network environment, such as interaction facilitated through the internet. The "real world" refers to public and private interactions in daily life occurring within the physical world. Similarly, the term "offline" is used to describe any facet of life occurring away from the computer screen. Often the distinction between the two blurs, as people take advantage of the internet's absence of social cues to experiment with new identities and ways of being. In the late 1990s, discussion of online religion and cyberchurch began to surface as proponents and pundits of technology began to be concerned about the potential effects technology was having on the culture of religion. Fears emerged that online religion would cause people to abandon their pews in exchange for worship via the keyboard and computer screen, further effecting the steady decline of "real world" church attendance. Many in traditional offline churches, those functioning in the physical world tied to a specific geography such as a local church or a denomination, see the internet simply as a threat or a new sphere for proselytizing. Online religion, the presentation of religious beliefs and practices online, has become a phenomenon of religious innovation and the repackaging of spirituality; it also creates deep suspicion and mistrust. In a new millennium, online religion and online community continue to be topics of debate.

The idea of community being created in a faceless, technologically constructed space is problematic in many respects. Embedded in this apprehension is the belief that "disembodied" spiritual practice is inauthentic, or at least severely impoverished. Yet some have argued the internet facilitates new, vibrant forms of spiritual engagement and connection (Zaleski, 1997; Brasher,

2001a). For those who have felt disappointed or disconnected in their experiences of local religious community, the internet provides an interesting option. This is the possibility of being together alone or being alone together.

Picture the great cathedrals of Europe. These vast stone buildings with their towering Gothic spires or Romanesque arches have been described as "early examples of virtual reality, their size and scale out of proportion to ordinary life" helping reinforce the "other-worldly aspects of Christianity" (Sherman and Judkins, 1992: 221). Inside, the congregation gathers for worship faithfully each Sunday, yet individual members and visitors often enter alone, sit alone, and leave alone. They are gathered together, yet in this gathering they realize this sense of loneliness; they are together alone.

Now picture a computer in a home or office, a sanctuary away from the rest of the world. Imagine the individual logged on to a chat room; maybe this is a weekly prayer group they faithfully plug into. As they watch the discussion scroll across their screen individuals in the group are aware of their presence indicated on the right side of the screen. If they are silent too long, they might receive a personal note from a group member asking them to join in. A frequent attendee's presence may command a sort of respect within the group, giving a kind of authority to the individual who types in comments that show up on other members' screens. Each individual on the channel may be alone, with only the computer screen for company, but the technology shows that each separate person is linked to a greater collective, a global community of like minds and spirits. They are alone together.

During my research into religious community and the internet, I experienced both of these types of encounters. Online community is not the same as embodied interaction. Yet when offline options do not provide the spiritual connection many individuals long for, it can become, as one member of a Christian email list stated, a "Godsend." The experience of being alone in proximity, yet seemingly together through an internet connection, provides comfort for many, knowing there is another space where these desires for connection and spiritual input can be realized. For this reason many individuals continue to search for God on the internet, thus posing a challenge to the religious culture and community. For this reason online religious communities need to be more deeply investigated.

In Search of Online Community

My search to understand community in the online world began in 1997 with an essay entitled "Virtual Communities in Cyberspace," written as part of a Masters-level course in the Theology and Ethics of Communication at the University of Edinburgh. Through a year of exploring the then new and

imaginative world of the internet, I encountered several religious groups that referred to themselves as online communities. In this essay, I detailed the phenomenon and definition of virtual communities and the questions their existence raised for society and in my own thinking. For me, virtual community demonstrated how technology could be used to bring people back into relationship with each other in a digital world that seems to separate us more and more from face to face contact with others. The essay concluded by stating virtual communities would continue to grow and flourish online. But this initial investigation sparked more questions than it answered, such as, how might virtual community influence religion and religious community? This book represents the results of seven years of investigating online religious communities in order to see how their relationships and communication habits form and identifying how individuals link their online and offline communities. The aim of this book is to highlight the characteristics of online community that individuals praise, and then consider what implications this might have for individuals in offline religious communities.

An important stimulus for this study came through reading Sherry Turkle's *The Second Self*, which explores how using computers not only influences attitudes and behavior toward the technology itself, but also the ways in which individuals respond and behave toward other people. Turkle begins her sociological study by asking, "The question is not what the computer will be like in the future but instead, WHAT WILL WE BE LIKE? What kind of people are we becoming?" (Turkle, 1985: 3). This question became the starting point for my study of how online culture might influence religious culture. This question, applied specifically to online community and religious culture, can be restated as:

> Because of the internet and the emergence of the online community WHAT WILL RELIGIOUS COMMUNITY BE LIKE in the future? How are people and religious communities being transformed because of online religious communities?

Identifying how the internet influences individual conceptions of church and community calls for an interdisciplinary approach, combining the fields of Technology Studies, Sociology, Media Studies, and Practical Theology. All of these areas are considered under the umbrella of Computer-Mediated Communication, a field that explores developments related to the internet, cyberspace, and computer technology, and the psychological and sociological effects these have on communication patterns and behavior.

As the study of religion online is still in its infancy, there is a need for detailed investigation of the many forms religious practice that are emerging. By focusing on one religion, Christianity, we can achieve a more focused and sys-

tematic investigation. In order to uncover the nature and practice of religious community online, this study focuses on three Christian email-based online communities. These communities were selected on the basis of their common online practices, yet each represents a diverse denominational group. Together they provide a snapshot of religious life online: how online Christian communities use the internet, negotiate their communal identities, interact with their offline faith communities, and evaluate notions of community. This brings together four years of online observation, data collection, and face-to-face interaction with these particular groups. Through these explorations a new definition of religious community will emerge, by identifying a set of characteristics of Christian online community. How an individual's involvement online influences offline interaction with a local church is also addressed.

A Journey toward Online Religious Community

The crux of this book is this: What makes online communities vibrant is not so much their location on the internet, but the attributes they exhibit and the conversation on the subject of community that their existence has generated. Investigating online religious community provides a snapshot of contemporary ideas about the nature of religious community offline as well as online. It is important to note the purpose of this book is not to debate whether a group of people who meet via the internet can be considered a church in a theological sense. The fact is that online religious communities do exist, and some people do describe these online networks as a form of church as well as a community. Rather, the focus of this investigation is on how online religious communities function and how the groups define themselves. The underlying question has not been "Can an online group be a community?" but "What type of community does an online group represent?"

This journey begins in the preface, where we are introduced to the Anglican Communion Online and a group of people who stepped beyond the computer screen to experience, on a new level, the reality of being part of a community of believers they have never seen. The Great Anglican Listmeet was not just about online "list sibs" meeting offline; it was about "brothers and sisters in Christ" sharing intimately with members of their larger communion. For these members the online community was simply another expression of a lived reality, a global community of faith. Yet understanding the richness and complexity of online community requires more than online immersion and offline observation of the phenomenon. It involves exploring the network that sustains these relationships, and even the very definition of the relationships themselves.

In order to understand the motivations and practices of this community, this book begins by introducing the larger themes of the history and development of the internet, in chapter one, and community, in chapter two. These provide background to the developments and debates surrounding online community and a framework for the book's focus on online religious communities, the online groups that share a common Christian commitment and unite through a specific faith-based discussion topic. Then, through an analysis of religion online and Christian internet use in chapter three, we see how online religious community has emerged as a new and growing phenomenon of spiritual practice. This lays the foundation and contextualizes the idea of community as a network of relationships being lived out online and the unique challenge posed by transferring religious practice and community life online. It also prepares the way for investigating online religious community through an in-depth exploration of the lives of three Christian email-based communities.

In chapters four through seven, several themes are explored, considering in detail how engagement in online communities is changing and challenging conception of offline religious community. First, chapter four describes the identity narratives of the three online religious communities to see how online groups develop unique patterns of behavior and a common identity. In chapter five, we explore how online communities use the internet, particularly email, to formulate their community and adapt their patterns of living to the online environment. Chapter six considers how each community connects online experiences with offline behavior and activities. In chapter seven we focus on how members identify positive characteristics and experiences of online community in order to critique their experiences of offline church and religious community. Finally, at the end of our journey in chapter eight we highlight the key attributes members desire in a community, based on their actions and language online, as well as the lessons and challenges this presents to the offline religious community.

As the number of religious websites and online communities increase, the relationship between online and offline religious practices and beliefs needs to be reevaluated. Critics suggest that the end result may be a mass exodus from the church to computer terminals. Others argue that online community is an illusion. On the other side, research shows that many individuals are reclaiming a lost sense of relationship and encouragement through their online involvement. Discovering how online relationships and religious communities are formed and how involvement in these affects individual involvement in the local church, promises to be an interesting, if perhaps contentious, journey.

chapter **one**

Understanding the Internet and Cyberspace

He who grasps the wire is powerful. He who grasps the wire and the screen is very powerful. He who will someday grasp the wire and the screen and the computer will possess the power of God the Father himself. (Quote attributed to unnamed French publisher responding to announcement of advent of a "paperless society" in mid-1900s [Feenberg, 1992: 172])

myth and story surround every technology. They emerge in a specific historical context which influences its shape and use. The internet is no different. The internet is referred to as is the "network of networks," a global network of large computers connected via phone lines and satellites, enabling individuals to connect with other computer users all over the world. Rooted in the American military of the 1950s, the internet has evolved in the twenty-first century into a common piece of technology in many homes. While it is often characterized simply as a tool, internet technology carries with it distinct ideologies and beliefs about the world. The story behind the internet reveals a narrative of potential and control. Cyberspace is more than a phrase used to describe a digital territory existing behind the computer screen; it is a metaphoric construct describing a certain understanding of the world. The internet is as much a reality-shaping medium as it is a tool for communication. Understanding the internet and cyberspace in both contexts is vital for this study.

Here the emergence of the internet and cyberspace are investigated, highlighting the ideological roots that have shaped the story of the internet and the online context. Examining the history and symbolic metaphors shaping them, as well as considering dominant conceptions and uses of internet technology, does this. This allows us to tease out a spectrum of responses to the internet influencing the ways users approach online technology.

A Brief History of the Internet

In the beginning ARPA created ARPANET.
And the ARPANET was without form and void.
And darkness was upon the deep.
And the spirit of ARPA moved upon the face of the network and ARPA said,
"Let there be a protocol," and there was a protocol.
And ARPA saw that it was good.
And ARPA said "Let there be more protocols," and it was so.
And ARPA saw that it was good.
And ARPA said, "Let there be more networks," and it was so.
(Danny Cohen at ARPANET's twentieth-year anniversary symposium
[Hafner and Lyon, 1996: 257])

The internet encompasses a collection of services and operations including email, bulletin board services (BBS), chat rooms, navigational systems, and multimedia components such as audio and video technology. The history of the internet is a multilayered story full of colorful characters: conspirators, passionate inventors, military strategists, hackers, computer scientists, whiz kids, and everyday computer hobbyists. The story of the internet has been told from many angles, flavored by the experiences of its tellers.[1]

Manuel Castells argues development of internet culture is characterized by a four-layer structure: technomeritocratic culture (technologically competent producers and literate members), hacker culture (outlaw innovators), virtual communitarian culture (social advocates and engineers), and entrepreneurial culture (commercial promoters) that promotes an ideology of freedom (2001: 37–60). Here the story is an amalgamation of four accounts (Ceruzzi, 1999; Hafner and Lyon, 1996; Rheingold, 1993a and Salus, 1995) highlighting how an information technology gave rise to a new way of communicating and being in community.

While the internet is often presented as a recent phenomenon, its roots can be traced back to the middle of the twentieth century, and are linked to the rise of the space race and the Cold War fear of nuclear war. In 1957, the same year Sputnik was launched, the US Defense Department established the Advanced Research Projects Agency (ARPA) to fund research into creating a "survivable national communication network" that could be maintained in a time of war (Salus, 1995: 5). Researchers throughout the United States were involved in this task, including Baran and the RAND Corporation in California, who developed "packet switching." This process allowed data to be broken into small, equal-sized packets that could travel electronically along telephone lines and be reassembled at a given destination, eliminating the need for a central command center. By the end of 1969 the ARPA Computer Network, ARPANET, went online. This first network consisted of four con-

nection nodes on the West Coast of the United States, but grew in two years to include over 30 different research communities.

At first ARPANET remained a relatively small and closed community, yet by the mid-1970s many research institutions which did not have access to it were anxious to have the ability to not only transfer data, but to communicate with other researchers. While ARPANET was not intended to be a message system, email soon dominated network use. As Hafner and Lyon stated, "Email was to the ARPANET what the Louisiana Purchase was to the young United States... technology converged with the torrential tendency to talk" (Hafner and Lyon, 1996: 189).

The birth of electronic mail (email) can be traced to 1970 when a message was successfully sent between two machines at the Bolt, Beranek, and Newman laboratory. "[I]n technical terms Tomlison's program was trivial," but although it was a simple experiment, "culturally it was revolutionary."[2] The email program was adapted and given to other servers on ARPANET. For researchers, communication is essential to their work, so "the advent of distant connectivity, the notion of computer mediated communication with someone on another computer was a popular one" (Salus, 96).

The communication exchange on the network through email was revolutionary. A hundred pages could be as easily transmitted as one line. The ARPANET mail system was intended to facilitate research activities, yet users quickly saw that email was a fast and easy way to communicate with coworkers. Correspondence quickly became group conversations as mail and news became the primary motivations for network use. By 1973 a study found three quarters of all traffic on ARPANET was email, and the volume of mail soon began to strain the system (Hafner and Lyon, 194). In order to streamline traffic, it was suggested that standardized headings and compatible protocols be implemented. This generated even more email discussion. In the end, the glut of network traffic became the springboard for the creation of mailing lists.

In 1975 an ARPANET manager announced the formation of "an electronic discussion group... to develop a sense of what is mandatory, what is nice and what is not desirable in a message service" (Hafner and Lyon, 200). This became the first Message Service Group (MsgGroup), a moderated group where members received daily posts from others on the list. Throughout the 1970s MsgGroups remained a dominant forum for conversations linking researchers. Developers also foresaw how email would become "the rule for remote collaboration" (Hafner and Lyon, 214). On the MsgGroup, "flaming" (fiery and often abusive forms of dialogue) and "emoticons" (punctuation meant to represent human gestures and facial expressions) first emerged.[3]

The social and communicative potential of the internet continued to expand, and by the late 1970s other unsanctioned groupings began to arise on

ARPANET. One of the first popular unofficial lists was SF-LOVERS, for those wanting to discuss science fiction. Other specialty nonresearch message groups continued to surface and, as Howard Rheingold stated, "It is to the credit of the top ARPA managers that they allowed virtual communities to happen, despite pressure to reign in the netheads when they seemed to be having too much fun" (Rheingold, 1993a: 77).

The increased communication also led to the creation of other systems, such as Joint Academic Network (JANET) in the UK and the UNIX time-share operating system, which helped widen the audience of the network. It was through the UNIX network Usenet that "newsgroups" emerged.

"Newsgroups" began as a simple program, written around 1979 at the University of North Carolina (UNC). The first newsgroup was created for the purpose of discussing version 7 of the UNIX system "partly as an exercise in learning details of the new system and partly to fill an administrative need" (Rheingold, 139–140).[4] Soon this rudimentary system allowed people to post articles to other newsgroups and other non-systems-related groups were created, such as net.jokes. At first Usenet newsgroups only linked UNC and Duke University in the United States, but in 1980 they were distributed freely on the UNIX system. By the mid-1980s dozens of institutions all over the world were plugged into Usenet.

Through new connection systems and other computer developments, ARPA's network domination began to break down in the 1980s. This was heightened by the advent of the personal computer, built at the Palo Alto Research Center. Not wanting to lose the personal communication they had grown accustomed to on ARPANET, its creators developed Ethernet, a local area network (LAN) linking all computers in their building. "internet-working" was still primarily accessible only to those inside the scientific community, yet "the more useful this powerful tool proved to be, the more people who were not originally authorized to use it wanted to get their hands on it" (Rheingold, 1993: 83).

In 1983 ARPANET split into MILNET, focused on defense networking, and other research remaining on ARPANET. The Internet Activities Board was formed as an independent committee of researchers to coordinate internet activities. The internet was defined as "a collection of over two thousand packet switched networks" located worldwide (Salus, 128). Still, it was social use of work-related tools such as email and newsgroups "that directly caused the increase in Internet use; these were the applications that began to drive the Internet" (Salus, 152). More and more special interest Usenet groups began to form online. These included "net.religion" in 1983, which was the "first networked forum for discussions on the religious, ethical, and moral implica-

tions of human actions" and "net.religion.jewish" in 1984 as the first group dedicated to a specific religion (Ciolek, 2004).

Using the network as a social sphere rather than a research space, as it was initially intended, also brought new challenges for system administrators. In 1986 the issue of censorship emerged on Usenet, when site administrators rejected requests for news groups on drugs (net.rec.drugs) and cooking (gourmand). This led to a series of online discussions from which an "alternative" or "alter" system category for newsgroups was created (alt.drugs and alt.gourmand). The alternative hierarchy caught on quickly and soon other categories were developed, such as "comp" for computer and "rec" for hobbies.

The advent of personal computer networks allowed the general public to gain access to forums of networked groups known as bulletin board systems (BBS). Running on public domain software and IBM or similar systems, individuals could post messages on electronic spaces that functioned like a bulletin board. In the 1980s prices of modems dropped, which enabled more people to utilize BBSs. University and industrial computer centers became storage houses for these online groups, both BBSs and newsgroups, which became "what the popular press calls a 'virtual community' based on the Internet" (Ceruzzi, 1999: 298).

In 1990 ARPANET was decommissioned, but its offspring networks enabled thousands of sites and individual computers to stay connected. Around this time the CERN physics laboratory in Switzerland created a multimedia application and navigational tool, which became known as the World Wide Web. By following a web of pointers, users were able to locate where specific information was actually stored on the network. Helped by the Mosaic interface, the forerunner of Netscape, graphics, text, and sounds were integrated into "pages" of information. Point-and-click mouse technology allowed users visual interactions with the network.

The United States High Performance Computing Act of 1991, allocating funding to upgrade the network for public and school access, transitioned the internet from governmental to private enterprise. Corporations such as IBM and AT&T began staking claims on the Net. In 1993 administrative functions of internet management such as assigning addresses and maintaining directories and information services were turned over to private companies, thus placing the internet in the public domain.

With the growing popularity of user-friendly internet service providers such as AOL and CompuServe and the widespread adoption of Netscape, by the mid-1990s the great internet rush was on. Search engines and navigation tool such as Yahoo and later Google provided a framework to navigate through the increasing amounts of content found online. The rise of shareware, open source software pushed forward by the hacking community and other

computer hobbyists, provided a challenge to the emerging conglomerates of IBM, Microsoft, and Apple/Macintosh. Sites such as Napster and Gnutella, online networks for sharing music files, demonstrated the power of users to mobilize for cooperation along common goals, even if they were later deemed illegal and reorganized into other more legitimate formats. Other innovations such as ICQ and MSN instant messaging, virtual gaming formats, and web logs offered users even more options for connection, interaction, and information searching.

Current use of the word "internet" typically refers to the connection of a variety of software, hardware, and computer systems. From this point onwards the internet is understood as the "network of all connected networks," an access tool and method with which numerous forms of computing technology are connected. Yet the internet is more than a tool; it is a medium, shaping the culture and ideas of technology.

In this brief historical overview, it is worth noting that the roots of the internet are characterized by two attributes: fear and promise. Beginning in the Cold War culture of suspicion, internet technology was created in response to the fear of looming devastation through nuclear war. The internet was created to sustain communication in the midst of catastrophe, and came out of an underlying feeling of alarm, mistrust, and desire to use technology to maintain control (Sardar, 1996: 24–36). Yet, the internet's development and expansion was also fueled by a positive belief in technological progress, the right to access, and promotion of freedom. The internet was presented as a new land of opportunity and a "wonderful pluralistic world," opening society to new potential ways of governing, relating, and being (Dyson et al., 1995: 28). Within this tension of the internet empowering both control and autonomy, social attributes and uses of the technology surfaced. The internet became more than an information dissemination tool; it became a social sphere.

The creation of the internet can be read as story of information, communication, and socialization. It is a story rooted also in fear and promise. These attributes are important to bear in mind, as the beliefs and rhetoric that surround this technology often influence how the internet is perceived and used.

The Story of Cyberspace

While the internet has become the central symbol of the digital information age, it cannot be fully understood without examining the story of cyberspace. Cyberspace is an idea that has become synonymous with the internet. Considering how it has served as both myth and metaphor demonstrates how these facets have shaped understanding of the internet.

Long before the internet became a common household word, the concept of cyberspace existed in science fiction and fantasy literature. William Gibson introduced cyberspace in the science fiction classic *Neuromancer*, prophetically written in 1984. Gibson describes a near future world where most of Earth's computers have been connected in a global network. People enter this network through "a virtual-reality grid space" known as cyberspace. According to Gibson it is meant to suggest,

> The point at which media (flow) together and surround us. It's the ultimate extension of the exclusion of daily life. With cyberspace as I describe it you can literally wrap yourself in the media and not have to see what's really going on around you. (Woolley quoting Rheingold, 1992: 122).

Again, within cyberspace is the tension of both fear and promise. Cyberspace as a technologically constructed reality offers the opportunity and ability to create a new and better reality.

As "a consensual hallucination" that blocks out the world of the five senses, it promises escape from the perceived chaos of the real world (Gibson, 1984: 51). Yet science fiction images of cyberspace also present a dark future where the technological world oppresses and exerts control over humanity, such as those presented in films like *Johnny Mnemonic* or *The Matrix*. As cyberspace has become equated with the internet, these conflicting images have been used to support the claims of both advocates and critics of the internet as being either utopian or dystopian (Wellman, 1997a: 448–51). Describing the myth and metaphor of cyberspace helps to bring an understanding of the criticism and accolades the internet has received. It also helps to illustrate how the internet can be described both as a tool to enhance community and as a tool of control and manipulation. Uncovering the myth and reality behind cyberspace may help to contextualize the social use of the internet and the debates surrounding them.

Myth

Cyberspace can be described as a mythical space, a closed reality, and an inorganic area existing somewhere beyond the computer screen. Some accounts say Gibson came up with the idea of cyberspace "after witnessing the spectacle of a child in a hypnotic symbiosis with a video arcade game" (Rushkoff, 1994: 12). It is meant to represent an otherworldly space where one can lose oneself, where reality is re-created through fantasy and experimentation.

Central to the myth and mystique behind cyberspace is the blurred distinction of what is "virtual" and what is "real" within the computer world. Virtual, as it is used in computer science, denotes something "whose existence

is simulated with software rather than actually existing in hardware or some physical form" (Hiltz, 1992: 188). It is often combined with other words, such as virtual reality or virtual community, to describe an "un-real" copy of something that exists in the "real world." Cyberspace is often closely related to the concept of "virtual reality" (VR). VR technology uses computer graphics and images to create a technologically enhanced reality controlled by its programmers. In science fiction the offline world is presented as lacking or even fundamentally flawed. Cyberspace offers a welcome escape, as illustrated by Case, the key character in *Neuromancer*, in his reentry into the network after an extended absence:

> Please, he prayed, now—
> A gray disk, the color of Chiba sky.
> Now—
> Disk beginning to rotate, faster, becoming a sphere of paler grey....
> And flowed, flowered for him, fluid neon origami trick, unfolding his distanceless home, his country, transparent 3D chessboard extending into infinity...
> And somewhere he was laughing, in a white painted loft, distant finger caressing the deck, tears of release streaking his face. (Gibson, 152)

In fiction, entering cyberspace can provide relief from embodied imperfections. It is painted as the promised land, a self-selecting reality where the best bits of the physical world can be combined with elements of fantasy. In VR humans are seen empowered with the ability to play God and write a new book of Genesis. This is illustrated in the movie *Lawnmower Man*, when a scientist uses VR treatments to increase the intelligence and mental capacity of a developmentally slow young man. In an opening scene, Dr. Angelo (played by Pierce Brosnan) reflects,

> Virtual reality holds the key to the evolution of the human mind.... Sometimes I think I have discovered a new planet, but it's what I am inventing and not discovering.... I have just touched the shore of one of its continents. (*Lawnmower Man*, New Line Video, 1992)

In the mythic world of cyberspace, computers enable people to right the wrongs of the natural world by creating a new world with a different set of rules.

For many in the mid-1980s to 1990s, cyberspace became an icon representing utopia. This was true not only of science fiction authors and fans, but was found in the beliefs and practice of computer scientists and hobbyists. Sherry Turkle in *Second Self* studied young male computer hackers fixated on pastimes such as "sport death" that pushed the mind and body to its limits in round-the-clock programming sprees. These hackers described programming

as a "Zen-like experience" enabling them to lose track of reality. Here cyber-space was an ideology rather than a fantasy. As one hacker, Alex, attested:

> When you type mail into the computer you feel you can say anything.... I don't even feel that I am typing. It feels much more like one of those Vulcan mind melds, you know, that Spock does on Star Trek. I am thinking it, and there it is on the screen. I would say I have perfect interface with the machine.... I feel totally telepathic with the computer. (Turkle, 1985: 217)

Computers offer a way to realize new forms of existence within a con-trolled reality. In these examples, cyberspace displays several key values and beliefs about technology. First, cyberspace presents a place of potential; in-side the computer lies a new world to be created and explored. Individual choice through the ability to create is valued. The idea that salvation can come through technology is ever present. In one sense, the cyberspace myth is grounded in a sense of hope for a better world within the computer network. As Buick states,

> The mystical and all encompassing vocabulary of "cyberia" and the "internet" is symptomatic of the participants' desire to create a utopian world of total knowl-edge, a human made machine with all the answers. (Buick and Jevtic, 1995: 26)

There is also a dark side of the world of cyberspace. Ziauddin Sardar describes it as a place of cultural control and manipulation, where a closed-minded Western culture is "spread like a virus to non-western cultures" (Sardar, 1996: 27). He calls cyberspace "social engineering of the worst kind," forcing people into fixed prejudices by offering limited perceptions of reality (Sardar, 38).

It has also been described as "an unhappy world... dystopic vision of the future," invoking caution and even fear (Benedikt, 1992a: 1). Cyberspace can represent control and the ability to manipulate not just an environment, but other individuals in that environment. The state of the landscape is dependent on those who are in command and their intentions. Consider movies such as *Tron* (Walt Disney Video, 1982) and *Johnny Mnemonic* (Twentieth Century Fox, 1995) that envision an oppressive future where man is controlled by com-puter technology. This is classically expressed by Spike (Henry Rollins) in *Johnny Mnemonic* commenting on a disease ravaging humanity brought on by computers. He says

> What causes it? The world causes it... information overload. All the electron-ics around you poisoning the airwaves, technological f***ing civilization, but we still have all this because we can't live without it. (*Johnny Mnemonic*, Twentieth Century Fox, 1995)

Sherman and Judkins suggest this in the title of their book on virtual reality, *Glimpses of Heaven, Visions of Hell* (1992), that what for some might be heaven, for others could be hell. In the worlds of *The Matrix* (Village Roadshow Pictures, 1999) and *Terminator* (Orion Pictures, 1984), human beings live in oppressive, slavery-like conditions when computers dominate the landscape. In these films, the sky is covered in darkness and the sun no longer shines. The world is physically dark and so is the future. Cyberspace is something that traps humanity, as demonstrated when Morpheus (Laurence Fishburne) in *The Matrix* proclaims, "The Matrix is everywhere. It's all around you," and in the infamous "cyber-sex" scene in *Lawnmower Man*, where the female cyborg becomes caught in a virtual reality web, unable to escape her dominator. This seems to directly contrast with the image of cyberspace as the promised land, flowing with information that will improve existence. The myth of cyberspace is a story of hope mingled with hopelessness.

Metaphor

Yet cyberspace is not just a word linked to science fiction; it has also become a metaphor to describe how individuals understand the internet to function. Douglas Rushkoff claimed in *Cyberia* that "in a bizarre self-fulfilling prophecy, the science fiction concept of reality that it can be consciously designed begins to emerge as a belief" (Rushkoff, 13). In the early- to mid-1990s, cyberspace moved from a construct confined to science fiction to being used as a descriptive noun.

In *Cyberspace: First Steps*, Michael Benedikt offered one of the first attempts by computer scientists and philosophers to describe cyberspace, which included definitions of cyberspace as "a parallel universe created and sustained by the world's computers and communication lines," "a screen becomes a virtual world, everywhere and nowhere," and "the realm of pure information" (Benedikt, 1992b: 1–3). This exploration represented an important transition from cyberspace being considered a mythic space to being perceived as an actual space. Benedikt claimed:

> Cyberspace has a geography, a physics, a nature, and a rule of human law. In cyberspace the common man, and the information worker—cowboy or infocrat—can search, manipulate, create or control information directly; he can be entertained or trained, seek solitude or company, win or lose power ... indeed, can "live" or "die" as he will. (Benedikt, 1992b: 123)

At the time Benedikt admitted this conception of cyberspace was "under construction," yet claimed it would eventually be both a physical reality and a new realm of consciousness. Heim, a philosopher of virtual reality, echoed

this, stating cyberspace was about more than just computer interface design; it was "a metaphysical laboratory, a tool for examining our sense of reality" (Benedikt 1992b: 59).

Seeing cyberspace as an actual place was actively promoted by the "digerati" or digital elite advocates of the 1990s, such as Esther Dyson (Electronic Frontiers Foundation), Bill Gates (Microsoft), and Michael Dertouzous (MIT labs). Outspoken advocates of the internet promoted cyberspace as a new information space accessible to everyone. Phrases like the "information highway" and "surfing the Web" were used to refer to the form and function of cyberspace.

In the introduction of the 1991 High Performance Computing Act, Al Gore championed the image of the internet as highway. Describing the emerging computer network system as a "superhighway," Gore drew upon the legacy of his father, who had sponsored the 1956 Federal Aid Highway Act establishing the US interstate highway system. The Clinton-Gore Administration regularly employed the highway image to promote progress through the expansion of a national information infrastructure. It was also picked up by cyberanarchists and computer marketers, who added to the discourse such slogans as "national borders are just speedbumps on the information superhighway" (slogan cited in May, 1996: 249). Bill Gates's book *The Road Ahead* (1995), also using the image of a highway, claimed this road would eliminate distances, and connect people to resources and others, while creating a new infrastructure where digital information would be the new medium of exchange. The highway image invoked ideas of progress and moving forward into new territory.

In the mid- to late 1990s, descriptions of cyberspace as a network or a web began to take precedence over the highway image. This also helped to give new shape to this digital landscape. The image of a web or network introduced a decentralized view of power and control. In a web, interactions can begin from a variety of points or perspectives, and information may travel many paths. The World Wide Web as the incarnation of cyberspace enforced this understanding. Many felt the Web offered a more accurate expression of cyberspace for popular culture, as Alex McHoul explained:

> What moves is no longer "information" along a highway.... What moves on the web is the movement of the web itself. Its motion creates the sites that it is possible to move to. This deletes the distinction between space and matter that is crucial to everyday thinking. In the web, "space" informs matter how to move, and matter "informs" space how to shape itself. (McHoul, 1997: 49)

Even Microsoft, in Windows 98, opted to replace the standard desktop metaphor with the icons and symbolism of a network. The web image became a way to speak of the redefinition of traditional boundaries. Cyber-feminists,

such as Donna Haraway, argued that the internet was often too closely tied to late-capitalistic culture and its military complex, limiting discussion of cyberspace to traditional ideologies. Framing cyberspace as a matrix or web unlocked the potential for redefining power relations, typically biased towards masculinist structures.

The freedom cyberspace was said to offer was based on a blurring of representation and reality. Images such as web and highway shaped not only language surrounding computer technology, but also underlying beliefs. This was a road not only to a brighter future but also to Baudrillard's idea of the "satellization of the real."

In the 1980s Jean Baudrillard proclaimed humanity had become enveloped in a technological cocoon shaping its understanding of the world. The "real" had become simulated through signs or metaphors. For Baudrillard these simulations become primary, replacing what they represent. This causes reality to "implode" into the "hyperreal," so reality becomes "no longer real at all" (Baudrillard, 1983: 3). In his interpretation, an image begins reflecting a basic reality, but soon begins to mask and pervert what it represents. Then the image disguises the absence of the initial reality, until finally it bears no relation to any reality whatsoever. Applying this to media technology, "we must think of the media as if they were... a sort of genetic code, which controls the mutation of the real into the hyperreal" (Baudrillard, 5). The media image becomes more real than what it actually represents.

The rhetoric of cyberspace began to blur what was real about how the internet actually functioned. The computer screen was described as offering the gateway to a new reality. It can also be argued the hyperreality of cyberspace had its roots in Apple's development of the desktop metaphor, giving the computer interface a "real world" representation. Macintosh desktop-style icons soon became the industry standard. More than simply offering a "user-friendly" way for people to use a computer, it informed how people understood the technology and how they engaged with it. As Turkle commented:

> These new interfaces modeled a way of understanding that depended on getting to know a computer through interacting with it as one might get to know a person or explore a town. (1995: 23)

While IBM and DOS systems initially encouraged users to understand the mechanisms inside and the underlying structure of a computer, Turkle claimed Macs encouraged users to stay "at the surface" and engage solely with the interface. This helped facilitate a shift from what she describes as "a culture of calculation, to a culture of simulation," where

> We have learned to take things at interface value. We are moving towards a culture of simulation in which people are increasingly comfortable with substituting representations of reality for the real. (Turkle, 23)

As personal computing and internet access increasingly moved into the public sphere, people readily appropriated the iconic language "surfing the Web" to describe their engagement online, but more subtly also to comprehend the function and purpose of the computer.

Mark Numes said in the mid-1990s that the internet was becoming what Baudrillard refers to as a "third order simulacrum," where the actual object is represented by an image made into a simplified icon. In such a way the "map of the territory" itself becomes the territory (Numes, 1995: 318). On the internet, that "which was previously mentally projected, which was lived as a metaphor in the terrestrial habitat is from now on projected entirely without metaphor into the absolute space of simulation" (Numes, 315). In other words, cyberspace had become an actual place, rather than just a way of describing the space created by the networking of computers. Even now people use cyberspace as a noun, connecting it to a sense of territory without knowing what it truly represents: "It has now entered into common speech on and off the internet as shorthand for this conception of computer networks as a cybernetic space" (Numes, 314).

The story of cyberspace reinforces both the hope and the fear of technology in the future. Cyberspace as myth in science fiction presents humanity with the opportunity to form a new reality beyond the screen, but is mingled with a dystopian sense that the technological world may exert control over humanity. Cyberspace as metaphor demonstrates how an image can be transformed into reality, a transition that carries with it certain values and beliefs about the world. Cyberspace becomes a conceptual, ideological space in the way, Baudrillard argues, that metaphors become the reality helped by images such as the highway and web, which promote it as an actual realm full of potential. The story of cyberspace and the internet reveals these ideological conceptions of life online, where the internet can be either a tool to create a better world or one that manipulates humanity.

Reactions to the Internet

At the invention of every new technology, a standard spectrum of reactions typically emerges.[5] First comes the "honeymoon" period at the technology's introduction, where advantages are presented and potential uses explored, especially by creators and marketers. Here advocates rush to champion the product and call for its adoption. During mass adoption at the popular level,

critics quickly surface. These may be Luddites, who rally against any form of technological innovation, or social critics who react toward changes the technology is making to the social landscape. After the pendulum has swung to both extremes, from supporters to opponents, a middle way emerges. A similar process has been evident regarding the internet. On one side are those who have described the internet as utopia. On the other side are those who have called it a tool of seduction and manipulation. In the middle are individuals trying carefully to weigh the advantages and disadvantages they see the internet creating. While highlighting only three responses to the internet may appear an oversimplification of these debates, it should be noted that most controversies related to issues of technology tend to identify extremes.[6]

In the mid- to late 1990s, as public internet adoption and access were being heavily pushed by the government and commercial sectors, heated debates between internet advocates and critics began to find voice in the mass media. Many of their reactions and arguments can be clearly linked to aspects of the internet's history and associated myths. The issues raised also provided the basis for critiques of and research into the nature of online community. Articulating these dominant responses to the internet—advocates, critics, and critical friends—is not only an important part of the story of the internet, but also provides a foundation for understanding community in the online world.

Advocates

> Everything informational and important to the life of individuals ... will be found for sale or for the taking in cyberspace. (Michael Benedikt, *Cyberspace: First Steps*, 1992a: 2)

Internet advocates, often referred to as "techno-utopians" or even "internet evangelists in the 1990s," attempt to boost the profile of the internet by "raving" about it in the media. Advocates characterized the internet as a communicative nirvana.

A foundational document illustrative of the utopian perspective was *A Magna Carta for the Knowledge Age* (Dyson et al., 1994). Authored by a futurist, an internet guru, and a media expert, it sketched a picture of the future where cyberspace served as a symbol of a new age of knowledge, possessing the ability to unlock widespread social change. Cyberspace offered a "wonderful pluralistic world," opening up new opportunities and providing "one of the main forms of glue holding together an increasingly free and diverse world" (Dyson, 28). This new age of knowledge was to be spread via the internet by introducing "new codes of behavior" through the proliferation of information and digital ideology that access would mean shared knowledge and harmony.

Potential, possibility, and empowerment are words often employed by advocates to speak about the internet. For them it is more than an information-gathering tool; it is a technological revolution leading to a more just and free society. Microsoft's Bill Gates still continues to serve as one of the internet's most enthusiastic cheerleaders, claiming it will offer the basis for new forms of personal and professional connection.

> The network will draw us together, if that's what we choose, or let us scatter ourselves into a million mediated communities. Above all, and in countless new ways, the information highway will give us choices that can put us in touch with entertainment, information, and each other. (1995: 274)

Advocates are optimistic about the future. While acknowledging that the digitization of culture may have its downsides, overall they foresee internet proliferation as a positive development worldwide.

Along with this comes the promotion of freedom online and the right to access. Hackers and "crypto-anarchists" have been outspoken advocates of the breakdown of the governmental monopoly of the internet and the belief that "information should be free" (Denning, 1996: 141). The freedom of information is regarded as a right of all and inevitable as technology removes barriers around intellectual property (May, 1996: 239). Internet advocates promote the internet's ability to make the world a better place where access to information equals freedom.

Critics

> Any concept which entails people enhancing their humanity from the example of a synthetic machine is morally ugly. (Michael Shallis, *The Silicon Idol*, 1984: 173)

Responding to the praise of entrepreneurs and computer enthusiasts about the internet's ability to bring humanity together, critics describe it instead as a path separating individuals. Their response to the internet focuses on the weakness of technology they see most people overlooking or brushing over.

Critics of the internet present varying degrees of concern, from guarded apprehension to antagonistic, confrontational approaches. Technology and society writer Langdon Winner strongly critiqued the *Magna Carta for the Knowledge Age*, calling it an "optimistic embrace of technological determinism" (1997: 989–1018). His worry was with the way computer technology was being used and the fear that online access to information would lead to a "decline in habits of sociability." While he was sure people would not reject all human company in favor of online interaction, he wrote

> What worries me is that people will begin to employ networked computing as they already use televisions, as a way of "staying in touch" while avoiding direct contact in the public world. The basic question is how will we regard ourselves and others in a wide range of technically mediated settings? (989–1018)

Critics of the internet continue to see it as a threat to "real community" and communication.

They stress its perceived disadvantages, believing that online communication will erode the ability to communicate "face to face." Clifford Stoll, another outspoken opponent in the 1990s, described the "darker side of the information superhighway" he saw coming out of the blurring of the lines between synthetic and real life.

> Electric communication is an instantaneous and illusionary contact that creates a sense of intimacy without the emotional investment that leads to close friendship. (Stoll, 1995: 24)

He and others believe that the lack of physical and social cues will ultimately lead to shallower forms of human interaction and the devaluing of "authentic community." Critics suggest the internet also leads to proliferation of misinformation, or at least "information of unknown pedigree and dubious quality," as "answers are less important than the process of discovery" online (Stoll, 124–25). They say rhetoric of the internet's ability to liberate the masses and usher in better standards of living is not only misleading, but also dangerous, for "despite the liberating wonders of this *telenovela*, piped water remains a dream for millions" (Slouka, 1995: 91). Critics see themselves as reality advocates, trying to counterbalance the hype surrounding the internet. Yet in the end they often present cyberspace as a dystopian landscape.

Critical Friends

> Technology should be embraced... but with care and skepticism. (Jeffrey Young on Technorealism, 1998: A23)

Amidst the ravings of technophiles and rants of technophobes another group seeks a middle-of-the-road approach, often referred to as "reflection," attempting to hold the criticism and advocacy in tension.[7] These individuals see the internet as neither evil nor a way to societal salvation. Nardi and O'Day offer the label of "critical friend" as a description of an alternative response between dystopian and utopian perspectives of technology. The critical friend attempts to address "different ways of doing and being that emerge with technological change" (Nardi and O'Day, 1999: 27).

"Critical friends" offers a helpful category for considering both positive and negative internet influences by identifying how they affect individual, community, and social-political structures. Nardi and O'Day suggest individuals embrace the internet with caution. The best example of critical friendship with the internet is "Technorealism," a school of thought that evolved in the late 1990s through email exchanges between friends in New York who called themselves "a new generation of cultural critics" (*Technorealism: get real!*, 1998: 19). As writers, researchers, and artists, they were concerned there wasn't a category "for someone who is very enthusiastic about technology, but is also very concerned about aspects of technology" (Young, 1998: A24). Their Technorealism manifesto went public online in 1998 (www.technorealism.org).

The authors, including author Douglas Rushkoff and Andrew Shapiro, wanted to consider the biases of various digital technologies while allowing individuals use them in creative ways. Their goal was "neither to champion or dismiss technology, but rather to understand it, and apply it in a manner more consistent with basic human values" (*Technorealism: get real!*, 19). Technorealism is based on eight shared principles:

1. Technologies are not neutral.
2. The Internet is revolutionary, but not Utopian.
3. Government has an important role to play on the electronic frontier.
4. Information is not knowledge.
5. Wiring the schools will not save them.
6. Information wants to be protected.
7. The public owns the airwaves, the public should benefit from their use.
8. Understanding technology should be an essential component of global citizenship. (www.technorealism.org)

The manifesto emphasizes that technology is not value-neutral; its creators, controllers, and users all contribute to the value-shaping process. Technology brings with it both opportunity and responsibility. The key is a balanced consideration of the benefits as well as the hazards of a technology. Individuals are still encouraged online to electronically sign their name to the manifesto, if the ideas expressed resonate with their beliefs. Their position is summed up as "communication and computing can be thrilling and disorienting.... Are these changes good or bad? The answer is both" (www.technorealism.org).

While Technorealism has been dismissed by some as simple and naïve, such as in "Glorifying the Obvious" (Levy, 1998), it has provided an important articulation of an objective approach to the internet and the need for broad

critiques of technology. Other forms of reflection in the spirit of being a critical friend of technology have also been applied to the internet, including ideas such as the domestication of technology (Silverstone and Haddon, 1996), social affordances (Hampton and Wellman, 2002), and discussions on the social shaping of digital technology. Critical friends portray the internet as a microcosm of society; cyberspace is seen as a place of both empowerment and limitation. By rejecting oversimplified misconceptions that either glorify or vilify, critical friends promote open-minded reflection and public debate about social and policy issues related to the internet.

This range of responses demonstrates that the internet creates an emotionally charged media environment. Advocates promote the internet's ability to make the world a better place, either for ideological reasons or personal benefits. Critics attack the image of the internet as a "promised land," arguing it is a dehumanizing medium. Critical friends attempt to reflect on both advantages and disadvantages introduced by internet technology. These labels will be useful to help identify positions and biases of various researchers and internet users.

The Internet:
Information, Identity, and Experimentation

So far the internet has been described as a place of dichotomy: unity and divisiveness, promise and hopelessness, freedom and control, opportunities and limits. The internet has provided new ways to think about identity, relationships, and one's sense of home. Living online is more than having a web page or an email address; having a home in cyberspace carries with it a set of assumptions about the world (Star, 1995). Identifying the internet as having its own unique culture forces the question: What kinds of homes are being created online? As more individuals are absorbed into internet culture, it is important to consider how their beliefs and practices shape the online environment. How people see the internet greatly depends on how they use it. Common patterns of life online range from utilitarian information-based pursuits, to those motivated by social networking or even religious purposes.

The internet and life online have been defined in a variety of ways. Ann Markham (1998), presenting one of the first attempts to describe the ways people visualize cyberspace, suggested people experience the internet within a continuum of options, such as tool, place, or state of mind. In the same year Phil Agre in "The Internet and Public Discourse" (1998) described the internet as a communications medium, a computer system, a discourse, and a set of standards. While both of these sets of descriptions provide helpful starting

places for defining different aspects of the internet, they are limiting when one considers the internet as a social phenomenon.

These models reflect differing ideological understandings and uses associated with the internet, yet also leave room for clarification, especially in relation to how the internet has been studied through the field of Computer-Mediated Communications (CMC). CMC is understood as "a process of human communication via computers, involving people, situated in particular contexts, engaging in processes to shape media for a variety of purposes" (December, 1997, www.december.com/cmc/mag/1997/jan/december.html). An interdisciplinary field encompassing areas such as sociology, computer science, psychology, informatics, and philosophy, CMC research often focuses on similar issues of identity and social structure and typically integrates diverse methodologies to do this.

Drawing on conceptions presented by Agre and Markham and considering the evolution of research in CMC, a set of descriptions is offered here, which describe specific transitions occurring in the popular use and study of the internet. Three typologies of the internet are identified: the internet as information space, as common mental geography, and as an identity workshop. These typologies of how users and researchers have seen the internet are utilitarian, conceptual, and experimental. They also set the stage for the more in-depth discussion of social and religious use of the internet within online religious communities as pursued in subsequent chapters.

An Information Space

Describing the internet as an information space highlights aspects of communication and information exchange. Attention is given to the internet's ability to allow individuals to utilize a variety of technologies to interact with data. This relates to Agre's description of the "Internet as a communications medium," serving as a communication technology or a "meta-medium," facilitating interaction. He argues this is the dominant conception of the internet (Agre, 1998). The internet exists as a tool for the utilitarian purpose of transferring messages and data. Compared to other modern communication media (e.g., newspapers, television), the internet is unique in that it allows users to simultaneously be "a publisher as well as a consumer of information" (Rheingold, 1993: 97). With minimal resources individuals can publish a website or start an email list on their preferred topic, generating and discovering information of personal interest. Internet technology becomes valued for its ability to retrieve and store data.

CMC research began with this focus by considering users' interactions with texts. These studies can be traced back to the 1970s, when CMC was

primarily interested in the technological capabilities of computers, exploring how particular technical, economic, and ergonomic characteristics of computers affected organizational efficiency and effectiveness (Kiesler, Siegel, and McGuire, 1984). While research expanded in the 1980s to consider more fully the context of computer interactions, it maintained an informational focus. Interest remained on organizational online communication and how individuals exchanged information while developing communicative networks (Rice, 1987). Studying the internet as an information space still is prevalent within discussion of copyright, navigation of information spaces, and cyberlaw (Katsh, 1996; Kirsh, Phillips, and McIntyre, 1996).

According to Spears and Lea, "CMC reflects a shift of the attentional focus to the content and context of the message" (1992: 40). The attention here is on the message over the producer, the textual creation instead of the text creator. These texts focus individuals on representations of reality. Numes argues that in the virtual world of the internet, "our words are our bodies" (1995: 326), where people become known by their words or their taglines. Texts become a defining factor of who one is and what one does in cyberspace. Through texts, readers construct mental images of one another. Information space dictates that individuals become data producers. Texts are seen as representing the totality of the particular producer, limiting interpersonal engagement with them at a deeper level. Information becomes abstracted from its author or creator; the focus becomes gathering data.

This model is useful when highlighting negative tendencies towards depersonalizing those who generate text. In *The Cult of Information*, Theodore Roszak argues this occurs as those in the information society mistake access to information for knowledge. He states society is now based on an "information economy"; those who control information are the new power brokers (Roszak, 1986: 91). The model is also central to debates of the "digital divide," advocating the need for more public online access, and to political dialogue about the "information rich" and "information poor" (Gunkel, 2003; Keeble, 2003). The focus is utilitarian, promoting the most access to the most information for the most people.

A Common Mental Geography[8]

The internet as common mental geography is more than a tool for communication; it is used by individuals to construct a common worldview. This can be loosely associated with Agre's "Internet as a computer system," where computers are identified as machines representing the world. The internet provides language and resources pointing to "real things in the world that the data records are suppose to represent" (Agre, 1998). Computers supply stan-

dardized methods of processing data. In turn, these processes link computer operators to a common platform of language and interactions.

This platform provides a common mental geography, a way to describe how the world functions using "computer-ese" and technological imagery. In this way the machine is used to understand humanity. This can be associated with "technobabble," where the "human condition is frequently explained in terms of technological metaphors" (Barry, 1993: xiii). The human brain is described as "hardwired" like a computer, talk is referred to as "output," and learning becomes "downloading" information. Mechanizing language about human behavior also enables individuals to apply anthropomorphic ideas, attributing human characteristics to material objects, to computers and their processes.

The result is a blurring of the human-machine distinction. The internet technology becomes a distinct way of viewing reality, the physical world interpreted through the screen. This goes back to the discussion of cyberspace evolving from myth to metaphor, illustrated by cyber-philosophical writings of Benedikt in *Cyberspace: First Steps* (1992a). Similarly, CMC studies in the areas of group norms and social identity or communication within communities of users touch on this (Spears and Lea, 1992). Developments in digital art and cyber-literature also characterize the internet as a new space for creativity. Cyberspace offers a digital canvas for new artistic and technological expression, from interactive poetry to 3D game imaging. This merging of technology and humanity is not just creative or metaphoric. Experimentation with wearable computers, implants, and technological extensions bring science fiction to life. These innovations have spawned dialogue on cyborg philosophy and posthuman discourses (Haraway, 1991; Gray, 1995).

This model demonstrates the bringing together of elements of science fiction with images of computer networks to describe the function of digital technologies. Yet, as has been articulated, reality is that cyberspace is a simulated territory which does not truly represent the actual computer network architecture. However, some users choose to let fantasy images inform their reality. This extreme is illustrated in Turkle's work on hacker culture at MIT, where she described individuals so obsessed with computers that their chief aim was to engage the world through this technology.

A common mental geography can evoke a mystical image of the internet facilitating a global consciousness, seen in the writings of the potential of virtual reality (VR). Derrick De Kerckhove stated it thus: "VR technology would allow many minds to collectively process a kind of group consciousness" (1995: 47). Seeing the internet as common mental geography supplies those who create computer technology, as well as users, with a common system of communication and a new meta-narrative to be used to make sense of

the world. Internet users see the online environment as a place to build utopia or pursue a "better" reality.

An Identity Workshop[9]

Understanding the internet as "identity workshop" allows people to use online space to learn and test new ways of being (Parks and Floyd, 1996: 83). The internet here is characterized as a place of freedom and experimentation. Individuals are able to "re-present" themselves by highlighting certain attributes or hiding others, or even creating whole new personas for themselves. The focus is on personalized use, seeing the internet as a forum in which users can re-create themselves.

Changing one's identity online is easy, as electronic communication allows certain social cues, such as status, power, and prestige to be hidden (Sproull and Kiesler, 1991). An individual constructs an online persona by the texts they generate and the online sources or sites they link themselves to. Online people are often described as "disembodied," detached or freed from the constraints of the physical. This is said to present the internet as a mecca of "multi-personality possibilities" where the internet unties the mind from the body, offering new ways of expression and opportunities for equality. This not only allows for experimentation, such as gender swapping, but also creates a space in which prejudices are seemingly eliminated (Stone, 1994). People are judged on the basis of the text they produce, not their social status or physical appearance.

One popular research area in CMC in the 1990s centered on exploring the question of "embodiment" online by distinguishing real from virtual identity. How users identify their body online can influence how they see themselves and communicate with other Net users. This is demonstrated by research in the mid-1990s focused on individual and communal identity construction within online environments. This ranged from describing patterns of life found in online forums such as MUDs (Multi-User Dungeons/Dimensions) such as described by Amy Bruckman and Paul Resnick (1995) and Jennifer Mnookin (1996), to the development of community on Usenet and IRC (Internet Relay Chat) systems done by individuals such as Elizabeth Reid (1995). Many researchers investigated these groups because they included a unique mixing of aspects of the offline social world with a computer-created "virtual" world. The online context offers users the opportunity to create a persona, providing options that are unavailable in the offline social context. Here, particular characteristics shaping online social behaviors and personal presentation were often identified and investigated (Baym, 1995, 1997).

While opportunities for anonymity and reduced social cues online have allowed individuals a sense of freedom, they have also created some unpleasant social by-products. The dissolution of boundaries can result in de-individualization, or "loss of identity and weakening of social norms and constraints associated with submergence in a group or a crowd" (Spears and Lea, 1992: 38). Thus online anonymity that promotes equal participation within a group can also lead to reduced self-regulation and promote uninhibited behavior, dishonesty, and deception (Donath, 1998). Julian Dibble's classic story, "A Rape in Cyberspace" (1996), where one player hacked into and manipulated the actions of another in a MUD in order to "virtually rape" their online character, demonstrated how identity construction in an online fantasy-based environment can have real-world psychological and sociological effects on participants. This model highlights a tendency of online users toward egocentric perceptions and behavior. The internet as an identity workshop focuses on the empowerment of individuals, which can lead to both positive and negative social outcomes.

On this journey through the history, myth, and ideology associated with the early stage of the internet's development and study, we have seen that the internet has been viewed through different lenses: of promise and fear; of hope and despair and gloom; and of information, identity formation, and experimentation.

Within this discussion the social use of the internet can also be clearly seen. Even from the very beginning of internet use, it has been evidenced in the rise of newsgroups and email discussion lists. Considering cyberspace as myth and nonfiction demonstrated how this word has become a metaphor to describe a new territory where not only information but also opportunities to connect with people can be found. The potential for building and maintaining relationships has been championed as one of the most powerful attributes of the internet. Sociability online has been an interest of many CMC researchers, considering the types of social structures that emerge and how people choose to live in this new mediated environment. Advocates have claimed that talking online will build a better world and bring unity to humankind by breaking down geographic and other traditional barriers. Critics, on the other hand, have cautioned that online communication would lead to the breakdown of authentic community and ways of interrelating. Exploring the internet as a social sphere quickly raises questions of the qualities of relationships online and what is the essence of community. Through investigating more fully the social side of the internet, not only are the structures of online relationships illuminated, but also the basic beliefs about the nature of community.

The Internet as a Social Network:
Community Online

Information age hunters and gatherers were lone wolves until we found the net.
(Howard Rheingold, *Virtual Community*, 1993a: 56)

the internet as a social network presents the online context as a social space, where connecting with people becomes the primary goal. Focus is placed on social connections formed online; individuals see the internet as a place that facilitates and sustains relationships. The internet becomes a place of unlimited communicative possibilities, where through a few clicks of a mouse or punches of a keyboard people find themselves connecting with others and not simply information.

Agre's description of the internet as a "discourse" (1998) points toward the social origins of the internet. Social discovery, he asserted, is part of all technological adoption. Discourse on innovations produces conversational communities. As people try to explain and manage new technologies, their discourse creates boundaries and connections with others. Through conversation the internet becomes a social network where social relations are established and nurtured.

Investigating social dimensions of the internet became a major theme in Computer-Mediated Communication (CMC) research in the 1990s. Within this area, virtual or online community became a popular area of study, pioneered by such individuals as Rheingold (1993b), Wellman (1997c), and Kollock and Smith (1994). Questions about the communication of social information, group identities, structures of relationship and social negotiation online were of keen interest to such researchers. Framing the internet as a

social space enabled these and others to approach the online environment as an experimental observatory. The internet became characterized as "made by people and thus, as the 'new public space'; it cojoins traditional mythic narratives of progress with the strong modern impulses toward self-fulfillment and personal development" (Jones, 1997: 22). This technology and new social space provoked concerns similar to those surfacing at the creation of the telephone and television, technology's ability to affect patterns of relating and sociability. It also gave new life to such old questions as "What is community?"

This chapter explores the study and definition of community, with the aim of addressing how particular ideas and traits challenge the idea that community can exist online. This discussion also involves highlighting certain religious understandings of community found in the Christian tradition. Highlighting these ideas of religious community is essential in order to comprehend the unique character of religious online communities studied in the following chapters.

Describing Community

No man is an Island, entire of itself; every man is a piece of the continent, part of the main... because I am involved in Mankind. (John Donne, "Meditation XVII" in *Oxford Dictionary of Quotations*, 1979: 190)

Humans are communal creatures, interconnected through social patterns and behaviors. Communities are often considered the basic building blocks of a society. They signify not just a sense of space, but also social relationships. Traditional understandings of community are often rooted in three key elements: territory, social system, and a sense of belonging (Stacey, 1974). This is aptly illustrated by the definition given in *Collins English Dictionary* for community: "(1) the people living in one locality; (2) groups of people having cultural, religious, ethnic or other characteristics in common; (3) a group of people having certain interests in common" (1992: 313). The term community is often used in a fixed or idealistic sense to describe a certain geographic boundary or group of individuals who live in a specific area or the ideal relationship of a given people or area. However, a community is more than its physical location. *The Oxford Dictionary* definition highlights another aspect of community, stating community is about "fellowship being alike in some way, a community of interest" (1979: 122). This definition stresses interaction through a common interest, emphasizing what is held in common rather than location. While these definitions are helpful starting points, they do not fully answer the question, "What is community?" especially when we introduce the idea of "online community." The emergence of community groups online has

challenged traditional and nostalgic conceptions of community, commonly tied to the boundaries of geography and social institutions. Understanding the internet as a social network requires the reexamination of the nature and definition of community.

How individuals form groups and understand these associations has been a key interest in the field of sociology. The concept of community emerged as a way to describe societal organizations and relationships. While many people assume they know what the word community means, it is not a simple construct. Within the sociological tradition numerous definitions of "community" exists, and according to Bell and Newby the only fundamental element of agreement between these definitions is that they deal with people (Bell and Newby, 1971: 27).

Many have argued that the idea of community is a relatively new concept, coming out of the creation of modernity. During the sixteenth through eighteenth centuries discussion of human relationships and social thought focused on theories of society, based on the idea of the "project of society." Corporations, families, and guilds were all combined and thought of as one grouping (Lemos, 1996: 43). Changes began to occur in the eighteenth century around the time of the Industrial Revolution, when thousands moved, in search of a better life, from farms and traditional rural communities to crowded tenement houses in developing urban centers. This "Age of Enlightenment" marked a transition in philosophical outlook from "traditional" to "modern" society, especially within Western societies. The "modern" mindset emphasized progress and development, rejecting "traditional" ideas and ways, which were thought to hinder personal and societal advancement. Middleton and Walsh describe these modern individuals as "autonomous subjects, scientifically grasping and technologically controlling and transforming the world, unimpeded by threats such as traditional ignorance and superstitions, [who] devise their own remedy" (Middleton and Walsh, 1995: 20).

It has been argued that the concept of community arose as an attempt to move away from the "the project of society" toward a "social collective." In modernity, community became an idea that was separate from society. Community was marked by the attributes of being a common project, institutionalization, appearance of proximity, a physical territory, and forms of direct or unmediated communication (Lemos, 43). Creating and maintaining a community thus became a worthwhile and achievable ideal for modern society.

Over time the understanding of community became rooted in three elements: territory, social system, and sense of belonging (Stacey, 13–26). Community was used to describe a locality, such as a "given geographical area as a basis of social organization" or a particular social system such as a "set of relationships that center upon a given locality" (O'Donnell, 1987: 130). It was

also used to describe a particular type of relationship, highlighting the shared identity of a given group of people. Often these notions of social systems and shared belonging were bound to the idea of a given territory, within which they could be contained.

Central to the development of this understanding of community was Ferdinand Tönnies's nineteenth century classic *Community and Association* (*Gemeinschaft und Gessellschaft*). Tönnies used the terms community and association to distinguish between changes in social relations occurring in the move from rural to urban living. *Gemeinschaft*, or community, meant "all kinds of association in which natural will are predominant," while *Gessellschaft* referred to society or associations "formed and fundamentally conditioned by rational will" (1887/1957: 17). These two terms did not refer to the distinction of social entities and groups, but were to denote a distinction between the rational and natural will of the individuals involved. For Tönnies, all social relationships are created by an act of human will. Community relationships involve the whole person, as in rural life, which he saw as requiring people to interact more fully with one another. Associative relationships could be seen in the urban setting where associations or transactions occurred for utilitarian purposes, often with minimal social exchange. Tönnies's distinction reflected changes he saw occurring within society "from the moral/emotional quality of traditional life to the practical/rational quality of modern life" (O'Donnell, 132).

Similarly, in the twentieth century Talcott Parsons attempted to describe the distinction between traditional and modern life through a list of comparison values and norms. He noted the following characteristics of traditional society: ascription (status coming through birth), diffuseness (relationships are broad, community-like), particularism (people treat one another in a particular way), affectivity (emotions are expressed openly, publicly), and collective orientation (shared interests are important). For modern society he noted the following: achievement (status based on personal efforts), specificity (relationships are for specific purposes), universalism (all laws apply to everyone), affective neutrality (emotions are controlled and closed), and self-orientation (individual interest is pursued first over family and community interests). For Parson the modern "cultural/community sub-system" was more rational and affectively neutral, though not completely limited to uncaring, nonfeeling interactions (O'Donnell, 135).

Identifying this shift in social relations has also been used to promote the "loss of community" thesis describing an unraveling in people's sense of community in modernity. Neil Postman (1993), for instance, wrote about the breakdown of community in American culture as society became a "technocracy." Although rural migrants did not leave their values and commitments to

relationships behind as they moved to cities, Postman claims the new culture bred a disdain for tradition. Traditional values, often relating to issues of faith and folk beliefs, were dissolved in favor of new ways of looking at the world. Postman claimed that the shift in values was also linked to acceptance of new technologies used to support this new society and rejection of traditional ones. Anything that could be tied to the tool-based culture from which they came was considered outdated and antimodern. This devaluation also brought an emphasis on product over producer, reducing the value of humanity to its ability to interact with technology. "The success of technology and the devaluation of traditional beliefs" together created a "technopoly," a society whose main concern and currency is information (p. 53). Here human beings are distanced from one another as technology mediates their interactions. Therefore the rise of the modern culture, he argues, brought with it a loss of community in America.

The loss of community thesis assumes that life was better in the past than it is now. This is problematic, as it can perpetuate a conservative nostalgia for the "good old days," invoking images of life where community was stronger and social relationships were healthier. It assumes that an ideal society actually existed, a claim many have come to question (Putnam, 2000), and it disregards the unpleasant characteristics of traditional societies, such as structural oppression and disparity of wealth. The loss of community thesis fails to offer a clear definition of community, as it is based on an image that "takes as a 'given' the capitalistic system instead of examining how this system shapes social life" (O'Donnell, 141). Hence, describing community in terms of what it might have been or as a vague ideal is not entirely helpful.

The question of what constitutes a community can be problematic, so much so that Margaret Stacey suggested avoiding the term altogether to move past conceptual disagreements. Her own work looked at the concept of "local social system" as an alternative way to speak of community (1974: 49). Sociologists have continued to look for ways to answer and study the community question. According to Barry Wellman several key changes in approach to community emerged after World War II that brought this discussion forward. First, "armchair theorizing" was replaced by systematic efforts to analyze genuine data about the nature of social relationships (Wellman, 1988: 83). Then studies of local social histories helped to "demythologize notions of stable pastoral villages," which lead to the growth of neighborhood studies. Next a shift toward structural analysis opened up studies of family, household, and urban settings as options to explore the idea of community. Finally, the emergence of social network analysis in the late 1960s "freed the community question from its traditional preoccupation with solidarity and neighborhood" (p. 83). Other methods such as human ecology, communities as organizations, communities

as microcosms, and the rural-urban dichotomy have also been employed to describe the social relationships we typically refer to as communities.[10]

Describing Religious Community

Approaching community as a system of social relationships involving people seems to be a general understanding from the discipline of sociology, but religious community is often understood from a very different starting point. Community is a manifestation of God in the world, a picture on Earth of a divine relationship. As the nature of religious community is the particular focus of this study, it is important to explore religious definitions and understandings of community.

Each faith tradition has a unique perspective on the idea of community (Ward, 1999). In Judaism it is the image of the land, *eretz Yisrael*. In Islam it is the *umma*, a meeting around the law. For Buddhists it is the gathered living place of disciples, the *sangha*, and Hindus describe it as *sampradaya*, the teaching community. In the Christian tradition, the focus of this study, community is typically described in terms of the church. Christian church represents a meeting place of two communities, the divine community and the human community. Understanding these distinct communities and their relationship is crucial.

The human and divine communities are described by metaphors and images found in the biblical text. The divine community refers to God and is understood through the concept of the Trinity. The Trinity represents three unique aspects or qualities of God, manifested in characters of God the Father, God the Son, and God the Holy Spirit. Miroslav Volf (1998) describes the Trinity as a social relationship of shared divine nature between divine persons. The Father, Son, and Holy Spirit cannot be separated from this relational focus; they share a special connection where "person and relation emerge simultaneously and mutually presuppose each other" (p. 205). The Trinity has been described as "the original community of oneness," providing an example for human relationships to mirror (Bilezikian, 1997: 16), and the ability to experience community is God's gift to humanity. "Christ desired that his church would be the earthly community of oneness modeled after the eternal community of oneness" (Bilezikian, 22).

This idea of intimate relationship between the human and divine community is found in some of the first and final images in the biblical texts through the metaphor of marriage. In the book of Genesis, the first human community is described as a community of "one flesh" (Gen 2:24) in the union and marriage of man and woman, in which two separate beings coming together to form one. It is also in Genesis that human community experiences separation

from the divine community through the "fall" (Genesis 3). The movement toward restoring this broken relationship re-engages the image of marriage, as human community is described in the New Testament as the "bride of Christ" (2 Cor 11:2), destined to be wed to the Trinity. In the final book, Revelation, this unification happens in the "marriage supper of the lamb" (Rev 21:9).

A distinction is made in the Bible about the human community as either being the worshiping community or the gathered people of God, the "church." This is illustrated in the New Testament in the Greek words *koinonia*, meaning "communion, or fellowship," and *ekklesia*, meaning "assembly or congregation" (Brown, 1975: 639, 291–92). In the Hellenistic world *koinonia* meant "unbroken fellowship between the gods and men" and so stood for a "sense of brotherhood" (291–92). It appears in Acts 2:42 as one of four basic ingredients of the worship life of the early Christians. *Koinonia* denoted a "group of people closely bound together by what they share," whether it be food or words (Snyder, 1983: 79). It represented the idea of a religious community united in fellowship through a matrix of shared faith. *Koinonia* highlights a relational focus, referring to a community of believers who experience communion with God through their fellowship with one another. It is a community of communion, where Christian believers are meant to share in each other's lives in order to experience God within each other.

While *koinonia* is closely associated with the idea of community, *ekklesia* is typically linked to the word "church." It suggests the idea of being organized for a purpose or gathering together for a meeting. In a secular sense it was used to characterize a political phenomenon, such as the gathering of a guild or an army (Brown, 291). In the biblical literature it is used to refer to the gathering of all Christians, as in the "*ekklesia* of Christ" (Col 1:17), or to refer to a specific congregation of believers, as in the "*ekklesia* of Ephesus" (Rev 2:1). *Ekklesia* has a particular form with distinct boundaries. It can be linked to the Old Testament "people of God" or the nation of Israel, brought together by God and set apart for specific purposes. In the New Testament *ekklesia* is illustrated by images of interdependence and organic structure, such as Christian believers being described as the "body of Christ" (Romans 12) or a church made of living stones (1 Pet 2:5). *Ekklesia*, or the church, has become "the standard designation of the Christian movement, referring either to the movement as a whole or to its local assemblies" (Hodgson, 1988: 26). Church denotes a living structure, having global connections while maintaining a local emphasis.

Though *ekklesia* has structural connotations and *koinonia* a relational focus, both descriptions of the human community stress that it is the relationship with God, the divine community, which gives them purpose and form. Human community in this discussion is distinguished in terms of acts (forming

a congregation) and states (experiencing fellowship). This distinction can be further understood in approaches to the idea or sacrament of communion. Communion is the reenactment of the "Last Supper," the last meal Christ shared with his disciples before the crucifixion. It represents a physical act (*ekklesia*) of gathering at a particular space and time to share in a particular event. It also represents a shared experience and mystery (*koinonia*) of symbolic and prophetic significance. In the Christian tradition the words "church" and "community" are often used interchangeably. Therefore, it is important to distinguish between the act of being gathered, as in the church, and the state and mystery of what is to happen in that gathering, as a community.

Christian community being equated with the church often promotes an institutional or structured understanding of community, grounded first in location and liturgy, and second in its fellowship and faith. Church is thought of as community because "the early Christians were one in understanding that while men and women individually came to faith in Christ, this involved by definition becoming part of the family of God" (Martin and Davids, 1997: 195). Religious community in the Christian tradition is meant to represent interdependence and connection by its members to each other and God through shared actions and a common call. Yet since the early days of Christianity numerous understandings and interpretations have emerged of how the church should gather and live out this shared faith.

Though it is often described as "one body," the Christian church represents a diversity of denominational groupings, each with distinct beliefs of how the church should operate. Avery Dulles (1974) provides a range of models that seek to describe the different ways church communities are defined and conceived by their members. The church can function as an institution, mystical communion, sacrament, herald, and servant. Each of these models highlights different perspectives and particular attributes of the church. Space is given here to a close examination of four of these models, which will have relevance to later discussions of specific online religious communities and the offline faith communities with which they link themselves.

Mystical Communion

The "church as mystical communion" model is not just a human grouping, but a divine mysterious relationship between God and humanity. Dulles describes it as an interpersonal model, stressing a horizontal dimension of relationship between the individual and the collective, and a vertical dimension of relationship between the community and the Holy Spirit. The church is seen primarily as "a communion of men, primarily interior but also expressed by external bonds of creed, worship and ecclesiastical fellowship," not a visibly

organized institution (Dulles, 51). The church is "mystical," being visible and invisible; visible through its connection to each other and invisible in its connection through the Spirit to God. Daniel Migliore (1991) describes this model as an "intimate community of the Spirit," where the church is "a closely knit group whose members share a common experience of God's reviving Spirit" (p. 194). It centers on the idea of support and fellowship. The main task of the church is to facilitate spiritual experiences and promote interpersonal relationships.

In practice such a community might focus on prayer, spiritual exercises, and sharing experiences in which individual growth is encouraged in a communal context. This model is lived out in the Charismatic and Pentecostal denominations, which emphasize the gifts of the Spirit and special experiences such as healing or the "baptism" of the Holy Spirit. Similarly, individual experiences of the Spirit create a common bond and language. Many people who are physically or spiritually broken find these communities places of healing and acceptance. Yet these groups often emphasize ecstatic intimate experiences, which can produce an inward focus on individuals and the group.

Sacrament

The "church as sacrament" model sees the church as a symbolic community. Dulles defines sacrament as "a socially constituted or communal symbol of the presence of grace coming to fulfillment" (p. 62). Christ is described as a "sacrament of God," a sign representing God and pointing toward the Trinity. The church, then, is the "sacrament of Christ," a symbol representing and making Christ present in the world. Sacraments involve action; they have an "event character" and are "dynamic." A sacrament is not merely an image, such as a religious icon or a cross, but an act of celebration, such as Baptism or Communion. Sacraments are also to be experienced in a communal context where Christ is seen as being present. Migliore states that through emphasis on worship, witness, and service "the church is the sign of the continuing presence of the grace of God in Jesus Christ in history" (p. 195).

The sacramental model is clearly demonstrated in the Roman Catholic Church and in the Anglican Communion. Here worship takes on a liturgical nature, and is expressed communally through services containing numerous symbolic elements such as icons, incense, candles, written prayers, and sung or spoken responsive readings led by the officiating priest. Emphasis is on corporate participation in sacramental acts, allowing them to become events of grace through the mysteries of the Spirit. Doctrines and beliefs such as transubstantiation, the actual embodiment of Christ in the communion elements, add to their significance as dramatizations in which Christ becomes visible to the community of faith. These communities often place primary focus on the

worship service event, which can tend toward a rigid structure that may not be transferable to some cultural expressions of Christian community.

Herald

The "church as herald" model is a community gathered around the Bible. Its message is very Christocentric. The church becomes the place where Christ is present when the scriptures are preached. Dulles describes the community's mission as the role of herald, "one who receives an official message with the commission ... [to] proclaim the royal decree in the public square."

In this way "language has an assembling function" (p. 76). Community is brought together through the act of proclamation. Another trait of the church as herald is its evangelistic or missionary thrust, rooted in the "Great Commission" to "go and make disciples of all nations" (Matt 28:18b). It is understood that only God can produce conversion, but the church's main role is to spread the Word and encourage individuals to put their faith in Christ. Institutional structures and connections are subordinate to the task of evangelization (Migliore, 196).

Unity is found within the greater church when all share in the common task of public proclamation of the biblical text. This is exemplified in Protestant churches, especially those having an "evangelical" emphasis. This is rooted in the time of the Protestant Reformation when worship services shifted emphasis from the sacraments to the "proclamation of the Christ event" (Dulles, 77). These worship services are still focused around sermons and preaching. Church activities outside these services are often focused on proselytizing and public sharing of scripture and testimonies. By highlighting this single action of the church, the communities can miss the holistic call to care for other human needs.

Servant

The "church as servant" model can be described as the "church for others." The image of Christ as suffering servant is central. The church is called to stand alongside Jesus in service to others. According to Dulles, to be a servant denotes three things about one's work: it is done under orders and not free choice; it is for the direct good of others and not self; and it is humble and demeaning (Dulles, 92–93). This links to the exhortations of Isaiah 61 to "preach good news to the poor... proclaim freedom for the captives and release from darkness for the prisoner." A servant is dedicated to transforming the world into the kingdom of God by meeting the needs of other people. As Bonhoeffer stated, "The Church is the Church only when it exists for oth-

ers.... The Church must share in the secular problems of ordinary human life, not dominating, but helping and serving" (Bonhoeffer, 1967: 55). The mission of the church is to be a "servant-community." Migliore describes this as a call "to minister in God's name on behalf of fullness of life for all God's creatures" (p. 196).

These churches often stress the need to work on behalf of the poor and oppressed. This is exemplified by churches that subscribe to liberation theology and create Christian-based service communities. These communities, many with links to Catholic or Methodist churches, focus on the "ministry of reconciliation" between different racial, ethnic, and economic groups. Service is seen as a duty and calling, as well as an act of worship. Communal living and communitarian ethics are stressed in daily life in this model, where both prayer and work become expressions of prophetic action, working on behalf of those in need of freedom and justice. The emphasis on service in these communities can focus on building God's kingdom in the here and now, sometimes at the expense of contributing to the eternal kingdom of God.

Sociology of Religious Community

Religious community in the Christian tradition sees the church as a special community, ordained and gathered by God. Descriptions of community can highlight aspects of being structurally bound with a distinct boundary, as in *ekklesia* or the image of the kingdom of God, or may be focused on a flexible and dynamic relational focus, as in *koinonia* and the image of Trinity. Many of these definitions of community emphasize theological ideals of how community should function. While these theological descriptions explain why a church or community gathers, they often fail to illuminate the inner workings of religious communities, specifically how members interact and gather. Here sociology of religion is helpful in order to address the interworkings of social relationships in religious communities.

The classical thinkers in sociology—Marx, Weber, and Durkheim—all gave significant consideration to religion's influence on the formation of societal relationships. Marx, a critic of religion, proclaimed it the "opiate of the people" and noted its strong ideological influence over the masses. Max Weber saw study of religion as important because of the role it plays in social change, in particular the emergence of capitalism. Emile Durkheim's work exploring the connection between church and religion has been influential within this development of the sociology of religion. He offered specific insights about religious communities, seeing the communal quality of religion as essential. Durkheim stated that religion provides cohesion by ensuring that people gather together regularly to affirm common beliefs and values through

particular practices or rituals. True religious beliefs bind together fellow believers, giving birth to the idea of a church.[11]

Much of sociology of religion's study of religious community has focused on the church as a place where individuals who share common beliefs gather, in contrast with religious institutions seeking to organize and regulate these centers of belief. Studies in the 1940s and onwards often focused on the organizational and institutional side of religious communities, such as demographic survey studies of churches, often trying to address the "secularization" of society thesis. In the 1960s and 1970s the field expanded to look at new religious movements, where various new cults and sects set out to form communities of faith. Since the 1980s it has expanded to non-Western religious communities, especially relating to the topic of globalization and changes within larger social structures. Sociology of religion still tends to focus on the collective gatherings of people through religion relating to issues of the individual within society, societal legitimacy of religious practice, and social control of religion.

However, in the 1990s some studies began to view religious community in terms of their relationship or ideological connection, rather than as institutional structures. This is linked to trends in declining church membership, but continued adherence to spiritual beliefs, as highlighted by Grace Davie's (1994) work on religious membership and institutions in Britain. She found people "believe without belonging." In other words, while people still hold to religious beliefs, they actively choose not to belong to the affiliated religious institutions with which these beliefs are connected. Religious community as a gathering around shared beliefs and common religious practice opens up the possibility of speaking about community in new ways.

Community as a Network

Community has been approached as a spatial, social, and value-laden construct. Religious community, in the Christian tradition, has been examined as an earthly and a divine association describing a specific form of gathering as well as a conceptual spiritual connection which believers share. Within the diversity of understandings and categorizations of community that have been described, focus has been placed on the formation of relationships and alliances within communities. This can be linked to the study of community as a network of relationships, an important trend within community studies.

Social network analysis emerged in the late 1960s and early 1970s in sociology under the belief that communities are, in their essence, social and not spatial structures. This approach to community sought to address trends toward the "privatization of community." Urban sociology studies have tended

to focus on neighborhoods and other small-scale communities, with large-scale social phenomena being overlooked (Wellman and Leighton, 1979). Yet it became evident that modern urban dwellers tended to associate with several groupings rather than a single neighborhood group. These links between groups formed networks of individuals whose ties vary in strength and intensity. Some networks were relied on for general purposes, such as work or family networks, and others served specific-assistance roles, such as emergency services or a special interest club.

In social network analysis a set of nodes is identified, and then a set of ties is mapped to determine how these nodes are connected. The resulting map or network represents the social structure of node (individual or group) or the "patterned organization of these networked members and their relationships" (Wellman, 1997b). In this analysis, social relationships that transcend groups are identified and used to describe underlying patterns of social structure. Analysts can approach networks as "ego-centered" (personal) or whole networks (a given population) in their efforts to identify the range, centrality, and roles of networks and their members. This approach has been used to study organizational, urban, rural, and personal communities.

By using this approach, analysts deal with community as a "network of significant, informal 'community ties' defined from a standpoint of a focal person" (Wellman, 1988: 86–87). In contemporary society most people do not live in densely knit, tightly bound communities; rather, they are found floating in sparse, loosely bound, frequently changing networks. Community ties become narrow, specialized relationships. Relations and emerging patterns become the focus of study in social network analysis as it seeks to "describe networks of relations as fully as possible, tease out prominent patterns in such networks, trace the flow of information through them and discover what effects these relations and networks have on people and organizations" (Garton, Haythornthwaite, and Wellman, 1997). Social Network Analysis looks at how social connections overlap, form and change into a network of interactions.[12] The view that communities have moved from a geographical focus to become dispersed networks of support and sociability has allowed researchers to study computer networks as social networks and a new form of community. Social network analysis has proved an important tool for understanding the nature and function of community online. Wellman, one of the pioneers of this approach, states:

> When a computer network connects people it is a social network. Just as a computer network is a set of machines connected by a set of cables, a social network is a set of people (or organizations or other social networks) connected by a set of socially meaningful relationships (Wellman, 1997c: 179).

"Computer-supported social networks" are groups where the "computerized flow of information" forms the basis for individuals' communication (Wellman, 1997c: 198). Computer networks support a variety of social networks, from tightly bound organizational information networks to loose networks of informal email exchanges. As computer networking has become an increasingly important way for individuals to maintain social relations, it cannot be overlooked that these actions may be redefining contemporary conceptions of community. While information technology extends and redefines work and social practices, Wellman argues it does not change the nature of social relations, which are facilitated through the technology. "Ties people develop online are much like their real-life ties: intermittent, specialized and varying in strength" (Wellman, 1998).

A networked view of community offers an important new approach, not only to examine patterns of online communication and interaction, but also to describe the evolution of community ties within society as a whole. It sits well with a sociological understanding of community based on flexible relationships. An image of community bound strictly to geographic, ethnicity, or culturally fixed relationships does not always seem applicable, especially within Western urban society. When technology mediates and sustains relationships, geographical separation no longer is a factor for exclusion from a social network. Increased ease of travel and technology such as the telephone allow people to maintain social contact with those with whom they have limited face-to-face contact. Other technologies, such as the television and computers, also break down barriers by providing access to information on a global scale. Conversely, it is not uncommon for individuals to be socially separate from those who live in close physical proximity. This was shown by Massey (1992), who found that people who live on the same street or geography may live in very different communities.

As a network, community is able to adapt easily to social change, allowing individuals or groups ties to shift without severing the connection of the larger community. Community as a network can also be applied to a religious or theological understanding of community. It has been shown that Trinity can be interpreted as a relationship network between persons of the Godhead. This is a relationship to be mirrored in human community. Marriage is presented as a network of interdependence and linked to the image of destiny of the believer's relationship with Christ. It also finds resonance with the notion of community (*koinonia*) as an open and dynamic shared interaction of like-minded members. Inherent in the idea of community as network is the notion of union; networks facilitate interaction through connection, not just with individuals but with a greater whole. The network image also can help explain how one community, the church, can function under very different models or

focuses. Just as a network map (sociogram) will appear different depending on the node selected as the starting point, so each of the four models represent a distinct church relationship structure based on the focal point of the given community.

The idea of the religious community as a network is demonstrated in Nancy Ammerman's work on how church congregations react to changes in the local community (1997). Ammerman identified congregations as a part of community institutional structures, which makes social life possible. These structures are understood as "living networks of meaning and activity, constructed by the individual and collective agents who inhabit and sustain them" (1997: 346). Religious community too has become embedded in a matrix of increasingly segmented relationships. She asserts that "understanding of the social systems of modern life must start with the individual's network of relations" (p. 352). Describing community as a network allows sociologists of religion to look at how congregations are connected to their communities through members' networks and associated organizations that affect the local church. These connections unite the congregation to the greater society through "webs of relationships out of which community structure is created and maintained" (p. 362). Studying local churches as a key part of a community's social web offers the possibility for religious community to be described, understood, and studied as a network of relationships.

Religious Community as a Story

While community as a network provides a foundational metaphor describing form and function of contemporary communities, especially those online, it does not provide full understanding of the nature of religious community. Christian community is rooted in a common belief in God and interpretation of communal destiny. This shared belief can best be described in terms of narrative, shaping members' behaviors and binding them together. Narrative theology seeks to describe the stories a given group lives by that provide cohesion and meaning. Approaching Christian community as a storied community in this study offers wider scope to explore how networks of relationships evolve and are maintained.

Stanley Hauerwas describes the church as a "story-formed community" (1981). For him, the church is a community meant to embody a distinct social ethic. Community does not evolve; it is shaped by deliberate practices that are supported by distinct values. "Good communities result from shared judgments derived from skills acquired through training necessary to pursue certain practices. . . . Different practices require different virtues" (1995: 9). By representing a unique social ethic the church seeks to be a "community of

character," striving to mirror the character of God in society. This community of character is shaped by the biblical narrative, causing it to present a "counter story" or alternative to the existing political and social world.

As a story-formed community, the church's structure, history, and way of being is dependent on its reading of this "truthful narrative." It is believed that individuals alone lack a common history sufficient to provide the resources necessary to find purpose in life (1981: 125). They choose to tie themselves to a given community in order to find meaning. This is also argued by Lemos as one's "capacity to be virtuous depends on the existence of communities, which have been formed by narratives faithful to the character of reality" (1996: 116). A community's story gives meaning and perspective to its members' attitudes and actions.

Hauerwas acknowledges that Christian communities might read the biblical story differently. Still, a given community must draw on a common set of interpretations about their history in order to provide the "sense that they are more alike than unlike" (1981: 60). A narrative is essentially a form of interpretation of a given history, and "the power of a narrative lies precisely in its potential for producing a community of interpretation sufficient for the growth of further narratives" (1981: 95). Christian community is the gathering of a "storied people" around a distinctive narrative. Therefore, identifying the story is essential to understanding a community's view of reality and the world. Understanding religious community as a network requires the uncovering of the dominant narrative, a community capable of "forming people with virtues to witness to God's truth in the world" (1981: 3).

Noting how members relate to the story and elements used to support narrative integrity helps to form a clearer picture of the network of connections within Christian communities. Community as a network that is "story-formed" provides a fuller understanding of how theological and sociological ideas of community come together.[13]

Defining Online Community

Emile Durkheim... called the premodern kind of social group *gemeinschaft*, which is closer to the English word community, and the new kind of social group he called *gesellschaft*, which can be translated roughly as society. All questions about community in cyberspace point to a similar kind of transition that might be taking place now, for which we have no technical names. (Howard Rheingold, *Virtual Community*, 1993a: 64)

For many the internet is more than an information technology or tool; it is a way of connecting and reuniting people. Seeing the internet as a social network focuses attention on ways the internet facilitates new forms of relating.

The internet as social network has a communal orientation. It involves not just creating individual social connections, but a relational social web (Wellman and Haythornthwaite, 2002). Research on the social nature of the internet often focuses on online communities, groupings online that allow individuals to select their neighbors and seek out new friends with common interests. Borders are erased, as the person in the next room or on the next continent is only an email away. Many people are drawn to online relationships, as they can appear less risky than real-world interactions (Block, 1996). The internet is seen to extend an individual's communicative abilities and to offer new opportunities for community.

In chapter one it was argued that online sociability was not simply a by-product of computer networking, but a prime motivator for the growth and development of the internet. The emergence of online community is in many respects a direct result of researchers using the network to form collaborative relationships based on shared interests. These webs of relationship have taken on a life of their own.

> The people who built CMC systems wanted to have a large population of people to communicate with; the value they sought was not the value of metering access to the community, but in intellectual values, the collective goods, that a community could create together. (Rheingold, 1993: 103)

Community online has become an area of much interest and debate. One of the most-cited and influential proponents of online community has been Rheingold, known for his involvement in the WELL, an email computer conference based in the San Francisco Bay area. In *Virtual Community* he described his experience of going online as transformative, like finding a new home. The online environment, he argued, offers potential for building new forms of community. He coined the term "virtual community" to refer to groups of persons who create, nurture, and invest in relationships maintained through computer connections. He defined virtual community as

> Social aggregations that emerge from the Net when enough people carry on public discussions long enough, with sufficient human feeling, to form webs of personal relationships in cyberspace. (1993: 5)

This definition highlights that online communities are formed not only through sustained conversation or a growing online membership, but where members are prepared to emotionally invest in a group. In writing about his own experience on the WELL, Rheingold candidly reflects on his own "emotional attachment to an apparently bloodless technological ritual" (p. 1). This study highlighted the promise and potential of the internet for helping people

to rediscover community in a postmodern society that often is perceived as detached and lacking social cohesion.

Awareness that the internet might facilitate new forms of social connection or community first emerged in the late 1980s, when the price of modems dropped and more people got access to computer networking abilities. While online discussion groups had existed in various forms since the 1970s interest was piqued by popular press coverage of what was described as a "'virtual community' based on the Internet" (Ceruzzi, 1999: 298).

It should be noted that the use of the term "virtual community" has been used to describe relationship networks online in order to distinguish these groups from "real" or offline communities. However, identifying a group as a "virtual" community can imply that online relationships are based on something false, as in the previous chapter in the story of cyberspace and its roots in virtual reality and science fiction. Therefore, from this point onward the term "online community" will be preferred to distance the discussions of community online from this assumption.

Email lists or discussion groups were the first forms of online networks, appearing in the mid-1970s not long after the creation of email. These message subscription services quickly facilitated group conversations. An email list is typically facilitated through a software program such as Lyris or Majordomo. Individuals create groups through such programs, which allow them to select how subscriptions, message traffic, and archives will be managed. Lists can be moderated, where posts are filtered and controlled by specific person, or unmoderated, where the list is constructed but then left on its own to run. Email communities typically gather around a specific topic. Not all email lists can be considered online communities. They may serve as news bulletin or information services, where posts are sent to a specific undisclosed list of people, but interaction between subscribers is limited or nonexistent. What makes a group a community is the ability to contact and interact with other members, either through posting messages to the entire group or through personal interaction with other subscribers.

In the late 1970s newsgroups and bulletin board services (BBSs) became the next opportunity for online social networking. Both are set up and housed on central computer databases. Some groups are open to the general public for participation, while others are selective groups that allow public reading, but posting only by members. Newsgroups and BBSs are also group conversations where individuals log on to a specified location to read and respond to messages posted by other participants. Since these groups are topic specific, they often gather a loyal core of people with passionate views on the given subject. Each group has a unique set of rules and expectations. It is commit-

ment to the discussion topic that keeps individuals logging on, reading, and participating.

Other forms of online community are role-playing games called MUDs. First developed in England in the 1980s, these were based on the fantasy game Dungeons and Dragons. A player was able to create a character (e.g., a wizard or a monster), and under specific rules act out these roles in a created reality. MUDs can be text- or image-based (MOOs, Multiuser Object Oriented) and range from medieval fantasy realms to cyber-cafes, where individuals create an identity or "alter ego" that interacts with other characters. MUDs and MOOs can be considered communities, as they cultivate a loyal following of members who "live" in these spaces. People develop standards of behavior based on the characters they present; some people even establish specific relationships, such as virtual marriages or partnerships. Similarly functioning are networked online gaming communities that have sprung up in the past decade, such as EverQuest and the Sims Online.

Conversational communities have also sprung up through Internet Relay Chat (IRC) and chat rooms that allow participants to "talk" to others through various types of software. In these chat rooms visitors interact with one another through two-way synchronous typed conversations, which give participants the feeling of carrying on a conversation or chat. IRC channels are found on a number of server systems such as the Undernet. IRC communities may be open forums that establish a certain rhythm collecting loyal participants at set times, or groups that have a weekly time slot when they gather for discussions to which they are committed. Chat rooms are similar, but often are more informal "live talk" forums attached to a website, where steady streams of visitors stop in for online conversations.

Like other online groups they become communities when they generate a loyal base of support and commitment from their members. The two unique markers in these types of community are the systems of symbolism and textual significance often devised to communicate certain nuances and ideas and the shared rules of "netiquette" and behavior standards which these groups often construct to maintain order (Reid, 1996).

Other forms of online community continue to emerge as new technology and communication software is developed and introduced online. ICQ and MSN Instant Messaging allow for creation of personal online community, typically built upon already established friendship networks. While functioning similar to chat rooms, this software allows for high levels of individual control through self-selected buddy lists and the option to accept or refuse any incoming communication from others online. "Blogs" (web logs) have become another form of online social connection. These online diaries enable

individuals to post personal information online and allow others to comment or even co-create personal commentary on the blog's set topic.

While online communities can form through a variety of media, how and why individuals use and structure these groups is often very similar. Online communities involve people gathering around a specific topic or purpose, with some level of commitment to that topic or purpose and each other. Returning to Rheingold's definition, an online group becomes a community when an online forum moves from being a platform of conversation to becoming a gathering place for a core group of people who invest emotionally in the discussion and generate feelings of attachment to other members. The internet serves as a social space or gathering point for people who share common passions and connections. Stone defines community online as,

> Social spaces in which people still meet face-to-face, but under new definitions of both "meet" and "face".... [V]irtual communities [are] passage points for collections of common beliefs and practices that unite people who were physically separate. (Stone, 1995: 19)

An individual's sense of online community is often influenced by the extent to which they are involved in that community. Core members or leaders, regular participants, and lurkers (members who read, but do not participate in online conversations) exhibit different levels of value and attachment to the community (Blanchard and Markus, 2004). Yet members of online community often identify similar markers or behaviors that are valued as part of their lived experiences of online groups. These include sharing common boundaries and symbols (Curtis, 1997; Kollock and Smith, 1994), exchanging and receiving support (Boshier, 1990), and mutual emotional connection with other members (Rheingold, 1993b). Similarly, Jan van Dijk (1998) identifies four common characteristics in online communities, taken from his review of various studies. Online communities have members, a social organization, language and patterns of interaction, and a shared culture and identity. They are unique in that they are "communities which are not tied to a particular place or time, but which still serve common interest in social, cultural and mental reality ranging from general to special interest or activities" (van Dijk, 1998: 40).

More about the character and desired qualities of online community will be expounded in chapters four through seven. At this point an online community must be recognized as a group utilizing some form of internet technology for two-way interaction—be it asynchronous, such as an email list, or synchronous, such as IRC. Websites themselves are not considered online communities, as they are typically tools for broadcasting information. However, a website can support an online community by hosting a chat room, or provide links to online communities by featuring information about

specific communities or serving as community message archives. Use of the label online community also indicates that group members have a significant level of investment in the group, not only in terms of time commitment, but in intellectual, emotional, or spiritual investment.

Research

Online communities and their unique patterns of socialization have fascinated many researchers. As Luciano Paccagnella states, "Cyberspace constitutes a wonderful example of how people can build relationships and social norms that are absolutely real and meaningful even in the absence of physical, touchable matter" (1997). Studies have looked at how people use different types of CMC technologies to build and maintain relationships, play games, and receive emotional support.

Seeing media environments as a source of community regeneration and innovation is not new. Since the development of radio in the 1920s, the relationships of media and community have been an area of interest (Jankowski, 2002). Studying community in an age of digital media engages traditional questions, such as how social cohesion and collective identity are established or maintained, while viewing this new media environment as having a novel effect on social ties.

Online community research peaked in the 1990s. Questions of communication of social information, group meanings and identities, forms of relationship, and social negotiation were just some of the issues explored. While previous CMC research was often task-oriented and laboratory-based, online community research became ethnographic and interpretive, as illustrated by Mnookin's study of the emergence of law in LambdaMOO (1996). Researchers were interested in getting their hands dirty in the trenches of cyberspace, immersing themselves in a given online community in order to better explain its social or identity structure. This naturalistic approach posed challenges as researchers, who operated as a participant-observers, experienced "role conflict" or confronted the possibility of "going native."

Rheingold (1993a) presented the first study observing how life online was being experienced. A series of volumes edited by Jones (1995; 1997; 1999) soon followed, considering the complexity of cybersociety and spotlighting numerous case studies of emerging online subcultures from behavior in fan communities to gender issues in virtual environments. Contributions by Jen Fernback (1997) on theoretical commentary or the evolving notion of community, Steve Jones's (1995; 1997) discussion of online social culture, and Nancy Baym's (1995) on characteristics of communities online provided foundational descriptions and frameworks for other researchers. These and other studies

promoted the idea of the internet as social network by providing valuable insight on patterns of online behavior and group structures. Noteworthy accounts by Tamir Maltz (1996) on power relations in MUDs, by Judith Donath (1998) on identity in Usenet groups, by Amy Bruckman (1992) on structures in MOOs, and by Elizabeth Reid (1996) on IRC communities demonstrated this ethnographic approach.

There are diverse approaches to studying online community. Profiling an exemplar group has been one common approach, as in Baym's study of fan culture in a newsgroup (1997; 1999). This is seen not only in rigorous academic studies, but also in narrative case studies that investigate questions of community at a more popular level, through telling stories. These studies tend toward journalistic accounts, such as Seabrook's *Deeper* (1997), about his first two years of "living online," or Dibble's *My Tiny Life* (1999), chronicling his experience in LambdaMOO, and the infamous account of cyberspace rape. Community media research, now known as community informatics, takes a very different approach to examining digital age community. These studies investigate how specific regions or physical communities use online technology to create new forms of online and offline social networks which affect conception of community. Hampton and Wellman's study of life in Toronto's wired suburb (1999), which showed that online access increased offline sociability and recognition in a local community, is a prime example of this.

Others have approached the study of online community as a theoretical exercise, identifying general qualities of online community and contrasting them with definitions of offline community. Van Djik (1999) in his comparison of "organic" and online communities argued that online social groupings are limited in scope and should be studied as special interest networks that encourage specialized and selective relations. Kevin Hetherington (1998) suggests that the concept of *Bund*, or communion, should be considered over the concept of community to describe online social groups; an online *Bund* may enable researchers to bypass problematic notions associated with debates of online community.

Many still find the idea of community online troubling. While some argue that the internet liberates people and breeds communities, others believe online relationships are shallow and impersonal. "One vision is of relationships lost, while the other is of relationships liberated and found" (Parks and Floyd, 1996: 81). The internet as a social space poses unique problems as well as possibilities. Online, the veil of the screen separates individuals from each other. This offers users both freedom from certain biases and constraints while presenting new complications as "communicators must imagine their audience, for at a terminal it almost seems as though the computer itself is the audience" (Kiesler et al., 1984: 125). If individuals wish to move past this

veiled interaction, they must reach beyond the screen. This is often a disappointing move (Katz and Aspden, 1997). The existence of online community is worrisome to many psychologists and internet critics, an anxiety that needs to be addressed.

Online community study must take into account the total environment in which it is situated. It involves considering issues of community structure, media landscape, personal and communal identity, evolution over time, and connection between online and offline participation and influence. All of these issues and the potential multiplicity of methods and perspectives make the study of online community both fascinating and complex. Yet at the base level all these approaches can be distilled into one question: What does online community tell us about the nature of community?

Debate

Can an online group truly be a community? Online communities were hotly debated in the mid-1990s. Much discussion focused around a crucial question posed by Rheingold (1995): "What is 'real' and what is 'virtual' in the 'virtual community'?" Strong responses on the nature of online social relationships came from both critics and advocates. Critics assumed there was something dangerous or at best incomplete about online communities, while advocates argued they represented a new social reality. By the late 1990s discussion in CMC research shifted from challenging the validity of online communities to accepting them as new social formations having implications for wider society. Researchers turned from the question "Are they communities?" to "What kind of communities are they?" Referring to these groups as virtual communities was also considered problematic by many. This term seemed to undermine the validity and study of these groups, so by the end of the 1990s many researchers opted for the label of online community.

Yet while debates about online community authenticity are no longer the central issue in CMC discussion of community, the issue of what is real and what is virtual online is still an issue for many in popular culture. The emergence of online communities continues to raise concerns, especially in discussions of religious community online. Therefore, it is important to consider the online community debate here to see how the hopes and fears of building community online shape popular perceptions of religion online.

This returns us to a discussion of the "virtual," begun in chapter one. Virtual carries with it the idea of simulation. When attached to community it evokes an image of something that is tangible, yet illusionary, serving as a substitute for the real. This idea underlies the argument of many critics, who believe defining groups online as communities is both dangerous and a threat

to true community. Critics typically identify what they see as two problematic characteristics of online relationships. First, virtual community provides a substitute for "real" relationships; being virtual means they serve as an escape from reality. Second, they claim virtual community becomes more real than the real world for its participants, causing them to log on and drop out.

Such claims are voiced by Kimberly Young's account of internet addiction, *Caught in the Net* (1998). Based on observations as a psychologist and survey research of obsessive online users, she argues that when people use the internet to fill relational needs, the internet use quickly becomes a complete escape from reality. "Internet users become psychologically dependent on feelings and experiences they get while using the machine and that's what makes it difficult to control or stop" (Young, 1998: 9). For people faced with dissolving families and community break-up, "going online can connect us to a new family that at least appears to offer what real families can't" (p. 29). Relationships online fill this void, but due to environmental limitations they will lead to disappointment and confusion. Online relationships, she claims, are illusionary, because online identities are often based on created personae, which are deliberate misrepresentations of the real person. She cites "virtual adultery" and "cyber widows" as examples of the consequences of internet obsession. She also draws on Turkle's work cautioning about the substitutionary nature of online relationships, as "computers offer the illusion of companionship without the demands of friendship" (Turkle, 1995: 30). For obsessive users the internet becomes a safe place "which many would rather spend time in than their own physical home" because internet community could be seen as vibrant, welcoming and "an antidote for our general cultural malaise" (Young, 20). The implication is that, by contrast, real-world relationships should be preferred as more positive and nurturing.

Young's observations were echoed in the findings of the HomeNet study that described internet users as "sad and lonely" people. Because online communication is often asynchronous and encourages quick, brief responses, it was seen to facilitate superficial interaction (Kraut et al., 1998). Other critics claim that what is virtual about community online is the online relationships. The internet is seen as a depersonalizing medium. Mark Slouka describes online community as a "digital hive," an anonymous mob guided by the invisible hand of the "digerati," where individuality is lost in the collective identity of a "global superorganism" (1995: 96). Alluding to the Third Reich, he argues that society is becoming "increasingly wired together economically and emotionally," causing it to be subsumed into a "global mind" controlled by webs of technology (p. 104).

Online community advocates approach these accusations by emphasizing that what is virtual is not the online relationships, but the environment in

which such relationships are established and constructed. Online relationships are "real" in the sense that they represent actual social interactions, though they are mediated. Rheingold (1995) explored this issue in an online document entitled, "Which part is Virtual? Which part is Real?" He criticizes those skeptical of the authenticity of online relationship authenticity, saying:

> Who made you the authority on what a life ought to be?... Who are you to say that their electronic conversations and virtual friendships are less valuable than yours? (1995)

He also urges internet users to "get out from behind their screens," pointedly asking, "If you claim to be part of a virtual community, do you feel an obligation to make your ties with others more solid than data on a display screen?" For Rheingold community is rooted in human connection that can "change human hearts and minds," whether they be direct or mediated. It is the internet's ability to provide a bridge between online and offline relationships that enables it to support community. Recounting his own online experience, he stated, "The WELL felt like an authentic community to me from the start because it was grounded in my everyday physical world" (Rheingold, 1993a: 2).

Critics, however, have labeled Rheingold a cyberutopian. In the mid-1990s one particular idealistic proclamation about the promise of the internet was often cited as proof he would encourage society to retreat into computer communities.

> We temporarily have access to a tool that could bring conviviality and understanding into our lives and might help revitalize the public sphere.... This vision of a citizen-designed, citizen-controlled worldwide communications network is a version of technological utopianism that could be called the vision of "the electronic agora." (Rheingold, 1993a: 14)

It cannot be overlooked that Rheingold has been heavily influenced by his experience with California communal culture in the 1960s. This is evident in his cautious approach to government control and use of technology: "before we argue the best way to build utopia, it might be time for citizens to unite against the encroachment of tyranny in the guise of technology" (1993a: 308). Yet he, as other advocates, also acknowledges the potential limits of the internet.[14]

He compares the internet to the agora, the marketplace of ancient Athens where individuals met to talk. He then contrasts it with the panopticon, a prison where architecture and optics allow prisoners to feel they are under constant surveillance. Both are options of where the internet could lead. Debate over online community authenticity, he feels, centers on confusion between "task" and "tool." Computer communication systems are tools, he claims, and community is one thing people can do with those tools.

> If we want to dig deep into what they mean by "virtual community," the people who meet each other through computer conversation need to take those relationships into the physical world, where people visit each other, have fun together, help each other out, fall in love. (1995)

Recognizing that communication media can produce new social phenomena means stretching the word community to include "groups of people who communicate socially and work together co-operatively and never meet in the real world" (Rheingold, 95).

Online communities are still seen by some as "pseudo-communities" because they denote a "reversal of centuries-old trend for organic community—based on interpersonal relationships—to impersonal association by mass means" (McLaughlin, Osborne, and Smith, 1996: 92). They are nontraditional in the sense that they involve mediated contact and are self-selecting and intentional.

They can also be deceptive, allowing individuals to hide true identity. They can breed shadow members or lurkers who do not fully participate in the community. They also can allow for uncensored or unsociable behaviors, such as flaming. The online context presents challenges for forming social relations, but these challenges are not dissimilar to those faced by "real" communities.

Online communities, in some respects, can be seen as a result of the conditions created by the information age. As people create and consume vast amounts of information, overload becomes commonplace. In *Technopoly*, Postman describes "what happens to society when defenses against information glut are broken down" (1993: 41). Culture, "overcome by information generated through technology, tries to employ technology as a means of providing clear direction and humane purpose" (p. 72). This state of information overload creates an open door for the formation of online community, technology being used to cope with a condition created by technology. Individuals dependent on information exchange find CMC a fertile ground for building social relationships. The online community as a "social aggregation" is a gathering of individuals in a mediated context who choose to communicate with and invest in other online users who share a common goal or interest. The context of gathering may be new, but how and why communities are formed is not.

The debate about the character and quality of online community still goes on as more people discover the possibilities and limitations of using the internet as part of their daily social communication. While critics continue to challenge online community authenticity, the more interesting question remains: "What kind of community is an online community?" An online community is a product of an information-driven culture providing a forum to sustain and connect individuals who would otherwise be distanced due to geography,

lifestyle, or other limitations. It is a new social grouping, created as people invest emotionally in relationships formed online. It is also a forum to sustain and connect. The characteristics of online relationships—being self-directed, nonphysical, and allowing anonymity—make online community both unique and complex.

Community as a network of relationships is an idea that sits well within the idea of the internet as the "network of networks." As people's social ties are increasing geographically dispersed and specialized and they employ technology such as phones or faxes, the internet has also become a common means for maintaining relationships. Using the internet to extend these relationships and create new ones is not only a natural progression; it demonstrates the shift toward "glocalized" communities. Here communities are "loosely coupled global networks" intersecting with "tightly bounded domestic networks, resulting in the blurring of domestic and work-related spaces" (Wellman, 1997b). Community as a network is a helpful image for the fluidity and flexibility of contemporary social relations. It also allows online groups to be studied and conceived of as communities, which are both global and local.

This network image of community can also be applied to religious communities. It brings together the divine and human communities by highlighting their shared connection as a network of spiritual relationships and practices. Employing dynamic understandings of the Trinity, communion, and *koinonia* from Christian theology demonstrates how these unseen spiritual connections between the church and God can be interpreted as a network. Combining these ideas with a social network approach to community offers a foundational conception of religious community that supports both interpersonal and spiritual relationship webs. This provides an exciting new framework for studying Christian community and describing a specific community's narrative. It also sets up an alternative conception of the internet as a spiritual network, where the internet becomes space that facilitates both relational and spiritual interaction.

The Internet as a Spiritual Network:

Spirituality and Religion Online

For many signing on to the Internet is a transformative act. In their eyes the web is more than just a global tapestry of personal computers. It is a vast cathedral of the mind, a place where ideas about God and religion can resonate, where faith can be shaped and defined by a collective spirit. (Joshua Chama, "Finding God on the Web," 1996: 57)

the internet has become not only a place of social connection, but also one where individuals can seek out personal spiritual enhancement. Located in the seemingly timeless, boundless realm of computers, a new breed of spiritual pilgrims has emerged. For some, the internet functions as a place of spiritual renewal as people seek truth on digital pilgrimages through web links. Others search for spiritual direction and fellowship with like-minded believers on email lists or BBSs. Online and IRC (Internet Relay Chat) prayer groups enable individuals simultaneously to exchange prayers that are typed in and shared with people all over the world. Many of these spiritual gathering forums are initiated at a grassroots level, by an individual rather than an organization or institution. Their motivations are as diverse as the technologies they use, from support groups for women in ministry to discussions on process theology. Listen closely in cyberspace and one may hear these new spiritual pilgrims singing, "Gimme that online religion" (Brasher, 2001b).

They believe, as Cobb states in *Cybergrace*, "Cyberspace can aid humanity's spiritual progression" by serving as an "important way station" on humanity's journey toward a greater spiritual evolution (1998: 97). By claiming that "the sacred is present in computers" (p. 42), Cobb interprets cyberspace as a place for society to find healing and reconnect the spheres of science and religion.

Using the internet as sacred or spiritual space encompasses a variety of online religious expressions. Some seek out traditional forms of religion from the thousands of religious websites (Lawrence, 2000; Horsfall, 2000). On their own terms and in the privacy of their own homes, some of these online pilgrims visit cyber-cathedrals or temples (Brasher, 2001a). Others experiment with newer forms of religious expression, altering and adapting ancient beliefs toward a technologically mediated environment (Davis, 1998). So far the internet has been discussed as a place to seek information, develop a particular worldview, experience personal empowerment, and engage in social formation. Yet the internet can also facilitate other pursuits. For many the internet functions as a spiritual network, where the primary motivations for internet use are spiritual or religious practices.

Spirituality is a concept found in many religious traditions and worldviews. It can be synonymous with consciousness, and implies that humanity exists as a union of a body and a spirit. The spirit is seen as distinct from physical matter. Spirituality differs from theology, which is an elaboration of religious doctrines or concepts. Spirituality, or the spiritual, refers to the human search for "meaning significance," recognizing the existence and development of a spiritual dimension in an individual's life (Jones, Wainwright, and Arnold, 1986: 50). A religion is a human system created to enable people to pursue a particular spiritual vision or understanding of life. Religion provides a framework in which specific beliefs and convictions can be lived out. The term often refers to an organized system of spiritual beliefs. Religious practice involves the establishment of sacramental or sacred spaces, which are set apart for holy use or where a discernible presence of an otherworldly spirit is revealed.

The internet as a spiritual network encompasses characteristics found in each of the previously presented models. It includes forming social structures to support spiritual activities, and creating or promoting a common belief and worldview through technological resources. It also entails constructing a specific religious identity and pursuing certain types of religious information online. Using the internet as a spiritual network interprets online activities or experiences to be part of a person's spiritual life, whether these pursuits are individual, communal, or informational. It also demonstrates the reconstruction, both public and private, of religious practice, as the model draws attention to the growing phenomenon of people using the internet as part of their religious routines. This includes searching out religious information and communities, as well as spiritual enlightenment or experiences online. This chapter will examine the expansion, use, and attitudes toward religion and spirituality online, with Christian use of the internet as primary focus. A survey of cyber-spirituality is presented, and this is done in order to contextualize the development of online Christian communities.

Cyber-Spirituality and Religion Online

While some find contemporary society breeds isolation and disconnection, the internet has come to represent an otherworldly space allowing people to reengage with spirituality in their daily lives (Barna, 2001). Cyberspace as a sacred space allows individuals to consider internet influence on many levels, including the spiritual dimension. Cobb claims the internet reconnects humanity with the spiritual by challenging the dualism of mind and body that underlies much of Western thought and philosophy. Cyberspace has "intrinsic value that ties it irretrievably to the larger sacred fabric of the universe" (Cobb, 1998: 233). She encourages people to find ways to bring computers into their "sacred lives" in order to more fully connect with the world and each other.

> The divine expresses itself in the digital terrain through the vast global computer networks that are now beginning to display rudimentary self organizing properties.... [I]f we can allow ourselves to understand the deeper, sacred mechanisms of cyberspace we can begin to experience it as a medium for grace. (1998: 42–43)

Wertheim makes a similar argument that the internet allows people to reconnect with ideas of the spiritual, immaterial world that have been silenced by the dualistic cosmology of Western science. Her historical examination of public notions of space argues that cyberspace is a nonphysical space, "outside the physical space that science has articulated" (McClellan, 1998). In *The Pearly Gates of Cyberspace* she points out that for the past 3,000 years there has been a link in Western thought "between what is immaterial, non-physical and the spiritual." Cyberspace provides a viable way to reintroduce the spiritual world into the postmodern context. She traces the idea of virtual reality and religious space back to the medieval artwork of Giotto and Gothic cathedrals, where virtual and physical spaces were united. Cyberspace, she claims, brings us back to an understanding of "Christian soul space" and the immaterial world by evoking a religious feeling and sentiment.

> The "spiritual" appeal of cyberspace lies precisely in this paradox: It is a repackaging of the old idea of Heaven, but in a secular, technologically sanctioned format. The perfect realm awaits us, we are told, not behind the pearly gates but the electronic gateways labeled .com and .net. and .edu. (Wertheim, 1999: 21)

In such ways the internet has been promoted as a place to actively reengage with spiritual practices and traditional religious beliefs. Religious use of the internet can be traced back to the early 1980s, when the first religious-oriented online group formed on Usenet. In 1983 the "net.religion" discussion list was formed, which grew and later split into the hierarchies of "alt. philosophy," "alt.religion," "soc.culture," "soc.religion," and "talk.religion" in

1986 during a reconfiguration of Usenet (Ciolek, 2004). In the early 1990s a series of mailing lists and discussion groups began to emerge for specific religions such as Christianity (Ecunet, now at www.ecunet.org), Judaism (H-Judaic, now at www.h-net.org/~judaic/), and Buddhism (BuddhaNet, now at www.buddhanet.net). By the publication of *Time* magazine's special issue on religion online and the landmark article "Finding God on the Web" (Chama, 1996), dozens of religious innovations and resources could be found online, from the first monastic website, "Monastery of Christ in the Desert" (www.christdesert.org) and first Islamic e-periodical, "Renaissance: A Monthly Islamic Journal" (www.renaissance.com.pk), to the first Zoroastrian cyber-temple (www.zarathushtra.com) and the "Virtual Memorial Garden" tribute to people and pets (http://catless.ncl.ac.uk/VMG). Since then the variety of expressions of religion online has continued to increase and spread.

In the mid-1990s religion online caught the attention of many research-ers and religious practitioners, yielding diverse reactions and methodologies (Campbell, 2003). Computer-Mediated Communication (CMC) researchers of religion began to describe the internet as a new realm in which to experi-ence the spiritual dimensions of life. Religious internet practices have been categorized in different ways. One popular distinction has been Helland's (2000) categories of religious internet use: religion-online and online-religion. Religion-online describes how religions import their traditional one-to-many communication into the online environment, as by establishing a religious denominational website. Online-religion, on the other hand, refers to how religions may adapt themselves in order to create new forms of communica-tion through many-to-many networked interactions, such as online prayer or worship services.

Another way to describe the internet as spiritual network is to distinguish the way it is perceived as either a spiritual or sacramental space (Campbell, 2001b). As a spiritual space the internet is seen to possess special qualities that facilitate spiritual experiences and encounters. The internet becomes expe-riential and experimental, facilitating spiritual enlightenment or innovation, often in nontraditional contexts. Here the internet alters individual and com-munal understanding of the religious when technology is used toward certain spiritual goals or ends. As a sacramental space, the internet is set apart for "holy use," which enables people to describe online activities as part of their spiritual life. The internet is recognized as a place that can be constructed as a sacred environment. People are able to incorporate the internet into their traditional religious practices. Sacramental use can include searching out reli-gious information online or forming religious communities.

Whether as spiritual and sacramental space or online-religion and religion-online, these distinctions highlight the diversity of traditional and

non-traditional understandings of the religious which can be cultivated online. People can perceive or use online technology in such a way that the internet becomes a place of spiritual experience or religious engagement. Both sets of distinctions are based on similar motivation for technological use, to cultivate and shape the spiritual dimensions of life. The internet as spiritual network draws attention to how the internet can create space for new forms of spiritual practice, especially online religious communities. These communities can serve either as tools for transmitting spiritual activities or as spaces for cultivating personal spiritual experience, relational support, or communal identity. These narratives are considered more fully in the next chapter.

In order to contextualize online Christianity, the focal religion of this study, we need to look at the depth and diversity of cyber-spirituality and religion online. Summarizing cyber-spirituality can be challenging. Bauwens (1996) identifies three dominant "spiritual attitudes" toward computer networks and technologies, which provide a helpful framework for discussion. His descriptions of technology as "The God Project" or "Electric Gaia" provide illustrations of how the internet can be seen as an experiential spiritual space. His third distinction, "technology as Sacramental Cyberspace," offers insight into how the internet can become sacramental space for traditional religious practice.

Technology as "God Project" and "Electric Gaia"

No unified overarching spiritual narrative exists in cyberspace. Like the world beyond the screen, the internet exists as a marketplace of spiritual options. Describing computer technology as possessing spiritual qualities has become common in the language of internet evangelists and hackers as well as advocates of religion and new age practitioners who have made their homes online. How internet becomes a spiritual space, offering new possibilities for spiritual experimentation and experiences, can be explained using the categories offered by Bauwens on different schools of spiritual thought related to technology. He argues that spirituality in the Wisdom traditions, "the means through which mankind finds meaning in its relationship to the totality of the external world," is being rediscovered in new ways in the digital environment. This is spirituality based on concrete experiences over concepts of "beliefs and faith" and is manifest in two ways.

First, Bauwens describes technology as the "God Project," where technology is seen as magic, possessing "God-like aspects." It can be seen as a "crude substitute for spiritual powers" or as empowering a search for a literal "Machine-God, Deus Ex Machina." Technology as the God Project is

demonstrated through technopaganism, neo-paganism adapted and cele-
brated within the online environment. Technopaganism is an umbrella term
covering a variety of beliefs and practices from pantheistic goddess wor-
ship to witchcraft. It is a religious practice that seeks to consciously ritual-
ize cyberspace. A technopagan is one who is "a participant in a small but
vital subculture of digital savants who keep one foot in the emerging tech-
nosphere and one foot in the wild and woolly world of Paganism" (Davis,
1997). VRML co-creator and frequently cited technopagan Mark Pesce says
the purpose of technopaganism is to bring magical space and cyberspace
together. "Without the sacred there is no differentiation in space. If we are
to enter cyberspace, the first thing we have to do is plant the divine in it"
(Davis, 1997).

Technopaganism allows individuals to practice ancient pagan rituals
online. Postings such as the Technopagan Blessing[15] and rituals such as
"Cyber Samhain" (a digitally enhanced version of the ancient Celtic cel-
ebration of the dead, also known as Halloween) combine myth and fantasy
with technology. The technopagan movement embraces techno-witches
(like Pesce), techno-druids, techno-shamans, and ravers. (It should be not-
ed that not all pagans are technopagans.) Yet, as Davis in *Techgnosis* says,
computers become for many pagans the holding grounds for myths of the
"ancient ways," and "spiritual powers" can be found online. Whether it is
used as a space for connection or as a "ritual technology," the internet be-
comes magical as it offers "portals into another world" (Davis, 1998: 189).
Technopaganism illustrates how individuals can use technology not just as
a tool or space for worship, but to adapt beliefs so that engaging with the
technology becomes an act of worship. The God Project is about technol-
ogy being magical, extending our senses and enabling the unfolding of our
human and spiritual abilities.

Second, Bauwens describes the "Electric Gaia," where technology is
"a necessary adjunct to make improvements in consciousness possible."
Cyberspace becomes a realm for utopian hopes for a better world. This is il-
lustrated by the adoption of the philosophy of Jesuit theologian and anthro-
pologist Pierre Teilhard de Chardin, who has been referred to as the patron
saint of cyberspace. De Chardin's theological writings envisioned an evolu-
tionary space called the "noosphere," a term loosely defined as the sphere of
the mind, in contrast to the term biosphere, the sphere of life (Huxley, 1959:
13). De Chardin described it as an evolving global consciousness that would
bring harmony to humankind (1959: 180–84). The noosphere was to emerge
as a web of global consciousness that would allow individuals to connect and
find freedom from the illusion of personal isolation. He predicted this would
lead to worldwide love and harmony.

No one can deny that a network (a world network) of economic and psychic affiliations is being woven at ever increasing speed, which envelops and constantly penetrates more deeply within each of us. With every day that passes it becomes a little more impossible for us to act or think otherwise than collectively. (Pierre Teilhard de Chardin, 1964: 174)

Many say the internet is the prophetic reality of what de Chardin's theology sought to describe. His ideas have been repackaged by many into a philosophy and way to describe the internet and the network of relationships emerging from it. Cobb uses his ideas of the noosphere and Omega point "where all layers of the universe are centered," and "the concentration of pure consciousness and absolute unity," in an attempt to create a "theology of cyberspace" (Cobb, 1998: 89). For de Chardin the Omega point is God or "pure spirit," and the process of evolution moves closer to this point of unity. Cobb claims that these ideas enable exploration of the internet as a spiritual network and that cyberspace can aid humanity's spiritual progression. She describes it as an "important way station" on humanity's journey toward a greater spiritual evolution (Cobb, 1998: 97).

Not surprisingly, de Chardin has a following on the internet. Hundreds of websites associate the idea of the noosphere with a new model for what many describe as the ideal community. The internet is seen as drawing humans together, producing a unified community. John Perry Barlow, cofounder of the Electronic Frontiers Foundation and lyricist for the Grateful Dead, considers de Chardin's ideas a model for the web, referring to it as the "hardwiring of the noosphere" and a place with the potential to create a united consciousness. "I think that the Internet is about us wiring together precisely what Teilhard was talking about, the collective organization of the mind" ("Communing with John Perry Barlow," 1997). This interpretation of the internet illustrates how individuals are seeking out not just new technological realities, such as virtual reality, but spiritual realities as well. As Electric Gaia the internet may extend the creative and cultural energy that could contribute to the greater development of human consciousness. The internet as spiritual space demonstrates a utopian reading of technology, possessing mystical qualities that can guide nontraditional pursuits for transcendent experience and meaning.

Technology as Sacramental Cyberspace

Besides new and novel spiritualities, every major religion can be found manifest in some way online. As previously mentioned, in various forums, websites, or discussion groups, traditional world religions such as Islam (Bunt, 2000), Judaism (Hammerman, 2000), and Hinduism (Zaleski, 1997), as well as

ancient pagan practices such as Wicca (NightMare, 2001) and other faiths can be found adapting themselves to cyberspace. The internet becomes sacramental space as portions of cyberspace are set apart specifically for religious engagement exemplified by Beliefnet (www.beliefnet.org), a resource website for numerous religious traditions.

Bauwens's third characterization of technology as "Sacramental Cyberspace" presents the internet as a place to further the aims of a particular religion. Traditional religions may be advanced when the digital environment is seen to facilitate the development of the spiritual life. Technology gives rise to Sacramental Cyberspace when the internet is set apart as a tool for spiritual connection. Many religious traditions have been proactive in cultivating the internet as a sacred sphere. One of the first demonstrations of this was in 1996 when Tibetan monks based in New York performed a special ceremony and ritual to bless cyberspace for use in Buddhist religious practices. The monastery's website notes,

> In using the Internet we noticed the Net breeds both positive and negative behaviors, reflecting the very human nature of we who use it. In this sense it became apparent that the space known as cyberspace was very appropriate for a tantric spiritual blessing—to help purify how it is used and the "results" it yields. ("The Blessings of Cyberspace," found online at www.namgyal.org/DailyLife/ blessings_of_cyberspace.htm)

During the thirty-minute ceremony monks chanted while "envisioning space as cyberspace, the networked realms of computers." Buddhism was also the first major world religion to duplicate online and in full a traditional form of religious practice. Dharma Combat, a form of unrehearsed dialogue that tests Zen practitioners in their understanding of Zen truth, takes place online hosted by the Zen Mountain monastery. They "have embraced the digital duality of 1 and 0 as skilful means for communicating the Dharma" as the internet facilitates this ritual practice and dialogue between spiritual teachers and students (Zaleski, 1997: 164). Both examples demonstrate the ways in which cyberspace is being used by religions to include technology in their spiritual practices.

A website designed to enable Jews worldwide to reengage with their religion and culture, Virtual Jerusalem (www.virtualjerusalem.com), also exemplifies the sacramental structuring of cyberspace. Webmaster Avi Moskowitz created the site to "try and recreate what was offline; I wanted to be the Jewish world online, mirroring the physical community or improving on it" (Morris, 1999). By housing information about Israel and Jewish culture in a central location, he hoped English-speaking Jews might reconnect with their shared faith. The site includes special features such as "Ask the Rabbi" and

"Send a Prayer," which allows registered users to send a prayer by email to Jerusalem and have it placed in the Western Wall, following the age-old custom. Testimonies from Jewish users of the site express how this online engagement helps them feel connected "not so much to Judaism as it links... to God" (Morris, 1999). Sacramental Cyberspace encourages people to see that there is an active spiritual life online. Also, the techno-world can learn from spiritual traditions by seeing links between religious belief and interaction with the immaterial world and the realm of cyberspace. The internet as sacramental space offers traditional religion a new place for believers to live out their religious convictions and extend their established rituals.

Every religion found online has bred its own unique expressions of religious practice and belief. Many of these involve the simple transfer of traditional rituals online, with some innovations. For example, a study of online prayer meetings in a multiuser virtual reality environment found "a prayer meeting in the virtual world may not provide the same type of religious experience as a conventional church service, but it certainly reproduces some of the essential features of the latter—albeit in novel way" (Schroeder et al., 1998). Thus, religion online cannot be fully separated from religion in the offline context. While exploring several religions online would provide an interesting comparison, this study focuses on Christianity online and how the internet is transforming certain Christian practices and beliefs. Looking in-depth into one religion enables us to make more detailed observation about the transfer and development of religion online.

A Look at Online Christianity

The boundary crossing, barrier breaking capacities that are intrinsic to both hypertext and computer networks are perfect illustrations of the happy conjunction of technology and theology. And there is every reason to believe that world shaking forces of similar proportion and power to those unleashed at the time of the Protestant Reformation are being set loose once again and shall have equally profound effects upon the way in which people practice faith as well as communicate with each other and with God. (Charles Henderson, "The Emerging Faith Communities of Cyberspace," 1997)

The internet has been proclaimed as the second, "electronic," Reformation. Like the printing press, the internet is seen as a revolutionary tool for spreading the message of Christianity. Still, online Christianity is about more than simply utilizing a new medium for proclamation. It is about reshaping ideas of faith and facilitating new ways of gathering as a new "digital body of Christ" worldwide.

Christians, like other traditional religious groups, are readily appropriating internet technology as outreach tools and as part of church life, with impressive results. This is illustrated by the highly popular Vatican homepage (www.vatican.va). Its "email the pope" link became overloaded within hours of being put online. The live webcasting of the installation of the American bishop in 1996 allowed Anglican communicants to virtually participate, even in the communion service.

A rallying call to embrace the internet in order for religion to remain culturally relevant has been sounded. Mello, an anthropologist and journalist from the Religious Studies Institute of Rio de Janeiro, stated:

> Religious groups that remain outside [the internet communication revolution] will become ghettos, like some Puritan communities in the 18th and 19th centuries, who tried to halt the passage of time to preserve tradition.... Changes arising from computer technology are irreversible. ("Join the internet or become a ghetto," 1998)

Many church officials and institutions have also encouraged incorporating internet technology into church ministry. "We live in a high-tech time," commented Archbishop Chaput, of the Catholic Diocese in Denver. "For us to miss the opportunity new technologies give us to preach and educate and inform would be harmful to the mission of the church" (Miller, 1998). Internet technology presents a new venue for encouraging and fostering religiosity by many organized religions.

Christian use of the internet began in the 1980s when computer enthusiasts in the Christian church began to explore "ways to use this new means of communication to express their religious interests" (Lochhead, 1997: 46). The Church Computer Users Network (CCUN), an ecumenical and national organization started in the US by the United Methodist Church, was an early example of computer networking by Christian groups. The network also facilitated several BBS discussion groups. The first Christian email newsletter was launched online in 1983 as "United Methodist Information" (Ciolek, 2004). By the mid-1980s there were several Christian online computer networking groups, such as Computer Applications for Ministry Network (CAMNET), Religious Associates, an electronic discussion group on software for religious groups, and PresbyNET, a BBS offering theological and technical assistance.[16]

In 1986 Ecunet (now at www.ecunet.org) became the first ecumenical network online, connecting 15 Christian communication groups (Ciolek, 2004). In this same year a landmark event for religious use of the internet occurred, according to Lochhead: an online memorial liturgy was conducted in remembrance of the US space shuttle *Challenger*, which had exploded soon after

takeoff. Organized on a network discussion board called Unison, it involved a liturgy, prayers, scripture, and meditation, followed by a "coffee hour," designed as general discussion for individuals to post reactions to the tragedy. This online service "demonstrated the power of the computer medium to unite a community in a time of crisis beyond the limits of geography or denomination" (Lochhead, p. 52). Lochhead claimed that while the church had always been about communication, online expressions of the church offered unique and vibrant innovation to traditional Christianity. These early groups and experiences contributed to a unique Christian ethos online and a "sense of identity as a community that existed independently of whatever service they chose for their electronic communication" (p. 53).

Other developments in Christian computer networks continued throughout the 1990s. Another notable first was the establishment of the first virtual Christian congregation by Presbyterians in New Jersey. "The First Church of Cyberspace" (www.godweb.org) was set up in 1992 as a nondenominational, nontraditional online church. As Christianity has continued to go online it has had to alter and adapt its methods of worship and ministry, and even to re-present some of its theological ideas. While many different manifestations of Christianity have emerged online, three dominant expressions are cyberchurches, e-vangelism, and Christian online communities.

To some, talk of a "cyberchurch" sounds like misguided science fiction; yet in one form or another it already exists. Many websites calling themselves cyberchurches have been designed with icons and structures to resemble a sanctuary or even use audio and video technology to allow individuals to listen to sermons or join in online services. Seeing the internet as a space for church planting has also given rise to a movement of cyber-evangelists seeking to spread the Christian message online. Often referred to as "e-vangelism," this online witnessing takes place through websites and chat rooms. Various books and online resources have been created to provide guidance in this activity. Others have used the internet to construct or search out Christian fellowship, creating online Christian communities on email, chat rooms, and through IRC links. These may be formed by individuals rather than by a specific offline Christian church or organization. These new communities of spiritual consensus represent grassroots efforts of individuals searching for like-minded believers with whom to communicate. However questionable online Christianity may seem to some, the fact remains that cyberchurches, web-based e-vangelism, and online Christian communities continue to emerge and grow online. These manifestations create new options for people of faith and may change people's expectations and conceptions of Christianity and Christian religious community.

Cyberchurches

The 1996 *Time* magazine article "Finding God on the Web" proclaimed,

> Just as urbanization brought people together for worship in the cities... so the electronic gathering of millions of faithful could someday lead to online entities that might be thought of as cyberchurches. (Chama, pp. 54–55)

Today numerous websites exist claiming to be these cyberchurches in various forms. Dixon declared that the internet is the "greatest new market to emerge in the history of humankind and will cause a revolution" birthing new manifestations of church. He defines cyberchurch in two ways: (1) "As the body of all Christians who interact using global computer networks," and (2) "as an electronically linked group of believers, aiming to reproduce in cyberspace aspects of conventional church life" (Dixon, 1997: 17). Here cyberchurch refers to church-like entities existing solely on the internet and having no real-world equivalent structure. These are to be distinguished from the thousands of "real world" churches represented online through web pages. Cyberchurches have been referred to as "churches without walls that literally 'gather together' via the internet" (Hewitt, 1998).

The First Church of Cyberspace is the most prominent example. Founded by Charles Henderson, it is described as a consortium of ecumenical churches and individuals who meet online every Sunday evening for conversations using IRC. The internet, Henderson argues, possesses the power of the Protestant Reformation to unleash new ways "in which people practice faith, as well as communicate with each other and God" (1997). Besides the weekly gathering on Sunday, the First Church of Cyberspace offers other interactive elements such as recorded sermons and songs, exchanges in its chat room, and a message board service where individuals can leave messages on "any topic of interest to Christians or pertaining to Christianity." According to the website, the church's online presence seeks to drop "clues that point to the presence of the Creator within the creative chaos of the Internet" and facilitate the formation of new faith communities online.

The success of the First Church of Cyberspace has made Henderson a major advocate of forming faith and community in and through the internet. He notes that traditional Protestant denominations are "declining and have an aging population. To grow, we're going to have to communicate on the Internet" (Miller, 1998). This is more than simply utilizing a new medium; it is learning a new way to communicate faith and the Bible. As the theologian Karl Barth challenged his students to grasp the Bible in one hand and a newspaper in the other, Henderson encourages the church to do likewise with a computer keyboard.

Other cyberchurches have also emerged, such as the Virtual Church of the Blind Chihuahua (www.dogchurch.org) and WebChurch (www.webchurch. org) which allow individuals to receive content through hypertext, images, and sound, but not to interact with other online attendees. These online creations have no real-world equivalent, which the faithful can visit beyond the computer screen. The Virtual Church of the Blind Chihuahua gets its name from a "little old dog with cataracts, which barked sideways at strangers, because he couldn't see where they were." The site claims "we humans relate to God in the same way, making noise in God's general direction, and expecting a reward for doing so." It seeks to provide a "Christian presence on the internet," and has given its separate page links names referring to parts of a traditional cathedral. In the "nave" one can select various links to traditional and original resources for daily offices and meditations. The "scriptorium" provides links to a "unique collection of illuminated (and benighted) manuscripts." The site is characterized by satire, and offers more light-hearted reading than religious devotion.

WebChurch calls itself the first online church outside the US and the first cyberchurch in Scotland. It exists to "help people connect with God." As its website states, "Like the church Jesus founded the WebChurch has no buildings, no fabric fund, no coffee mornings and no committees. The WebChurch is people: people who visit this site and people who pray for the visitors to this site." Based in Newport-on-Tay, Scotland, one of its main focuses is offering prayer support for those who visit the site. Individuals can read various prayers on the site and are encouraged to send email prayer requests. According to an article in the *Internet for Christians* email newsletter, "Christians from eight village churches pray daily for each request" with most being housebound volunteers who devote their time to this ministry (IFC, 1999). Seeking to be a spiritual home on the internet for "netizens," WebChurch provides information and material and prayer support for its visitors.

Cyberchurches have become a sacred space to which devotees travel to interact alone or together with others. Dozens exist online in various forms, yet most remain as broadcast rather than interactive forums. While some still find the idea of a cyberchurch with no real-world counterpart worrying, the fact remains online religious-based entities and groups are continuing to emerge online.

E-vangelism

Besides challenging ideas of what it means to gather as a church, the internet is changing the ways people communicate ideas of faith. A movement in witnessing online has emerged, often referred to as "e-vangelism." Quentin Schultze,

professor of communications at Calvin College and author of *Internet for Christians*, is quoted as saying,

> A lot of religious groups are finding that if you're really serious about evangelizing and preaching the gospel and bringing the word of God to people, then you probably have to have a presence on the Internet. (Schultze in Ribadeneira, 1998: A01)

E-vangelism focuses on presenting a purposeful Christian presence in cyberspace through a variety of means, through websites, in chat rooms, and on email lists. While in some cases this is promoted in a top-down manner, with religious organizations encouraging these activities and providing resources, in many instances it is individuals undertaking these tasks. This bottom-up movement means that while official sources may provide resources, anyone with the motivation can be an online evangelist.

One of the first organizations to see the internet as a potential "mission field" was Gospel Communication Network (Gospelcom, www.gospelcom.net), launched in 1995 with the goal to "provoke people to think deeply about the nature of God" by "saturating cyberspace with the greatest news of all." Under the umbrella of Gospel Films, GCN provides web hosting and set-up services as well as technological support for Christian ministries such as the Billy Graham Center (www.gospelcom.net/bgc), InterVarsity Christian Fellowship (www.intervarsity.org), and the International Bible Society (www.gospelcom.net/ibs). Gospelcom's home page also serves as a clearinghouse for various Christian ministries and resources, receiving over one million hits a day. Schultze calls the growth of Gospelcom a "technological unfolding of God's creation," enabling the church to reach out to people who may never enter a church building. This desire to see the "gospel penetrate cyberspace" has also given rise to a movement of cyber-evangelists who want to see this new technology used "for the glory of God" (Ribadeneira, 1998: A01).

A common method of e-vangelism is through websites designed with a deliberate presentation of the gospel or "plan of salvation." Such is the case with the site Who Is Jesus? (http://www.ccci.org/wij/?) which presents an apologetic argument about the person and life of Jesus Christ. Linked to the online text version of a traditional evangelistic tract called "The Four Spiritual Laws," it provides a response form for individuals to gain information about a film on the life of Jesus or request information about Christianity. This page is linked to the Campus Crusade for Christ International home page, an evangelistic student organization.

Many resource pages have surfaced providing instructions and training for those looking for strategies for online e-vangelism. Gospelcom's Online Evangelism web guide (www.gospelcom.net/guide) and Brigada's Online Web

Evangelism Guide (www.brigada.org/today/articles/web-evangelism.html) present ideas on creating web environments to "draw in non-believers and introduce them to Christ." They provide practical advice on setting up websites and how to witness in a chat room. Other resource pages, such as E-vangelism.com, provide site links for "electronic evangelists" and those involved in "virtual ministries." This site, focused around Andrew Carega's book *E-vangelism: Sharing the Gospel in Cyberspace*, addresses issues raised by doing "friendship evangelism" through building relationships in online conferences or "surf evangelism" through visiting websites. Carega advocates that online missionaries be fluent in the language of technology as well as aware and sensitive to this new culture of the internet before venturing into cyberspace. He uses talk of empowerment to rally support of the masses for involvement in the information revolution. "It's up to us, the 'peasants' of the revolution, to take the Internet for Christ. It is up to those of us who will devote ourselves to the task, who will take the time to build relationships with seekers online and commit themselves to nurturing those relationships" (Carega, 1999: 24).

E-vangelism presents the internet as the new mission field of the twenty-first century. In *The Internet Church*, Walter Wilson asserts that through the internet "we have the opportunity to reach every man, woman and child on the face of the earth in the next decade," a phrase used three times in his book (Wilson, 2000: 2, 120, 154). Wilson stresses that the internet's pervasive nature, its ability to cross social and cultural borders, and its nonthreatening environment make it an ideal medium for individuals to engage in spiritual searching. "It provides a seeker with the ability to navigate his or her way to the foot of Calvary's cross," he claims (Wilson, 25). E-vangelism focuses on utilizing the internet as a tool for conversion, and e-vangelists call for Christians to pick up this tool as part of the divine mandate to "Go into all the world" (Matt 28:18–20). Yet research on the electronic television church has shown that the fact that one can utilize a new technology for evangelism does not mean that the medium will be effective or lead to the intended results.[17] Nonetheless, while claims about complete penetration of the gospel may be hard to substantiate, e-vangelism activities seem likely to increase over the next decade.

Online Christian Communities

Another trend in online Christianity is the gathering of the "digital body of Christ" in online Christian communities. These groups facilitate interactions with believers who are separated by geography but share some sort of religious connection or conviction. Some online Christian communities are intentionally created by a church or denomination, often based on a website, sometimes

employing audio and video technologies. One example of this is the Toronto Airport Christian Fellowship (TACF), the church made famous in the mid-1990s through the "Toronto Blessing." In January 1998 it launched Revival Live Network to daily live broadcast services on the Web. Digital cameras in the church allow online users to "come on line with your computer and have a front row seat, hear and see what the Spirit is doing in Toronto and never leave the comfort of your own home or office." Sources at the church estimate that somewhere between 1,500 to 4,000 people access the TACF website each day (www.tacf.org). In a marketing letter sent out by TACF, numerous individuals shared testimonies of how access affected their spiritual lives, many commenting that the broadcasts enabled them to engage with God. One couple from Israel was quoted as saying, "Just wanted you to know that we are now with you everyday live on the internet and that God is ministering to us in Power."[18] While testimonies of this sort speak to the value of these religious spaces for some such services, they typically follow a broadcast model similar to the electronic churches created on television by "televangelists."

In this study the more interesting and dynamic online Christian communities observed were those formed at a grassroots level, through individuals rather than institutions. These communities often emerged as people found others online while searching to become part of a group conversation on a specific topic. Online Christian communities congregate around an issue of faith, from a general topic of mysticism or spiritual discipline to a specific focus on doctrinal beliefs or denominational emphasis (e.g., Episcopal or Baptist). While many websites refer to themselves as online communities, most provide interaction with hypertext and images only. Online Christian communities are interactive groups, facilitating two-way interaction through various computer technologies.

Some groups utilize Internet Relay Chat (IRC) as a forum to congregate. By downloading IRC software individuals are able to access various channels designated as Christian meeting places and hold "typed" conversations with others. IRC communities often encompass specific groups of people who have met through another medium, such as an email list, and have a designated channel and a specific time to meet. IRC is also used for online prayer meetings, with members gathering at a specific time each week for moderated prayers and times of encouragement.

Similar to IRC are website-based chat rooms. These help create interest and keep a steady flow of visitors to a website. An example of a Christian chat room popular in the late 1990s is ReaperNET (http://chat.reapernet.com/), a website created by individuals influenced by the Pensacola/Brownsville Revival in Florida (US). One of its main features is ReaperNET Chat, described as an "international revival community for Christians." Though open

to all faiths and backgrounds, it seems mainly to draw charismatic, Pentecostal Christians. On visiting one may observe conversations about Christian holidays (Easter and Christmas), discussions of revival sermons, or prayer request exchanges. ReaperNET Chat is an example of how the Web can provide a meeting point for individuals of similar interests and convictions to connect with one another.

Another form is an email list, which gathers around a common theme and typically is managed by a central computer database; individuals receive general postings or mail from members of the community. To be a true community, it must allow members not only to read, but also to exchange messages with the entire group. This type of online community is the focus of this study and will be expanded upon in later chapters.

All of these forms of Christian online communities revolve around common themes: experience, interaction, and connection. Members select the type and topic of community they join based on the type of experience they are looking for. Interaction is based on what they are able to receive and give to the group. The strength of the connection is based on the affinity an individual feels for the group or topic. In each case the internet enables individuals to engage with people in ways they would normally be unable to experience. For some members, online Christian community life is perceived as more vibrant than that which they experience in their real-world church or community. This is an area to be explored further in future chapters.

This survey of online Christianity shows how some of the faithful have embraced the internet in new and specialized ways to express their beliefs. Yet this utilization of internet technology in Christian practice is not always a "happy conjunction of technology and theology" as Henderson has claimed. For some the notion of online Christian community is problematic or even dangerous. Whether the digital revolution will usher in a new religious reformation is yet to be seen. Online Christianity has created a new arena of debate about religious lifestyle and practice, raising familiar questions about the nature of humanity in the face of technology.

Considering Challenges of Online Religious Community

This survey of online Christianity sparks many questions. How do cyberchurches interact with offline churches? Is e-vangelism having any impact on cyberspace or on individuals' conceptions of Christianity? How do the manifestations of online Christianity compare to other forms of religion online? While many such issues could be explored, this study maintains its focus on

Christian online community, so as to provide a detailed investigation of the development and understanding of a specific type of online religious community and how it interacts with similar offline communities. Christian community online provides a laboratory to observe the interaction of online and offline religious structures as well as beliefs about the nature of community.

In the Bible the Apostle Paul charged the first century church to "Forsake not the assembling of yourselves together as the manner of some is" (Rom 10:24). In this light the rise of online Christian communities gives a new meaning to the notion of "assembling." Paul has been described as the first "cyberapostle," whose use of the technology of his day (letter writing) enabled him to be virtually present in different churches and even in different eras (Dixon, 1997). Some advocate that the Christian church should take this approach today.

These are some of the same people who claim online communities are contributing to the building of the greater Christian community. As Baker wrote in the *Christian Cyberspace Companion*, "Cyberspace has enabled believers to cross social, geographical and denomination boundaries and has done a great deal to bring together the body of Christ" (1995: 163). This suggests that the internet is a religious utopia, a place of ecumenical peace and harmony. While examples of such harmony can be found, such as Ecunet or Beliefnet, in many respects the internet "has come to resemble a high-speed spiritual bazaar" (Chama, p. 53). Rather than presenting a unified or cohesive image of Christianity, the diversity of Christian offerings online seems to suggest an increase in special-interest communities. Some argue that this contributes to a new "ghettoizing" of religion.

> In the 1990s, Christianity has found a new platform to spread the word. But the Internet being what it is—the ultimate venue for freedom of expression— that word has a host of manifestations, amounting to a digital Tower of Babel. (Chidley, 1997: 46)

This diversity of uses and opinions of the internet has led to heated debates in some areas of the Christian community about the internet and its ability to be a carrier of true spirituality. In 1997 three books came out offering very different responses to Christian internet use.

In *Cyberchurch*, British researcher Patrick Dixon characterized the internet as a place of opportunity for the church, outlining possible ministry applications such as electronic prayer gatherings, online discipleship courses, and email support for missionaries. He argued the internet is a "God-given" tool to be used in proclamation and relationship building. The church needs to embrace the internet.

The internet world needs cyberchurch, not as a substitute for local church life, but as a vibrant electronic expression of the life found in the body of Christ world-wide.... We cannot fulfil the great Commission to go into all the world if we stay out of the cyberworld. (1997: 162)

He also claimed that the globalization of the work force "means that many churches will need to use the internet to enable basic fellowship and friendship to be maintained" (p. 143), and suggested establishing cyberclubs for global Christian travelers. Cyber-relationships should be seen as part of the church's ministry network of support and encouragement. His enthusiastic support was tempered by only a hint of caution, saying a "clear call from God" (p. 162) should be sought before incorporating the internet into church life, and that cyberchurch is not a substitute for real-life membership and involvement (p. 94). Yet his advocacy of the internet was evident, addressing it as a tool for God's manifest purposes.

In stark contrast, *Virtual Gods* harshly criticized the internet and its influence on the "spiritual landscape." Tal Brooke, director of the Spiritual Counterfeits Project (SCP) in California, argued that the internet leads people to a similar place as before the great flood in Genesis, where "man creates his own universe with no god in it but himself" (Brooke, 1997: 126). The internet is described as a "mechanical beast," and cyberspace as a breeding ground for delusion, where people experience "the worst kind of alienation—from reality and from God" (p. 176). Similarly, Brooks Alexander, founder of SCP, identified what he calls "instrumental Gnosticism" in the techno-culture, where illusionary forms of knowledge exist and are encouraged.

The spiritual world is the techno-world intersected in the media.... Aberrant spiritual ideas flourish readily in that realm of collective fantasy. As the media reduce all events to info-tainment, the line between interpreting reality and inventing it starts to blur in the popular mind. (Alexander, 1997: 162)

Both believe that mediated reality as experienced through new technology leads people into deception in their relationships and identity. Cyberspace not only separates body from spirit, but becomes a "refuge from God" as boundaries between the "personal self and the ultimate reality" begin to blur (Alexander, p. 168). They suggest that Christians should approach technology through "sanctified cynicism," a position that emphasizes the danger technology poses for believers' relationships with God and the church.

Amidst this strong advocacy and criticism of the internet in Christian practice Douglas Groothuis, a Denver Seminary theologian, endeavored to offer balanced reflection in *The Soul in Cyberspace*. While admitting a tendency to "include more rant than rave" about the internet, he tried to employ "principles of discernment" which are neither "digitopian nor Luddite," stating,

"given the present tendency to worship technology, some negativity is necessary in order to bring some balance. In this sense, being negative is positive" (1997: 155). He questioned whether the internet is an appropriate medium for the Christian message, considering the impact of hypertext on authorial intent and on Christians as "people of the book." He also cautiously wrote about trends in e-vangelism and cyberchurch, expressing concern about the effect of "disembodied" communication on Christian community. As he stated in an interview,

> When cyberspace begins to replace embodied interaction, we fail to honor the incarnational nature of Christianity. We may be "connected" to people around the world through the Internet while we neglect our spouses, neighbors and churches. This is wrong. (Kellner, 1997: 54)

As all technologies alter human life, Groothuis argues, internet technology will inevitably affect "our souls and our society" (p. 15). As a critical friend of the internet, he challenged Christians to ponder how internet use may shape their spiritual destiny and relationships as well as their earthly lifestyle.

These three books provide a spectrum of religious response to the internet: advocacy, criticism, and critical friendship or reflection. Several concerns regarding Christian relationships online emerge from this survey. Some of these are similar to general debates about the nature of online community, such as the internet's potential promotion of deception and hidden identities, the blurring of reality, and online replacing offline relationships. Yet online religion also raises unique concerns about the character of technology and how internet use will shape Christians' attitudes and actions toward others online. Will Christians use the new creative power to build just relationships, or to "play God," and will they steward the technology wisely? Graham Houston argues that Christians need to develop a "virtual morality," an ethical framework based on "Christian realism," presupposing that the moral order is the created order and technological determinism is not necessary (1998: 183). He encourages Christians to engage technology with discernment, understanding how the nature of reality can be simulated in the digital world, so they can inform the technology rather than letting it inform their worldview. Responding to online Christian community from this perspective remains a constant tension as controversial claims and findings about religion online continue to emerge.

In 1998 the Barna Research Group (US) proclaimed "The Cyberchurch is coming." This judgment, based on a national survey of teenagers, found that one out of six teenagers said they expected to use the internet as a substitute for current church-based religious experience within the next five years. Common uses included interactions with others in chat rooms or email ex-

changes about religious beliefs. "If you add up the proportion of people who will call the Cyberchurch their 'church home', those who will align with an independent house church and those who will be steadfastly unchurched... a majority of Americans will be completely isolated from the traditional church format" (Barna, 1998). The challenge facing Christian leaders, Barna claimed, is not how to stop new forms of church, but how to meet the challenge of ensuring "those forms are tied in to the foundational theology and principles that reflect the basis of the existing church" (Barna, 1998). These findings were verified in 2001 by a Barna survey on internet-based faith experiences, which found 8 percent of the surveyed adult population and 12 percent of teenagers now use the internet for religious purposes. Barna predicts the American church will drastically change in the next decade, as their research found that "Christian internet users already spend more time surfing the Net than they do communicating with God through prayer" (Barna, 2001).

While the practice of religion online poses a challenge to traditional religious notions of community, the fact remains that engagement in these communities continues to increase. Instead of simple criticism of these trends, there is a need for more study and careful assessment of these developments. Seeking to understand the general concerns and perceptions of the religious community about the emergence of online religious community is important. Yet messianic claims and adversarial condemnations must be responded to in light of solid empirical findings. It is in this direction we move in our search for the nature of religious community online.

Various forms of cyber-spirituality and religion can be found online. The internet becomes a spiritual network as people transport their religious practice and conceive of their online engagement as being spiritually motivated and enhancing. Online Christian community demonstrates one way religious community has transported and adapted to the online environment. Rather than shy away from the internet, many groups have readily and creatively appropriated it into their practices through church-like online gatherings in cyberchurches, witnessing on the Web through e-vangelism, and forming online communities focused on an issue of faith.

Online Christian communities are online groups who share a common bond of Christianity and unite through two-way interaction on a specific faith-based discussion topic. Advantages like freedom of expression, the ability to choose a community based on interest instead of geography, and a level of involvement based on personal needs and desires, are some of the reasons for this growth. However, while broad generalizations and observations are often used both to support and denounce online religious community, substantive proof is normally lacking in the current analyses and conclusions about the Christian online community. The goal of this study is to analyze the develop-

Story-Formed Community Online:

Identity Narratives in Cyberspace

It seems to me our community is sometimes like a soap opera. We're in the business of story construction. We're characters, in a way, playing out the roles we have presented. (Personal Interview in Toronto, Great Anglican Listmeet, September 1999)

the internet has been described as an electronic "campfire around which we tell our stories" (McCorduck, 1994). It is a digital space where people can weave tales of hope, promise, struggle and discovery. It provides not only an audience and a forum, but a plot and actors.

In the preface we were introduced to a face-to-face gathering of an Anglican email list. The gathering demonstrates the extent to which some people have invested in the process of story construction online. As one member of the Anglican Communion Online observed in the quote above, at a pub after the community mass, online community is often about telling personal stories, re-presenting old tales and creating new ones. As a storied community, online community is both pre-shaped and co-created. Some groups offer online pilgrims a home, allowing them to connect into a larger established story that frames the community's members and focus. Others provide a more fluid space where online pilgrims can construct new stories together. Both forms of stories are shaped by the beliefs and interests members bring with them to the community.

In order to grasp the ethos of religious community online we will explore in detail three email-based Christian communities. Each email list embodies a unique story emerging from the group's history, focus topic, style of interaction, and their preestablished ideas about the nature of community

and church. In this chapter we are introduced to these communities and their stories. These have been identified through extensive research, investigating religious use of the internet and Christian conceptions of community both online and offline.

Here we will hear the stories Christian email communities tell about themselves, and the unspoken religious community narratives that shape their communal identities. These narratives provide cohesion by defining the discussion topics of each email list and shaping the behaviors and beliefs of community members. Their stories dictate the boundaries, expectations, and traits of each community. The primary focus is to discover how each online Christian community characterizes itself and lives out a communal narrative online.

Researching Life Online

Each different discipline fails to see something that another discipline sees very well. We need to think as a team here, across boundaries of academic discipline, industrial affiliation, and nation to understand, and thus perhaps regain control of, the way human communities are being transformed by communication technologies. We can't do this solely as dispassionate observers, although there is certainly a huge need for detached assessment of the social science. But community is a matter of the heart and the gut as well as the head. Some of the most important learning will always have to be done by jumping into one corner or another of cyberspace, living there, and getting up to your elbows in the problems that virtual communities face. (Rheingold, 1993b: 80)

Studying religious community online has proved to be a challenge. When this research study began in the late 1990s, limited information was available on the scope of Christian internet use and the numbers of Christian communities existing online. While a few web pages (such as www.gospelcom.net) and resource books (Baker, 1995; Kellner, 1996) were available, systematic web searches and word-of-mouth proved to be the best ways to locate Christian activities online. After a year of web browsing and referrals, I had identified and observed fourteen online communities. It was noted that the groups which were most active and animated were those that had started at a grassroots level, by individuals rather than religious institutions or organizations.

In order to narrow the field of study, while providing room for comparisons, three groups were selected based on several factors, including levels of group participation, consistency of email exchanges, and depth of discussion. Each email community possessed similar traits and patterns of communication, while representing very different Christian traditions—Charismatic-Pentecostal, broadly evangelical, and Anglican. Each group came from a distinct theological perspective and church style. This diversity allowed room for comparison of how Christian communities import their beliefs and practices online in

different ways. Also, the willingness of an email list to participate in the study was an issue. The list owner and moderator of each potential group was initially contacted for permission. If consent was granted, a "de-lurking" email of intent and permission was sent to the entire list. However, in three instances, when potential communities were identified and selected, permission was denied. In two instances the list owner/moderator declined and in another instance the list members responded unfavorably to being studied.

Information about the beliefs, patterns, and practices of these groups were gathered over a four-year period through participant-observation online, email questionnaires to the communities, and face-to-face interviews with selected members. While online observation of each community took place at different points over three years, a designated period of data of collection and online participation was set for each group. This time period was approved by the list moderator or owner, ranging from six to ten weeks of data collection. During this time all email postings and interactions between community members and myself were recorded in an electronic logbook. A research diary was also kept, recording daily and weekly community events, logging selected extracts from key emails for analysis, and making comments based on a set of predetermined research questions. Key themes investigated included the unique qualities that online communication offers to internet users, how members described and interacted with their online community, and the perceived and actual relationships between online and offline community.

Community members were made aware of periods of participant-observation on the list through emails posted before, at the beginning of, and during this period, in order to notify new members joining during this time. Emails were cited in accordance with the group's protocol procedures. Permission was obtained from all individual members whose posts were to be used in any publication.

At the end of the participant-observation period, the members of each community were sent an email questionnaire. The questionnaire was pretested and standardized for all three groups, with only slight alteration of wording to personalize them to each group. The questionnaire had three sections gathering information on demographics, the member's history with and opinions of the online community, and on general internet and email usage. To gather respondents, an email was sent to each list asking volunteers to contact the researcher via personal email. Questionnaires were then sent privately to respondents. In the latter two case studies the initial response was quite low, so additional email requests were sent to the list to encourage more volunteers to participate. This raised some interesting issues of how individuals view community membership and "outsiders"; these issues will be discussed in future chapters.

After the questionnaires were collated, several community members were selected from among the questionnaire respondents for interviews. This selection was based on their level of online participation, how closely they represented a "typical" member (determined through community profiles constructed after analyzing questionnaire data), and willingness to be interviewed. Geographic location was a determining factor; due to time and funding, interviews were limited to members living in Britain and North America. Interviews were conducted in each community member's home, and whenever possible included observation of internet use, interviews with family members about their internet habits, and visits to their local church. Extended interaction with the member's family and friends was also done to relieve apprehension of spouses about an unknown "internet friend" being invited into their home, often for a two-day period. The intent was not only to verify data collected online about members, but also to observe more fully how the internet shaped their engagement with their offline community and local church.

Hakken suggests that in online ethnographies a researcher should identify the level of inquiry he or she wishes to explore, in order to help focus the appropriate research framework and fieldwork needed to answer the question of what it means to be human in these new spaces. While there is no single ideal approach to studying online community, he suggests studies should limit their inquiry to one or two levels in order to focus the research narratives and conclusions rather than make broad generalizations. He claims that because there is still "no single appropriate way to enter the field," diverse approaches should be encouraged as long as they are clearly defined and explained (1999: 39). This study focused on two levels of analysis: community relationships, and social relations between individual connections which support the construction of community identity. Case study methodology was employed because it allowed the use of multiple research techniques, enabling the collection of "rich" and "thick" data. This was done through an ethnographic approach presenting individual snapshots of three online communities in an effort to compare findings and draw general conclusions about the nature of Christian community online.

The goal of this in-depth three-part investigation was to identify marking characteristics of Christian community online and assess how involvement online may influence individual member interactions with and perceptions of offline faith communities. In chapters five through seven, each community is examined in four areas, including how it has utilized and adapted to the online context, how it interacted with the world beyond the screen, and its reflection of offline religious life and community. In this chapter the focus is on how these three email lists formed, functioned, and conceived of themselves as a community.

Finding the Story of Community Online

One trend in online community research is to identify patterns and behaviors of a specific online group. This approach seeks to present a "picture of a people," describing unique characteristics of the group contextualized within a larger framework of constructed meaning. Telling the story of a community involves uncovering foundational beliefs the community ascribes to and identifying the ideology emerging from community interactions that brings cohesion to the group.

Hauerwas (1981) defined the "story-formed community" as one whose form and substance are linked to a "truthful narrative" bound to the community's history. It is the narrative, the story behind the community, which gives meaning and perspective for group members' attitudes and actions. Understanding a community's story is essential in order to understand how it views reality and the world. Such an understanding involves highlighting the history, motivations for gathering, structure and philosophy supporting the community. In the case of online Christian communities this also involves identifying the theological convictions about the nature of church and religious community that influence each individual community's identity and practice. Similarly, Warren argues that recognizing a religious group's life narrative or "pattern of choices and ways of living that becomes the established mode of a person/group" is key to understanding the culture of that group (1997: 29).

Ammerman's idea of "autobiographical narratives" could also be applied here (Ammerman, 2003). Autobiographical narratives are stories that individuals weave to describe their particular form of life. They are dependent on internal themes and plots that the individual ascribes to, and they influence choices about how to act and react to new events. Identifying an individual's autobiographical narrative helps to determine what the "core self" is. An individual's affiliation and adherence to specific religious traditions, as well as emergent experience within that context, structures the religious autobiographical narrative. This idea could also be applied to a group; a community's religious autobiographical narrative is formed by its known history, unspoken tradition, and the ways in which its members negotiate these to create a pattern of life together. A community's religious autobiography could be seen as the constructed story of the corporate self, formed through the integration of beliefs and expectations held by a given group of religious believers.

Telling the story of a Christian community involves several factors: uncovering its history, identifying its faith-based focus, considering its interpretation of the larger Christian narrative, locating its definition of community, and labeling the core self or identity of the group. Online religious communities congregate around a specific issue of faith, from a general topic such as spiritual

discipline or mysticism to a specific focus on doctrinal beliefs or denominational emphasis. They are interactive groups, facilitating two-way interaction through various forms of technology. The online communities in this study were selected because they shared common online practices or structures, yet represented denominationally diverse groups. The first to be considered in the Community of Prophecy is an email list associated with Charismatic-Pentecostal beliefs and practices, focused around the gift of prophecy. Next, the Online Church is explored, a diverse group of sensory-impaired individuals with evangelical leanings. Then the Anglican Communion Online, an email list with links to the Anglican Communion introduced in the preface is considered.

Each email list characterized itself as a community or, as described in chapter two, a social network. This was evidenced in the language and form of social interaction each encouraged. As a social network each list emphasized the internet's ability to facilitate the formation of social webs online in its online discussions, as well as in accounts given in questionnaires and interviews. As communal networks, each encourage members to invest emotionally in online relationships. By providing a summary of the development, practices, and focus of these online communities, we are able to see clearly how they function and characterize themselves as social networks

Each email list represented itself as a distinct type of network—a spiritual network, a support network, and a religious identity network—and saw the internet not only as a suitable space for religious discourse, but as a sacred space constructed through religious activities. Though some groups did this more explicitly than others, all three demonstrated sacramental use of online space and created a unique narrative informing spiritual aspects of community life. These religious narratives brought cohesion and identity to these communities and gave members communal purpose and sense of worth. By providing a profile of each community from material collected during the research case studies, we are able to explore the formation and focus of the narratives of each group.

The Community of Prophecy

The Community of Prophecy is living proof that God can and will use the web for spiritual development. (Personal Interview in Devon, England, July 1998)

The Community of Prophecy (CP) describes itself in its online charter as

An electronic community or kinship of people who believe the Lord has given them some degree of prophetic gifting. It provides a safe (non-threatening) place to learn to walk out and grow in that prophetic anointing. It provides a place to build each other up and to encourage each other in our prophetic gifting.[19]

This email list focuses on the "gift of prophecy," providing individuals who feel God have given them such a gift a place to practice and receive teaching about it. A prophecy or a prophetic word is defined as "that which brings edification, exhortation and comfort to people" (Email sent to CP list, 11 Jan 1998 Subject: Week 1 Teaching - Prophetic Training 101 Course). It is revelation perceived to be given by God in the form of words, impressions, pictures, visions, or dreams used to offer encouragement or exhortation to others. This understanding of the gift of prophecy is emphasized and practiced by many Charismatic and Pentecostal churches.

Initially, the Community of Prophecy began as a sub-list of another popular Charismatic renewal email list in the 1990s. It was not very active, and after a year the list owner felt there were not enough people interested to keep the list going. However, several of the group's advisors did not want to see it "killed." In response one of the list advisors, Carla, a computer professional from California, felt prompted "by the Lord" to start up a new list on a similar theme, and in 1994 the Community of Prophecy was born. Carla still serves as the list owner and moderator. Through her involvement in the community she has become an ordained minister with a Baptist denomination and has launched her own ministry as a speaker and prophet.

The list exists to train members and to "encourage each other in our prophetic gifting." Individuals are encouraged to ask questions, to share words, prophecies, or visions they receive from God, and to ask for help in interpreting them. Periodic classes are offered on issues related to prophecy such as spiritual discernment or the role and character of prophets. The CP also offers various sub-lists on specialized topics such as dream interpretation. The community describes itself as a "school" and a "safe place" to learn; therefore debates on the relevance or validity of the gift of prophecy and other "off-topic" issues are not allowed. This is emphasized in an email letter sent to each new member. It encourages them to submit to their church pastor leadership and inform their pastor about their involvement in the list.

> This list builds community and is a place to support and encourage each other and to build up each other in our gifting. However, this list is not a support group for emotional or mental problems and is not a place to dump problems that are unrelated to the prophetic gifting. (Email sent to CP, 12 Dec 1997, Subject: Letter to your Pastor)

To maintain this perception of a safe environment and keep the list discussions focused, the CP is overseen by a "leadership core" of pastors and parachurch ministers from a variety of Christian groups. Their purpose is to guide the online discussion and provide teaching on the gift of prophecy. Led by the

founder-moderator, the leadership core is clearly identified within the group, and a profile of each individual can be found on the community website.

The CP offers various forms of member involvement. The main focus is the CP "school" list on which individuals post prophetic words or revelations and elicit feedback from other members. Another function of the main list is to offer prophetic training courses led by members of the leadership core. In these classes a teaching article is posted on the list with a discussion topic each week and members are encouraged to offer related responses. Everyone subscribed to the CP list receives these lessons and can choose whether or not to read or participate. Classes run concurrently with other general discussions. Examples of past classes include "avoiding prophetic pitfalls," character issues related to prophecy and the relationship between the apostolic and the prophetic. My ten-week period of online observation and data collection was focused on the first course ever run by the CP: Prophetic Training 101.

The CP also facilitates several chat rooms in AOL and IRC forums. These groups meet weekly at designated times on predetermined channels, typically for a two-hour period. Some are informal drop-in discussions, while others are more structured online prayer meetings. Another opportunity offered to CP members is a monthly Personal Prophecy Session (PPS) in which the leadership core offers personal prophecy and feedback online. Open only to CP members, these sessions offer one-to-one prayer and counseling from the community leaders via AOL or IRC. Members are required to sign up ahead of time, as there are a limited number of slots per session. All of these forms of CP involvement are governed by clear protocol guidelines detailed in the list charter that set the standard for acceptable and unacceptable community behavior. The charter stresses

> No discussion will be permitted in this conference that questions the basics of the Christian faith.... They are assumed fundamental and agreed upon by all participants.

These fundamental assumptions include accepting the Bible as the ultimate authority, belief in Jesus Christ as the Son of God, and belief in the bodily resurrection of Jesus. The focus of the list is prophecy, and other topics are not permitted. Unacceptable behavior outlined in the charter includes: flaming or personal attacks, openly hostile posts, attacks on any Christian leader or group, and off-topic posts related to debate and theologizing on biblical prophecy. A violation of the charter results in a warning from the leadership core. Repeat violations can result in removal from the list, as will be explored later.

The size of the community has steadily increased since initial contact in 1997 from 200 members to over 1200 at the height of the study. The list attracts a diverse membership representing various countries with an even num-

ber of actively participating men and women. While most members are based in North America, others come from places such as Hong Kong, Tasmania, Paraguay, Hungary, Norway, and the Philippines. It is consistent in its daily communication, about 5 to 10 posts on a typical day and 15 to 20 posts daily when certain classes are offered. It has a clear focus, a community mission statement, and standards of protocol and community practice, which are maintained and enforced by the group.

A Social Network

The connection members felt to one another was clearly expressed. In email and interviews, they referred to the CP as an "online congregation." They also frequently referred to the group as "brothers and sisters," their "Prophetic Family," "Good People of God," and "Precious Saints." This language indicates the connection many CP members felt for one another and the community as a whole. Members also used metaphors such as "army" or "team" in their emails to describe the community. These not only expressed how individuals conceptualized the community; they described perceptions of the CP's purpose.

Throughout the case study members expressed strong feelings of unity and belonging in their messages about the community. Over the ten weeks of online observation increasing numbers of individuals shared openly about their offline lives and how this related to the community. This was evidenced in email sent to the entire list and through "activation exercises," weekly assignments given to members to help them put into practice what they had learned. Replies to lessons and activations often included personal details. Many posts during the course shared not only personal reactions, but also referred to emotional and even physical responses.

> I too had a real sense that the group took on a unity this week, which was not there at the same level in previous weeks. It is feeling really safe and comfortable, in the right sense of the word. I am soooo excited to think what the Lord will do this week! (Email sent to CP, 11 Feb 1998, Subject: Re: Week 4)

Activations could be done through email partnering, IRC groups, or even face-to-face meetings of CP members. Emphasizing and facilitating person-to-person interaction encouraged a greater sense of investment and camaraderie in the community. Private activation groups often reported the results of their interactions back to the entire community. Others sent their responses directed at individual members to the entire list. In this way discussions, typically private in a face-to-face community, were made public. This allowed the entire community to observe how individuals interacted with one another and

for members to become acquainted with others without directly communicating with them.

The public nature of email communication helped members move individual discussions into the corporate sphere. As members grew more comfortable with CP, some began to root their personal identity online with the community's identity. This process is described in the following email:

> Hi there!... I have been lurking on the list for months.... I am a fairly new Christian... and am attending a non denominational church, moving in the prophetic and God has used me in this prophetic way from time to time.... I am so happy that He has chosen to guide me to this place to learn more about His gifts and how to properly care for them!!! (Email sent to CP, 23 Jan 1998, Subject: Course 101 Week 2)

The leadership core also promoted the idea of social networking by emphasizing that the list was a "safe place" and encouraging members to share personal details with the community. This was demonstrated through the leadership core's monitoring of discussions and enforcing issues of protocol. Encouraging an atmosphere of intimacy aided CP members to develop high levels of emotional investment in the community. Individuals often displayed a willingness to be vulnerable in their emails. One instance of this developed during week four with a community member who described himself as depressed. Initially, he responded to a post about "discouragement" and proclaimed "one more ounce of pressure, and I'm gone. Seriously" (Email sent to CP, 3 Feb 1998, Subject: Re: [email-activation] Discouragement).

Over the next few days several posts personally directed to him were made by members seeking to encourage him. One earnest plea was made for him not to go but to stay with the group. At the end of the week he responded by thanking the group for blessing him with public and private support messages. He also shared his perception of "Satan attacking his computer modem" to keep him offline, but he was back, and thanks to the group he was going to hang on.

> Satan has put me offline for a few days, but he forgot that I kept my old modem, so I'm online again.... You have blessed me both in public and private messages, in the natural things haven't changed, however, I see those "chariots all around me." (Email sent to CP, 8 Feb 1998, Subject: Re: [email-activation] A Big Thank You!!!)

The CP creates a forum for members to respond easily in supportive ways to each other, and public posts allow encouragement to be given and received quickly. When a member is encouraged publicly, it highlights the positive supportive atmosphere within the community. Support of this nature may not always be this visible in a local church environment; hence an online environ-

ment can seem to be more caring and supportive. The social and supportive connections facilitated within the CP helped sustain the social bond of the group, encouraging members to invest themselves in the community.

A Spiritual Network

Relationships within the CP were not only characterized as social; many members described them as spiritual. This was partly due to the community's focus on the gift of prophecy. Members are taught to seek prophetic revelation from God, by making a transition from functioning with their "natural" minds to connecting with God in the realm of the "Spirit." In the CP there is a correlation between the spiritual world and the online context, both being invisible realms. It appears that cyberspace, as unseen virtual space, may be conducive for this type of community function, as it creates an "other-worldly" environment.

The CP's focus is to train and equip members in the prophetic realm. Individuals must in one sense leave the natural world in order to search out revelation only available in spiritual territory. Transition between the natural-spiritual-online worlds becomes an easy, almost natural progression, as the "prophet" must block out all external stimuli and thought in order to focus and "hear what the Spirit is saying." The lack of nonverbal cues and visual stimuli within internet communication may be advantageous in this process.

A "prophecy" shared and proved accurate online receives a unique credibility over one shared face to face. Within the CP, as the "prophet" typically knows only the name and possibly the age and marital status of the individual they are addressing, information must come from the Spirit rather than through skills of deduction. Many feel the internet is a helpful medium for "prophetic prayer," especially when "it is from someone who doesn't know you well and has not even met you and it is a right on prayer... you know it is from the heart of the Father" (Personal Interview in Michigan, June 1998). The activation component of the CP training facilitated many such interactions. Therefore, the CP is thought to aid functioning in the gift of prophecy by its very location on the internet.

The CP's narrative can be described as a spiritual network. The term "spiritual networking" came from a face to face meeting with a couple from the CP leadership core during the sixth week of the case study. During the conversation these members described a spiritual network emerging in forums such as the CP, explaining it as "God is weaving connections and creating relationships between people all over the world" for prayer and support. They felt connections within the CP would lead to opportunities for members to become involved in others' offline lives and ministries. They stressed connections

were designed and initiated by God and were internationally diverse, forming an overlapping network of online and offline communities. From their perspective, spiritual networking was not limited to the internet and it was most evident in the Christian "renewal" community.

At its simplest, spiritual networking is "networking with spiritual friends." On a larger scale it can be seen as "webs of connection brought together by a spiritual or divine source" (CP Online Interview, March 1998). The understanding of the CP as a spiritual network was illustrated in two email discussion topics during the case study. They are being referred to as the "pioneer/ Manifest Destiny" thread and the "warfare/battle plan" thread. These do not represent distinct discussion threads; rather they encompass a series of emails on connected topics.

The pioneer thread was first expressed in a post during week two, when a member described seeing a picture of a ship crossing the ocean. This was interpreted as a metaphor relating to the "spirit" of the early American pioneers, who came in boats to America to colonize the "new" land. The email emphasized obstacles the pioneers encountered and had to overcome. A "pioneer" was established as a positive image to emulate. The process of taming new territory was interpreted not only as a privilege, but a prophetic calling. The writer linked the struggles of the pioneers to potential problems that may be encountered by this online community.

> At this time however, we must remain extra-vigilant and cover each other in prayer, if we are to come to the other side of the "ocean," and into God's blessings....
>
> I will tell you this—the devil IS AFRAID (of the group) as they are now, but especially of what they can become.... I see a time when there will be members of the schools in every country of the world, and that together we will become an incredible, united fighting machine for the kingdom of God. (Email sent to CP, 24 Jan 1998, Subject: Pioneer spirit)

Characterizing the group as being on a divine mission with predications being made of the community's potential provided the CP with a way to move beyond the bounds of the online setting to predict its influence in the offline world.

The warfare thread followed the pioneer thread, building on the image of divine destiny being lived out. The image of warfare or conflict established that the group faced an enemy who sought to prevent exploration and expansion of the community. These attacks took the form of computer technical problems and situations in the community leading to "confusion, intimidation, discouragement." A battle plan was given to the group: members needed to pray for the community and its leadership.

In week six the CP experienced major technical difficulties when the community's administrator server crashed, erasing the CP website and the archive

of community emails. These incidents were interpreted as a "spiritual attack" on the community. Members reacted with a spiritual call-to-arms, to pray for the community and its technical problems. As one member wrote:

> On Monday we saw the message of the WWW problem & started praying and Monday night late my computer started giving error messages & just bombed out for no reason. I think the devil is trying every trick he knows. Ha! Well he's lost the battle when Jesus had risen! Praise God! The gates of hell will not prevail as the saints of God march on! We also pray for a total restoration of all the work on the web site. (Email sent to CP, 18 Feb 1998, Subject: WWW pages gone)

Identifying the conflict and the enemy helped clarify the strategic role of the CP and its perceived struggle against external spiritual forces. Acceptance of these ideas enabled community members to see themselves as part of a group with spiritual significance not only online, but in the offline Christian community.

Seeing the CP as a spiritual network was used to explain how members should react to conflict experienced individually and communally. One member, overwhelmed by stress and the amount of email, publicly wrote of wanting to withdraw from the community during week six. However, these personal feelings were reinterpreted when she saw the circumstances as having been planted by Satan to get her away from the community. Spiritual networking was also used to explain how relationships were formed and sustained in the CP. God instigates connections online and offline, which are seen as strategic. As one member wrote:

> The Lord has created friendship and bonds and He will use these bonds in times ahead. Value the bonds that have been created, for the Lord will form intercessory teams that will strengthen places that are weak. Expand your horizons says the Lord.... I am raising up teams, teams of "nobodies"... nobodies as far as title goes, but of great value and worth to Me, says the Lord. (Email sent to CP, 10 Feb 1998, Subject: [email-activation] wk 5 activation)

This idea of "teams" being raised up became more than just words when, in the final week of the CP training, the administrator announced that a new ministry had been formed by several CP members. This seemed to fulfill prophecies that ministries would be born out of the CP. Not only did they offer logistic and factual data about this new online and offline prophetic ministry, they also offered evidence of how God had given a "signature of approval" on this venture. They posted testimonies of how needs had been met, such as the provision of unsolicited funds to pay the federal registration expenses for nonprofit status and a well-received prophetic seminar taught by one of the board members.

The CP is a community with a unique story. Spiritual networking demonstrated how a narrative could bring cohesion and identity to a community. It also showed that as members identify with a narrative they find purpose or sense of worth, shaping their conception of the group and their role in it. Spiritual networking allows community members to see themselves as part of something that reaches beyond the screen with the potential to influence the global Christian community through online spiritual connections.

The spiritual network narrative empowered members to understand their community as possessing power from God to influence the global Christian community. Thus online community as a spiritual network is characterized as being designed and initiated by God for a specific purpose. This fits in with the idea of the internet as "identity workshop." The internet is seen as a place to search out personal spiritual destiny that can be interpreted though a narrative of shared experience. It highlights the desire for freedom and spiritual experience within the community network.

The Online Church

> All here on OLC we are special friends—yes, more than that—we are brothers and sisters "in Christ." We are to help and encourage one another and to pray for one another as each has a need. How blessed it is to do this! (Email sent to OLC, 24 Nov 1998, Subject: Re: To a friend of Mine)

The Online Church (OLC) describes itself as a place where Christians can share personal problems, prayer requests, and progress reports or ask questions related to the Bible. This is outlined in an introductory email sent to all new subscribers:

> The Online Church is a mailing list open to the public with the purpose of holding discussions relating to the Christian's walk with God and how the Bible applies to everyday life. Nonchristians are welcome to participate as long as their questions and comments remain within the list guidelines. (Email sent to OLC, 3 Apr 1998, Subject: Usage guidelines for OLC-list)

Individuals wishing to join the list must agree to basic rules of conduct: "No profanity or unchristian conduct is allowed. In short, one damn or hell and you are off the list." The basic behavior rule is, "Be nice to everybody because everybody is having a tough time" (OLC Introductory email for new subscribers, Subject: Usage guidelines for OLC-list).

While it is open to discussions of all types, the bulk of the community's correspondence focuses on supporting or encouraging individual members. The supportive atmosphere is something members strive to create as one frequent poster noted:

One thing I really love about this List is that I am totally at home. I have been on other electronic lists which have proved far too intellectual for me and, although the Word has been shared, it was at a level at which I felt unable to contribute. Our aims are basically to love and encourage one another. (Well, that's how things seem to me)! (Email sent to OLC, 29 Oct 1998, Subject: Re: Delurking)

Members are very open about their personal lives. They often give progress reports related to their offline lives in order to gain community support. During the case study one individual chronicled her battle with anorexia for several weeks, giving daily updates of her struggle to eat and not purge. At the same time the story of a member's daughter working in Paris as a model was shared asking for prayer for her.

Unlike the Community of Prophecy (CP), with the OLC it was difficult to identify the list moderator. The only information about the list owner was in the introductory email for new members. The community is more free-form than hierarchical; the moderator steps in only to address technical problems or to remind members of length limits on email posts. The OLC, however, tends to be overseen by a core of frequent posters whose emails and input tend to guide list discussions and the character of the community. The membership averages from 30 to 70 members.

Another unique aspect of the OLC is that the majority of members are visually or otherwise physically impaired, giving them a common bond, physically as well as spiritually. While the community was not created just for blind or deaf Christians, many have gravitated toward this list due to their contact with other blind members. Many use special computer screens or voice activation software to facilitate their online involvement. The freedom from their physical limitations is therefore an important factor for the growth of this community

Interestingly, the fact that many members are visually impaired is not always evident to new subscribers. Indeed, it was after six weeks of lurking and sporadic reading of posts that I learned this, after noticing a discussion thread on training guide dogs and locating Braille resources online. On the internet nobody knows you are blind, physically challenged, male or female. This aspect of the list's identity and the difficulty of distinguishing those who were or were not sighted online was intriguing, adding new meaning to description of the internet as a "blind medium."

The OLC began in early 1990 when the list founder, Stuart from Colorado, first went online through Fidonet, an earlier form of computer networking. On Fidonet he started a BBS "electronic library" for blind people looking for information on software computer resources. A few years after building connections with other blind people online he moved to the internet and began exploring chat rooms. In one particular chat room he met a few other blind

Christians, who together discussed a need to start a new chat room, "an open discussion, kind of support group in a chat room of Christian related topics." This became the first version of the OLC.

A small core of frequent participants formed in the chat room, and they began to talk about starting an email list that offered its members something different. Most Christian discussion lists they had come across focused on theology and doctrine with "more debating going on in them than support." They wanted to create an email list with a supportive environment similar to what they had found in the chat room.

> I thought, let's start one where Christians can just get together and discuss… offer prayer or make prayer requests and then just generally support each other, like a church would. And though we stray from that sometimes, that's what it's been from the very beginning. (Personal Interview in Colorado, September 1999)

Stuart had already started "Blind Exchange," a general information email list for the blind, so he seemed the logical person to establish the new list. In 1995 the OLC mailing list was set up. For the first year the OLC was mostly inactive, with only about 4 or 5 people subscribed. But since then the list has grown, mostly by word of mouth, as membership has stabilized, ranging from 25 to 70 list members. According to Stuart, the list's focus has stayed pretty much the same, as people join for the "encouragement aspect of it and the fellowship, just like a church would be." Due to an increased workload with his own online business, supplying specialized software for blind computer users, in 1999 Stuart turned over the moderator responsibilities to another OLC member. The role of moderator has changed hands several times as the list has evolved over the years, but many of the original core members have remained active. Strong friendships have been formed, and even several marriage partnerships have come out of interaction on the list.

The OLC is an equalizing space for its members where technology frees them from the physical limitations of their sensory impairments. This freedom, along with the deep level of emotional ties demonstrated within the community, were key reasons for studying this group. While it is a small group that frequently uses evangelical language, members come from a cross section of denominations including Pentecostal, Baptist, and Catholic.

Several core members describe the list as "like a church," providing a supportive environment for its members. The founder said his prime motivation for starting the OLC was that he had met numerous people on the internet who didn't go to church but referred to themselves as Christians. Stuart explained:

> Lots of them had bad experiences, had feelings hurt… or become confused about what the church was all about and I thought OLC could help bridge that gap if there was one. That helped people at least realize that there are some oth-

er Christians that experience some of the same thing. (Personal Interview in Colorado, September 1999)

A desire to bridge the gap between disassociated Christians and the church influenced the atmosphere that has emerged. Several members have shared testimonies of the OLC's role in helping them "come back to God" or at least "start looking for a Church again." The OLC fills a need for support and fellowship many members find lacking in their own church experience.

> The list almost runs itself and I am amazed how the Lord has caused the list to grow and to expand into a truly electronic church. (Email sent to OLC, 3 Jun 1998, Subject: watching and reading)

Over the course of three years of observation, interaction, and face to face meeting in the UK and US, I began to see the OLC as a small, committed social support network.

A Social Network

Social support and cohesion were demonstrated in the network of relationships formed by the OLC. Members shared three common traits. First, they identified themselves as Christians speaking openly about their faith and beliefs. Second, most active members identified themselves as having physical limitations, such as blindness or hearing loss. Third, members regularly shared their personal struggles, either by empathetically responding to others' problems, or by sharing their own in order to solicit prayer and encouragement. These common traits created the basis for the network of exchanging and receiving support.

The OLC provides a place of social acceptance; members portray it as a haven where they are not judged on the basis of their disabilities. Members are described as sympathetic Christians who understand the challenges others face. This occurs both through individuals and communal interactions. As one member stated,

> This OLC list is a place of refuge... where I have been nurtured, trimmed and groomed. I have learned to have passions for others, learned how to say prayers... learned to lift up my brothers and sisters in time of needs. In return I get a family, not a fake one, a loving one who accepts me as I am, deaf/blind with faults. (OLC Email Questionnaire Response, 11 Feb 1999)

The social network is created and reinforced as members personally connect with other members' situations or problems. OLC discussion threads often appear like a group counseling session, with members providing advice by

sharing personal stories of overcoming hardship, weaving a communal web of comfort. An example occurred in my second and third weeks of online observations, when a discussion on depression was started by a member, sharing her personal struggles:

> I have something I need to talk about concerning depression and Christianity.... I know I'm opening myself up for criticism here, but please be gentle, because I've had some rough goings with people lately and I don't think I can take much more unkind remarks, but I do want your kind help and advice. (Email sent to OLC, 20 Nov 1998, Subject: depression)

Her honesty was interpreted as a cry for help and understanding that she seemed unable to find in her offline community. She received the following response from another member:

> I want to know if anyone sends you a harsh or unkind message regarding how you feel or anything. That is not what God wants us to do. He wants us to be loving and kind to those who are hurting—And you, my dear Sister in Christ, you are in need of lots and lots of lovings and squeezings. I'll be praying for you.... You are a precious loving one, and we all love you dearly. (Email sent to OLC, 20 Nov 1998, Subject: Re: depression)

Validating each other's struggles and affirming each member's worth are central in the OLC social network. As members come to rely on this validation, the OLC becomes a network to fall back on when times get tough. On three occasions during the case study one infrequent poster sent "good night" wishes to the OLC relating to this:

> I just want to say good night, and to tell all you guys I LOVE YOU VERY MUCH AND I THANK GOD FOR YOU ALL (EACH OF YOU) YOU ALL ARE SO IMPORTANT TO ME, YOU ALL HELP ME MORE THAN YOU WILL EVER KNOW.
> GOOD NIGHT
> I LOVE YOU ALL
> PLEASE DON'T EVER GO AWAY
> (Email sent to OLC, 10 Dec 1998, Subject: Good Night)

Though it seemed she did not know some OLC members intimately or personally, she consistently referred to them as her family and appeared to depend on their fellowship. She stressed this in her emails by frequently using capital letters, equivalent to shouting online, to accentuate the importance she placed on the OLC as a cushion of care.

The social network of the OLC is also maintained through members' prayer support of one another. List founder Stuart described the OLC as a good place to receive prayer, as he often shared prayer needs online.

I've said things on OLC myself, that I've never felt that I should say in my own church.... It's much easier just to type a message out and send it out to a mailing list than it is to stand up in a church and say pray for me, I'm not doing too well right now. (Personal Interview in Colorado, September 1999)

Although he later described the OLC as a "poor substitute" for a real church that can intervene face to face in the lives of its members, online Christian communities often create spaces where members feel freer to share personal needs and receive input. Respondents to an online questionnaire, at the end of eight weeks of recorded observation, unanimously described online prayer as equally effective and meaningful as prayer from a friend or church member. Online Christian fellowship is also unique and valued because it is accessible 24 hours a day. So stated Arthur, a middle-aged man from southeastern England who suffered from degenerative eye disease:

Unfortunately because of the pressures of society the church has lost its 7-days a week ministry, in a lot of areas. And I think that is where the OLC picks up and largely does a tremendous amount of support work in the middle of the week. (Personal Interview in England, April 1999)

The ease of sending email and the ability to stay connected seven days a week are strengths of online communication and community. In the OLC, the internet provided a dynamic network enabling members to form a caring community. This is a social network, focused on providing help and encouragement for its members.

A Support Network

I like the fact that OLC is more of a support group for believers than a place where Christians come to debate and argue, so keep up the good work. (Email sent to OLC, 3 Jun 1998, Subject: watching and reading)

Throughout the case study the OLC took the form of a support group, members giving testimonials of struggles they faced offline and community members rallying around them with encouraging emails. Support, which typically involves posting positive messages or affirmations, is ingrained in the foundations of the OLC as stated in the introductory email to new subscribers, "Be nice to everybody because everybody is having a tough time" (Email sent to new OLC subscribers, From: "L-Soft list server," Subject: Usage guidelines for OLC-L). This relates to the New Testament description of the church as the body of Christ in the Bible: where or when one member hurts, all share the hurt and when one rejoices, all rejoice (1 Cor 12:26). The community promotes affirmative support; correctional advice and criticism are discouraged.

Functioning as a support network means individual problems become the community's problems. Advice flows freely, even though to an outsider it can appear unbalanced. An example occurred in week one of the case study when an OLC member's sister disappeared, not returning home after work. The member emailed the list explaining the situation. "It's a scary thing, and I'd appreciate any prayers or good thoughts" (Email sent to OLC, 15 Nov 1998, Subject: need prayers or good thoughts or whatever). Within an hour the group received a second post reporting the sister had returned home, having gone clubbing without bothering to inform her husband. However, instead of being happy, the member's email expressed in detail resentment toward her sister and family about issues accompanying the incident.

> I am really struggling with some deep family issues regarding how my blindness has affected my role in the family... and the fact that despite some very stupid choices and a lot of spiritual immaturity she is treated more as an adult than I am.... I'm glad that she was safe, but I am very angry about the way she has treated her family today and for so many years. (Email sent to OLC, 15 Nov 1998, Subject: Re: sister is found)

Members rallied around her pain and offered prayer support. Her hurts became the group's hurts, as members made efforts to identify with her feelings. Several even stated that her willingness to share brought her closer to the community. As one member responded,

> Much of what you write is certainly an experience shared by a number of us on the List.... [T]here's only one way through it—and through it you shall go—and that is with God!... Be assured I do understand and you have lots of us out there who care too. It's good to have you with us. (Email sent to OLC, 15 Nov 1998, Subject: Re: sister is found)

As the saga unfolded in the following week, she wrote more about the history of her situation with her family. A fight with her father, partially brought on by advice she received from the OLC, gave more opportunity to express her frustration online. She apologized for sharing such personal details, yet said it was important to her to keep the OLC informed about the progress of the situation, especially because of the prayer members had given her.

> Well, I finally had a bit of a blow-out with my dad this evening.... I talked about how I've spent all these years talking to therapists, friends, anyone but the family because the family didn't listen, and how I am no longer willing to talk to substitute family and allow issues to go untouched in the family.... I apologize if this is too personal for the list, but I wanted to put it in writing and, most of all, to thank those of you who are praying for my family. (Email sent to OLC, 15 Nov 1998, Subject: update on family stuff)

Members once again encouraged and commended her openness in facing the situation. Two members even "congratulated" her for standing up for herself. In affirming her behavior the OLC also affirms the community as a space where personal information should be shared because members can offer advice and comfort.

This situation prompted others to confess personal struggles with their families, claiming blind people commonly experience rejection and misunderstanding from family. The content of many posts transformed the OLC into a self-help or support group. A routine cycle was observed of members sharing personal issues, apologizing for sharing, and then receiving affirmation from the community.

The OLC became a resource for members to validate their feelings and reactions to personal crises, as they heard from individuals in similar situations. The moderator told this struggling member that her family problems were not uncommon for those who are blind. By relating her situation to his history, he gave her affirmation as well as a grim view for potential reconciliation.

> I don't know how many blind people have told me similar stories and my family has been like that for years even though I left home and got married at 19 years of age. I hate to say it, but they are not likely to change. The problem is not your younger sister, nor your parents. It is your blindness that is the root of this situation, so don't feel bad; we, those who are blind, know this type of relationship in the family quite well. (Email sent to OLC, 17 Nov 1998, Subject: Re: sister is found)

Responses like this promote the OLC as a place where members will find empathy and understanding, while implying offline relationships with sighted family members or friends will continue to be disappointing. Connecting with the pain of another list member reinforces an inward focus within the group, as the only ones who truly understand.

The question could be asked whether the OLC is overly supportive of its members' behavior, especially since they only know selective information about any individual. It is likely the OLC would counter this argument by stating that the community is simply displaying Christian love, which should be "blind" and accepting of others. OLC members are quick to praise one another; they give testimonies of how email input has benefited them and helped sustain the community as a support network. Members depend on the OLC as a source of advice in their daily lives, relying on others because they share common attributes and beliefs.

The support narrative allows members to see this community as a place offering acceptance and care to members in ways they often say are unavailable

to them offline. Karen, a middle-aged woman who was born blind and is a frequent poster on the OLC, commented:

> I think OLC's strength and why a lot of blind Christians go to OLC is that there is there a community who not only cares but understands what blind Christians in particular are going through.... I don't know that a local church could do any better. (Personal Interview in London, May 1999)

The "support network" definition characterizes the online community as existing to provide a spiritually and emotionally supportive atmosphere, emphasizing transparency and disclosure in its membership. These communities use the network as a support structure facilitating personal and spiritual growth for its members.

The Anglican Communion Online

> I've come to see the face of Christ in all the list sibs... even though it's sometimes been difficult to do so. (Personal Interview in St. Joseph, Michigan, August 1999)

The Anglican Communion Online (AC) was introduced in the preface. Their informational website describes this email list as a "cyberparish," which has been running, in one form or another, for more than fifteen years.

> This CYBERPARISH (sometimes called the ANGLICAN COMMUNION ONLINE mailing list) is, in rather formal language, a forum for discussion of matters of interest in the churches of the Anglican Communion, such as the Episcopal Church in the USA, the Church of England [and the communicants of AC, i.e., drivel, accomplishments of sons and daughters, prayer requests, rants, raves, etc., i.e., things of interest to the people that make up this very real and very human community][20]

As the first two case studies were from communities with predominantly evangelical and charismatic leanings, it was determined that a third case study from the Anglo-Catholic tradition would broaden the scope of this research. This "cyberparish" not only sustains discussion, but members also provide prayer and share sermons with one another. *Christian Century* magazine described the AC as one of the "best places" to see a community of Christ on the Web, stating, "you'll see Christian community—warts, halos and all—alive and at work" (Keene, 1999). The list generates large volumes of postings each day, around 75 to 100, which some new subscribers find a bit overwhelming. One member posts a monthly list of the top fifty posters to the list, and for some

making the list is a point of pride. Yet it maintains a fairly consistent membership of between 400 and 500 members.

The list began around 1988, initially as a handful of people interested in the Episcopal church. They attempted to create a Catholic and Anglican newsgroup on Usenet, but failed to receive approval. Initial participants were recruited from Usenet by one of the founding list members. The AC began as an informational email service, providing news of the Episcopal church, sent out periodically, from weekly to monthly. After a year the list format changed and the Episcopal mailing list was born. List traffic steadily increased to the point where the software could not keep up with demand, so it was moved to a new listserve, American.edu. Because this software had a limit of eight characters for list titles, its name was changed to Anglican, reflecting the growing worldwide participation and membership.

AC members demonstrate a high level of technological literacy. One core AC member works for IBM, and was involved in early research and networking efforts related to the development of the internet and helped in establishing email and discussion list protocols. He was also key in the creation of the original Anglican list. Another core list member recruited her husband, a computer analyst and manager, for the early technical administration of this list. He now serves as official list owner. When the list again had to move to a different server in the late 1990s, a number of members contributed financially to the purchase of the new server specifically for the Anglican list. For a time it lived at the list owner's house in Georgia until it moved to his office to take advantage of a faster connection, where it remains. The AC has a core membership of people who have been part of the list for five years or more. It also maintains a steady influx of new and changing subscribers at any given time, as well as members who come and go as their lives dictate.

Online discussions range from scholarly to the casual. During my first week of observing the list, I saw posts on topics ranging from homosexuality in the church, baseball, use of the f-word, and the education level of Episcopal bishops. Some of the common themes are debate, drivel, humor, personal reflection, and prayer. Debate threads deal with issues of church politics and liturgy to contentious issues such as the ordination of women and homosexuality, which emerge in regular cycles. The AC values tolerance, allowing members of differing views to respectfully vocalize opposing opinions. Yet debates often take on a life of their own and evolve, as illustrated in one week when a thread called "It's the guns!" on school violence turned into arguments on abortion and evolution. Serious posts often evolve into "drivel," or humorous posts and puns. This illustrates the community's creativity as members link lighthearted stories to their beliefs. Drivel and humorous threads highlight AC members' desire to have fun together.

Members also use the list to post "dear diary" style entries, personal reflections offering written accounts of their offline lives. These are not intended to start a discussion or even to solicit comments; rather they appear as attempts by members to offer personal insights with the AC. These can be serious and contemplative, such as in week two when a longtime member posted a commentary on returning to his former parish for the funeral of a good friend, or humorous, as a new member posted an account of trying to corral a hamster. Another feature of the AC is a weekly email sent to the list in the form of a liturgical prayer, encompassing all the prayer requests shared by members that week. In general this list is a place where

> We pray, we share our joys and sorrows and we openly discuss all aspects of our faith, remembering in many matters people may legitimately hold diverse views. (Taken from the AC website)

The AC also goes by the name of St. Sam's, referring to the "unofficial patron saint" of those who use a keyboard and the list. St. Sam was an American bishop and missionary to China who typed the Bible into Mandarin using one hand because of physical limitations. The AC community has a motto, "via media via modem,"[21] and a logo in which the motto encircles the top of a crosier staff, signifying that through the internet they connect and through the church they are a community.

The AC is run by group consensus; the list moderator and owner serves as a technical consultant, not directly monitoring discussion topics. In week four of the case study, problems arose when an impatient new subscriber attempted to unsubscribe from the list. The list owner's response to the inquiry reveals that he leaves the AC to run on its own, trusting members to regulate the community:

> I don't follow all the threads, and sometimes I'm traveling for a week or more at a time. I may skim over the topics when I get back. I have a bunch of other lists I'm on that are either work related or trade association related.... I get around 2500 emails a day over eight mailboxes.... I just skim the subjects of 99% of which I read maybe 10%. (Email sent to AC, 17 Jun 1999, Subject: Re: pleplease [sic] cancel subscription)

Like many email communities, the AC is dominated by a core of frequent posters. This group can be identified through the monthly tally. While the list is not exclusive and readily welcomes new subscribers, it is evident that "old-timers" set the behavior expectations and regulate discussions.

When I first "delurked" on the list after obtaining permission from the list owner to study the group, a welcome post clearly described how members see the AC:

Two things strike me about this cyberparish: First, I have made some delightful friends on this list all over the world. I've corresponded privately with about a dozen and have spoken with one on the phone and met several others in one of our local get-togethers. I really love (most) of the folks on the list! Second, it's very difficult to leave the list. I've left twice over frustration (we run cycles where the same threads get hashed out over and over again when new folks come on board...) and once because the volume of mail simply became overwhelming. Since I joined 2-1/2 years ago I've left three times and the longest time away was about three weeks. I've always rejoined because I miss the people, I miss the banter, I miss learning new things and I miss what's happening in the lives of my listmates!

Realize I am no reclusive, shy Anglican who uses his 'puter for socialization. I have a real job, a family, golf way too much, and serve on the vestry of my parish. (Email sent to AC, 26 May 1999, Subject: Web page and the AC)

This post highlights two features of the AC: the high level of commitment by members to online interaction, and the face-to-face meetings. A "listmeet" is said to occur whenever three or more list sibs gather in person. These are often described in great detail in emails. The opportunity to participate or organize a listmeet is highly valued by the group and encouraged, as is illustrated by the Great Toronto Listmeet. Their website houses a "kiosk," archiving photos from these various gatherings.

A Social Network

While much of the AC's energy is spent in debates and detailed discussions, in interview and questionnaire responses members articulated that it was the network of relationships the list facilitated with fellow Anglicans that kept them attached to the group. Again the internet was affirmed as a social network, creating a public space where social connections could be made with like-minded people. Online social networks allow members to receive care and support from others in the network, building on common experiences and beliefs. These ties were characterized by some AC members as stronger than their connections to their offline Christian community.

Different explanations and justification were given for this. Sally, a female Anglican ordinand in New York, said it was the opportunity to publicly share "God stories" that made this community unique. God stories, she explained, are accounts "people write about an experience that they've just had where they really feel God was in it." When members open up their spiritual and emotional lives online through these stories, a "personal element of caring" about one another grows. Sally began to post her own God stories while in seminary, and received many personal responses from members, which gave her "a sense of people really caring about me." She described one instance that

occurred while she was doing chaplaincy training at a hospice. This was a very stressful experience where she found herself alone much of the time:

> I had my heart broken about ten times a week and it was very holy. It was my online people I could talk to about that. My best friend (back in NY) didn't really understand it.... But online, I could tell people about how holy it was and how important it was and about how heartbreaking it was and people understood. And people would write back and say.... "that was really wonderful" or "I could see God in that story" or whatever. (Personal Interview in New York, September 1999)

As a seminarian training for the priesthood, Sally found this support invaluable. Many AC members reported that some of their deepest friendships were founded online, after having contact with other AC members over several years and strengthening these bonds of friendship through personal email, phone conversations, and face-to-face meetings.

Online communities often demonstrate high levels of care and concern for their members in need. Members often used online contact to offer support. When a member failed to respond to encouragement emails in a timely fashion, after earlier expressing a need or struggle, others often became concerned. In one case an AC member desperately tried to contact another without success. Finally she emailed the entire list. This showed the extent to which people cared for their online friends and that many online relationships are not limited to only online contact.

> INQUIRY: 3 notes (1 public 2 private) and no response—I'm really worried about you. Just in case you didn't get them I'll recount the main points
> 1) My mother says she'll drive me over to see you anytime. So just let us know....
> 2) If you want to speak by phone I'd be happy to talk for a quick or long time... (on private note I gave my #) Please sweetheart let me/us know you are still with us— Please! (Email sent to AC, 20 Jun 1999, Subject: Hey Madge!!! You there???)

> RESPONSE: well, i have been making it out—only in the wee hours of the morning (like 2 and 3 a.m.) to the grocery store when there are no crowds or traffic to deal with. i suppose that's a small step.... Thank God for my community here at AC—i don't know what i would do without all of you! (Email sent to AC, 22 Jun 1999, Subject: agoraphobia—a step in the right direction!)

Being able to demonstrate care is important within the AC. As in the previous case studies, all questionnaire respondents felt their lives would be different in one degree or another if they did not have access to email or the internet. Many indicated their lives would be "less rich" in relationships, saying that without email they would have less contact with family or friends. The AC was characterized as a good place to develop supportive friendships. One questionnaire respondent explained:

Last fall my husband of 22 years abruptly left. Although I have friends locally, the email community has been a marvelous support. At some particularly difficult moments their prayers and companionship have been a lifeline. (AC Email Questionnaire Response, 23 Aug 1999)

The ability to be transparent about personal struggles is an important part of the AC social network. During the observation period one member of the AC posted a commentary on returning to his former parish to attend the funeral of a good friend. This post demonstrates the depth of emotion members share.

It was my first time back in my erstwhile beloved parish in four years or so.... To be in that building again with those people—once a source of great strength and inspiration, later a place of great pain—was very confusing. I said I would never re-enter that place. I did it because Karen was my choir partner and neighbor and it was she who first brought me there. Thanks for all those who said a prayer. I still don't know what to feel, although it was very clear to me yesterday that the ghost of the former rector is not so present these days. (Email sent to AC, 30 May 1999, Subject: Jane's funeral)

His personal reflection is as much about expressing his struggles with church as it is about grieving for a friend. Many members expressed such transparency and vulnerability in their posts.

At the Toronto listmeet many openly said they valued and even to an extent defined themselves by being part of the AC. One member, Terry, became emotional while expressing this over brunch on the second day:

The AC at its best is about recognizing God in the group and in each other. What keeps us together is that mystical element, of it being something bigger than ourselves. (Personal Interview in Toronto, Great Anglican Listmeet, September 1999)

He described the listmeet as "one of the highlights of my life" because the AC had assisted him in identifying God in others and in living out his Christian commitment. The AC is seen as a community where members find understanding because of their shared Anglican connection and their long-term investment in each other's lives.

A Religious Identity Network

Because I'm a member of the ministerial staff where I worship, I need to maintain boundaries around my personal life in front of congregants. On the AC I can be much more vulnerable.... it gives me an Anglican community when my work schedule in the local PCUSA congregation precludes substantive involvement. (AC Email Questionnaire Response, 30 Aug 1999)

The AC is a community gathered around Anglicanism; their shared faith tradition and practice is central to the group. While some online communities gather around a single discussion topic, the AC rallies around their common bond with the Anglican Communion. One member said in a face to face interview that it was the shared Anglican connection that cemented the group. In her opinion, the AC connects members to the larger Anglican Communion, helping people understand how different parts of the church function. The AC, she insisted, can help people "who don't understand church structure at all. It's a wonderful way to begin to understand how the parts and pieces of the church fit together" (Personal interview in Michigan, August 1999).

The AC's communal narrative as an Anglican network provides a mutual religious identity. While a few members come from Catholic and Orthodox traditions, the overwhelming majority attend Anglican churches. Members are committed to their local churches; of the 38 questionnaire respondents, 32 indicated that they were actively involved in local parishes, with a large number being chalice bearers, lay readers, or Sunday school teachers. A number of AC members hold clergy or church leadership roles. For most members, the AC is identified as a complement or supplement to the local church; out of 38 questionnaire respondents, 26 affirmed this. One member used the phrase "companion parish" to describe the AC's role as it enabled her to connect with the offline church online. Several cited connections to the Anglican Communion as an important addition the internet had brought to their lives, stressing that they would "know less what others think, and have less information about the church" if it weren't for their membership in the AC.

As an Anglican network the AC becomes a bridge to the Anglican church. In an interview Gail, a recent seminary graduate who works for a local Presbyterian church in the southern US, said she prefers to worship at a local Episcopalian church when she has a Sunday off. For her the AC is "a kind of pseudo worshipping community" where she feels "interconnected sacramentally" to other Anglicans.[22] Being able to share fellowship with those who enjoy a similar worship style, and staying informed about church news "really does help me maintain my sort of Anglican identity," she claimed (Personal Interview in Virginia, July 1999). Thus for her and other AC members the AC helps build and support a particular religious identity.

Commitment to Anglican worship and liturgy also came up in drivel postings. One example occurred in a thread about Trinity Sunday, where a member shared how her local parish serves Neapolitan ice cream sundaes in honor of the day. This started a discussion on the potential heresy of using three separate flavors of ice cream. After numerous posts the verdict was that separate scoops would be comparable to polytheism or "Poly-icecreamism" (Email sent to AC, 31 May 1999, Subject: RE: Heresy!). Threads like these show

members take their links with Anglicanism seriously, and not-so-seriously, as Anglican beliefs direct their online discussions as well as their offline choice of worship style.

The AC enjoys debating and grappling with Anglican theology and church politics. Members' theological perspectives are as diverse as the personalities on the list. This diversity was illustrated through a discussion on the inerrancy of scripture. One member responded in shock that another took the story of the fall in Genesis literally, commenting "Holy Moses! I do so hope we are beyond believing in the inerrancy of the Bible" (Email sent to AC, 31 May 1999, Subject: RE: Natural Sex [Was: For Joan]). Several members responded that diversity of opinion on church-related issues was a trademark of the AC:

> Welcome to the AC! This is precisely the issue in most of the posts. We all read our Bible differently, as though we each had on a different pair of glasses. Further, we all have glasses that differ from those of the early Church Fathers, the Protestants of the Reformation, those of the present church Earldom in the AC Parish. I don't like the idea of Cafeteria Christianity, but when I am really honest with myself, I recognize that it is unavoidable. And all the nit-picking and word-slinging on AC helps me discern that Truth. (Email sent to AC, 31 May 1999, Subject: Re: Natural Sex [Was: For Joan])

Members of the AC seem to appreciate clearly articulated convictions and well-substantiated arguments. While they hold similar desires for shared conversation on Anglican topics, they often join the list with different agendas. In order to maintain a civil atmosphere, toleration is emphasized by the list leaders. Several members, such as Helen, an elderly librarian from Michigan, articulated that tolerance is a core value for Anglicans.

> The Anglican Communion is bigger than we are and… if you are an Anglican who is going to be unhappy because somebody disagrees with you someplace or holds to something you don't want to hold to, the Anglican Church is probably the wrong place for you anyway. Because it just isn't a church where everybody agrees and I guess if you find that out online it's a healthy thing. (Personal Interview in St. Joseph, Michigan, August 1999)

Interactions on the AC are not always friendly; they can be heated and hostile. During the participant-observation phase a set of "rules" emerged to cope with emotional debates, such as abortion. Loosely evolving from Robert's Rules of Order, unique to the AC, the "Jones rule" was used to close threads on issues of misquotation. The "Hitler rule" was used to end a discussion that turned nasty or that quoted untruths, clarified by one member as, "If one is going to tell a lie, tell a big one" (Email sent to AC, 24 Jun 1999, Subject: Re: P.S. Stanton on Spong). Rules were used to intervene in discussions that had

become virtual shouting matches. They also provided social stability by redirecting discussion to more relationally neutral topics.

Some members become frustrated by these cycles of debate, while others thrive on them. When harassed members send posts trying to terminate a debate, often someone responds, "If you don't like it, DELETE!" Diversity of belief is both tolerated and supported by the community. The AC's connection with the offline Anglican Communion provides social cement that keeps the community together. While members join with different agendas, most stay because they develop personal relationships with others and deeper understanding of the Anglican church. Members of the AC are committed to each other through their shared faith and allegiance to Anglicanism.

The Anglican network narrative enabled individuals to see their online involvement as an opportunity to be "interconnected sacramentally" with others from the Anglican tradition. The "religious identity network" model characterizes the online community as a group committed to one another through their shared faith and chosen liturgical expression or religious tradition. Identity comes from reinforcing a particular set of beliefs or rituals that are transported online. Members encouraged one another in their shared convictions and supported this unifying narrative through supportive discussion on their choice of religious identification. This also relates to the model of internet as "common mental geography," which uses the network to promote a sense of shared identity.

In this chapter we have been introduced to three Christian email communities. Each email list functions and defines itself as a form of community—a learning community, support group, and cyberparish—which functions as a social network. Though organization, style, and social boundaries differ between these communities, all construct webs of social ties that are loose, flexible, and decentralized. Each email list also presents a unique story or narrative providing a snapshot of the history, motivation, and practices of different expressions of online religious community. These narratives encapsulate the core self of each community, or how each saw itself and related to the larger Christian community and narrative.

The Community of Prophecy as a "spiritual network" uses the internet to cultivate personal spiritual experiences toward a common vision. The community describes the internet as a space shaped by God for holy purposes. Community connections are seen as designed by God, internationally diverse and creating an overlapping network of the online and offline Christian community of the spirit. As "pioneers" on a divine mission, members felt that connection with the community would lead to opportunities for ministry and involvement in the lives of others and the global church. Members also characterize the group as involved in "warfare" against an enemy seeking to

sabotage the community's potential and destiny. The spiritual network creates both a focus on members' personal development and a communal outward or missionary thrust.

The Online Church as a "support network" characterizes its list as a support group, where an individual's problems become the community's problems. Here the internet is used to cultivate relational support, which involved posting affirmative messages for those who shared problems. Parallels are drawn between the group and the biblical Pauline description of the church as the body of Christ: when one member hurts, all share the hurt, and when one rejoices, all rejoice. Members are encouraged to discuss their struggles online, where they will find empathy and understanding which may be lacking from offline friends and family. Correction and criticism are discouraged. Many members share common physical limitations which helps them bond with one another in empathy.

The Anglican Communion Online can also be characterized as a "religious identity network," used to create and strengthen ties to Anglicanism. The internet facilitates discussion on a specific theology and style of worship, demonstrating member commitment to the beliefs and practices of the Anglican church. Building this communal identity links members to the Anglican Communion, as a microcosm or an expression of something larger than themselves. One member described this Anglican connection as "a real core of what we believe in and the church that we love." Members strive to affirm their involvement and connection to the Anglican Communion by discussing key issues and helping others understand how different parts of the church function. While members often join the community to gain a better understanding of the Anglican church, they typically stay because of relationships they form with others who share their religious identity.

Each narrative informs and guides community members' participation, including how they deal with crises and maintain a corporate identity. These snapshots provide a guide for more fully evaluating how online communities negotiate identity through online engagement and use of technology. In the chapters that follow, common themes within each community are presented under the categories of technological use, online-offline connection, and perception of offline church. This moves us toward a redefinition of religious community grounded in the experience of community online.

Communicating Online:
Creating Community Through Email

While the internet offers many options for communication and information gathering, emailing still remains the most popular activity among users. The Pew Internet and American Life project has consistently found email to be the favorite online pursuit, with nine out of ten online Americans having sent or received email and over 100 million logging on each day to access email (Madden, 2003). Whether it is work related, seeking information, or communicating with friends and family, email has become the dominant way people interact online.

The popularity of email is linked to several factors. Partially it is the increasing ease of access for many people to email, through the global proliferation of the internet. Email offers the ability to transcend geographic barriers and time limitations. The instantaneous nature of online communication also makes it appealing. Using email has become a way for people to sustain and maintain their traditional relationships with co-workers, friends, and family. Yet what is of more interest to this study is how email is being used to construct new social networks. What happens when a group of unknown, faceless email users find each other and form a community is the focus of this chapter. We will also consider how online communication and the context of the internet shape the character and patterns of these relationships.

Let us return briefly to the Great Toronto Listmeet. In the early morning hours at an outdoor pub, while conversations flitted from theology of the sacraments to gossip about absent list sibs, a digital camera and two laptops emerged. Two members began taking digital pictures and downloading the shots onto a computer so they could be put on the list's web page. Another

started a "round-robin" email, passing the laptop around the tables so members present could post their thoughts and descriptions of the evening's events, as part of a group email to be sent to the entire list. Amidst this embodied gathering, attention was drawn back to the online context.

```
=========================================
```
Date: Mon, 27 Sep 1999
To: ALC@list.ALC.org>
Subject: you are there: Toronto Listmeet

HERE IS HOW WE WERE LAST NIGHT!!!
dearest ones not here, wherever else ye may be if it isn't Toronto:

Mary here:
Well, here a lot of us are—at the Duke of York Pub Place. We had a WONDERFUL service at Church of the Redeemer. I was extremely loud, Steve was extremely wonderful ensconced in the organ pit, somewhat far away from us all—but he conquered. Mark preached a lovely sermon—he spoke about the Anglican List, about our patron saint—and other godly thangs.... Everyone is just as you would imagine them to be.

I'm going to pass the computer around until the batteries die. Miss you all... but WOW a lot of "ya" (= Us) are here.
```
======
```
James here—turns out Man Called Darling is not a cyberfiction—he does exist! Also turns out, I really cannot sing. I always thought so and it's nice to have it confirmed.
```
======
```
Linda H here—not the other Linda—who is real kewl person and not cyberfiction either—it is so wonderful to have everyone here—but boy are we loud when we all get in one room!! Especially all those introverted types. <g>—must get back to the party—James is showing Liz's photos from today on his laptop and the waiter wants advice on internet connections. (I'll do anything for a cute young man—shut up Karen!)
```
==========
```
Greetings from Ina to all of you in cyberspace.
Enough prayers got sent up for you to make you levitate. Somebody was actin' up in church. I know it wasn't me, heh, heh. All the snakebellies here choked on holy smoke, and Mark preached a good one! Wish you were here—peace and love and all that jazz.
```
==========
```
(Extracts from email posted to AC the day after the Great Anglican Listmeet in Toronto)

Members of the Anglican Communion Online had come to Toronto in order to get "some face time with each other," as several commented. Yet while these self-described introverts seemed to thrive at the opportunity to meet and talk with one another, there was also a definite sense that this was only a partial expression of their community. Members present wanted to share these face-to-face moments with the greater community. Email had brought them

together initially, and email became a way to network the group, even during this gathering. The internet shaped both their conversation and conception of being in community.

Email and the internet provide powerful tools for forming and sustaining relationships, shaping the character of community formed online. This chapter examines how these three Christian email communities use the internet and adapt to the online environment. How email influences each community's method and style of communication is evaluated, with unique aspects of social interaction and online communication being highlighted. Other issues such as language usage, perceptions of the body online, anonymity or hidden identities, and dealing with "antisocial online behavior" are also addressed.

Appeal of Email

Within the three online communities studied, three common explanations emerged as to why many of the users found email so appealing. These related to the character of the medium, the lifestyles of the members, and their perception of email as an honest form of communication.

It's the Email

The findings of the email questionnaires showed that members of the three email communities spent on average 12 hours a week using email, with the majority of that time being spent on correspondence and communicating with others. While they overwhelmingly described the internet as a tool (rather than a friend, business object, or entertainment source) it was seen predominantly as a tool for communication. Email was used in "building relationships."[23]

There are many qualities that make email a popular form of communication, such as easy access and fast responses, as mentioned above. Overall the question "Do you 'talk' or communicate with people differently online compared with 'real life'?" solicited a split yes/no response on the questionnaire. Those who said yes clarified their responses in several ways. A dominant reaction was that email encourages concise and frequent communication. About half of the Community of Prophecy (CP) questionnaire respondents described email as "briefer, more direct" in its style than other forms of communication. Yet email also allowed people more time to reflect and construct responses. As Howard, an accountant and CP member from England, commented in an offline interview,

> The big advantage I find is that you can take time out to think without being required to give a reaction to something. So if somebody asks you a pointed question... it gives you time to count to ten without having to

respond. I find that very useful. (Personal Interview in Devon, England, July 1998)

Other online community members highlighted different factors concerning the appeal of email. Members who lacked physical, geographic proximity to other Christians especially valued online fellowship. Many depended on email, saying otherwise their contact with like-minded believers would be severely limited. Several, such as a mother from the western US, commented on this:

> Living in a rural area, as well as being a housewife, tends to make me feel isolated sometimes. I love the fact that I can log on and share with people I would never have had the opportunity of meeting otherwise. (CP Email Questionnaire Response, 28 Mar 1998)

In the case of the Online Church (OLC), email allowed members to feel empowered. Their limitations in sight or oral communication could be bridged through computer and internet access, using special equipment. One member, Arthur, who had a condition called Retinitis Pigmentosa, which limited his eyesight to a tunnel of only 3 percent of the normal sight window, had a special magnifying screen enabling him to work with a standard computer. By enlarging character point size and adjusting computer screen colors he was able to read email in a way he could not read a standard book or write a letter. Another member, who was born blind, used a Braille keyboard and voice recognition software, which allowed her to communicate online and to work as a secretary. She encouraged other blind people to get online because "many of the books that are out there just have never been available to us, so we can get access to things that we have never been able to get before."

Email enabled OLC members to express themselves more easily not just in practical but in personal ways. Many felt more free online, knowing they would not immediately be judged on the basis of their looks or abilities. One member said online "you don't know someone's blind unless somebody says it on a mailing list," so people can get to know others without preconceived notions about them. The fact that certain aspects of individuals can be hidden online is an advantage, giving people an opportunity to associate with those they might shy away from in real life.

One OLC member, who is wheelchair-bound and legally blind, finds the internet a vital tie for her to the outside world. "I am unable to do much else other than watch TV, listen to the radio or tapes from 'Recordings for the Blind.' This way I hear often from my daughter in Georgia, sister and friends in Illinois, cousins in Oklahoma and Montana. I am not as lonely" (OLC Email Questionnaire Response, 12 Feb 1999). The internet extends members' abilities and options for communication.

Others explained that they found it easier to communicate in writing than in person. One member of the Anglican Communion Online (AC) stated in an interview, "Online I can think through and polish what I say, so that I probably communicate better online than in real life." Another AC member described this as the revival of the well-written letter. For him, written communication is important in forming relationships.

> For somebody to sit down and write something and put some thought into it is so precious.... to write five or six sincere paragraphs on the internet, it takes time. You can't just compose something that quickly and have it mean something to someone.... To develop a relationship with someone online like that is really special because you know that the connection is made. (Personal Interview in Missouri, September 1999)

Email is a desirable tool for communication both because of its form and the style of communication it solicits. Email promotes a particular type of communication, one that is short and direct, yet it also offers the option of slow reflection. It offers new options and builds bridges for those with specific limitations inhibiting their communication skills. Email also offers new opportunities for those who prefer written communication.

It's the Lifestyle

The appeal of email can also be linked to the life choices and situations of certain users. Take for instance the situations of three members.

Charlotte is a housewife in Illinois. She became part of the Community of Prophecy (CP) about a year before the case study began, when a friend forwarded her a prophecy from the CP moderator. She contacted the moderator personally to find out where the post originated and then signed up for the group. Claiming to live in a "geek home," she was introduced to the internet through her web-designer son and engineer husband. At that time she had severe environmental allergies that prevented her from reading magazines and newspapers, due to reactions to the ink and paper. Forced to stay indoors most of the time, she found various magazines online to read. She became involved in several online groups, which opened a new social dimension for her. Email, especially, became a tool to make friends and "talk" to other people. Charlotte demonstrates how email allows her to overcome traditional gender boundaries and transcend physical limitations to gain access to information and people

Rick is a member of the OLC who lives in Missouri with his wife and two children. At the time of his interview he was unemployed due to his disabilities, being partially deaf and blind. He acquired his first computer in December 1996, and soon got email and found his way into chat rooms,

wanting to socialize with others who were deaf or blind. Through a chat room he met someone who introduced him to the OLC, and he has now been a member for over four years. In the "real world" he often struggles to understand conversations taking place around him. Because he reads lips he has to focus on a person's mouth, so rarely is able to make direct eye contact with people. This has caused him difficulty and frustration in the past when he has tried to participate in church activities with others who "don't know what to do to communicate with me." Because email uses written rather than spoken communication, Rick can connect more easily with members of his "electronic church." Email has provided him a new communication bridge.

Jonathan is a critical care nurse from Missouri. He was introduced to the internet about eight years ago by a co-worker and came across the AC while looking for sites on theology and philosophy. He joined to learn more about the Anglican church and stayed for the friendships he made on the AC. "If somebody 600 miles away is going to spend that much time developing a relationship with somebody then I think its worthy." The internet has become part of Jonathan's lifestyle. He has a routine of checking his email first thing in the morning, after getting off the late shift he works at the hospital, and again at least twice during the day. Because he sleeps during the day, email allows him to remain in contact with his friends during "unsociable" hours. While some may see computers as something used for entertainment, and the internet for people who "have got a lot of time on their hands," he sees them as important communication tools. Email provides Jonathan the opportunity to communicate socially in ways that work well with his schedule.

These three individuals use the internet for similar reasons. Whether motivated by physical limitations or time constraints, each found that email meets an articulated need for contact and communication with people. Involvement in an email community can provide a significant social outlet to users, especially for those desiring Christian fellowship. Over half of the questionnaire respondents stated that without the internet their lives would be limited in terms of friendship or social interaction.

In some cases, preference for online communication was attributed not just to personal circumstances, but limited relationships offline. One AC member said in his questionnaire response that he has minimal Christian interaction because his wife does not go to church and his work schedule does not allow him much time to interact socially. Without email, he asserted, "I would go crazy very quickly. I am completely dependent on this communication in order to feel socialized." Another AC member said the email community fulfills her need to meet socially with lots of other people:

> I am a raging extrovert married to a raging introvert. My idea of entertaining is that it would be open house at our house all the time. His idea is two other people plus us. The cyberworld has allowed me to have hundreds of people over to our house without making him uncomfortable. I appreciate that—It has helped us stay happily married. (AC Email Questionnaire Response, 28 Jul 1999)

Personality styles may also determine who thrives in the online environment. Self-professed introverts often state that they prefer written to oral communication, because it allows them to respond on their own terms and in their own time. Several members claimed that a high percentage of participants in the AC list were introverts. As one member asserted, "I am alternately shy and verbally klutzy, while I swim in writing like a porpoise. (BTW, 75% of AC members turn out to be introverted on the Myers-Briggs scale—introverts tend to prefer writing to talking)" (AC Email Questionnaire Response, 28 Jul 1999). While the high number of introverts in the AC could not be verified, it seemed to be a common belief held by many members. During the Toronto Listmeet dinner this topic was raised when one member stood up and said, "For a bunch of introverts, you guys sure make a lot of noise." This remark was greeted by laughter. An impromptu survey revealed that 34 of the 36 people present had high "I" (introvert) scores on the Myers-Briggs scale.

The affinity of AC members to written communication, feeling more confident expressing themselves textually rather than orally, may not only be about their disposition to introversion. It could also be linked to their preference to Anglican style of liturgy, which is typically textually dependent. In any case, email is notably desirable for the freedom and opportunities it affords to its users. It provides new possibilities for those who face the constraints of work schedules, disabilities, fears, or offline relationships.

It's the Honesty

In all three email communities many questionnaire respondents indicated that they could be more open, honest, or direct online. This openness meant sharing intimate details of their lives with the email list. Their willingness to be vulnerable was partly because of the anonymity they felt online. As one OLC member stated, "I share more personal things with people I barely know online, where in real life I don't share intimate personal things with just casual acquaintances" (OLC Email Questionnaire Response, 15 Feb 1999). Some individuals said it was the character and structure of email that encouraged a purer form of communication. Rick, from the OLC list, believes the internet allows people to judge one another on the basis of what they write and not how they look. Through email you "see the spirit of the person" and not their limitations.

> I think that every church should have a chat room, where people can hide them-
> selves and ask a question about Bible stuff, and don't have to be embarrassed. If
> I sign on as "readyforjesus" you don't know who I am, you just see the spirit of
> Rick. You don't see that deaf-blind guy that comes to your church, who is asking
> those old questions, where you can release judgement. (Personal Interview in St.
> Louis, Missouri, September 1999)

The assumption that email possesses a unique ability to facilitate trusting relationships is based on the perceived nature of internet technology. Email communication is seen as "oddly transparent," allowing "the soul to shine through." This requires users to trust not only the people they communicate with but the medium itself, "but if you do, personalities really do shine through" (AC Email Questionnaire Response, 28 Jul 1999). This also seems to challenge some literature that claims the anonymity of online communication—which is asynchronous and encourages quick, brief responses—facilitates superficial interaction and distorts the true identity of users (Kraut et al., 1998; Kraut 1998).

Here email is described as an "honest" form of communication, facilitating genuine relationships. This was expressed by a CP member in an email posted after the first online school. Email has become a tool to build a transparent community.

> In this "congregation" we can't hide much. We don't stay isolated in our bubbles
> with our own burdens and struggles. We get stripped of our masks (they don't
> work well by email). Although we are from all over the world, all different from
> each other, our distinctiveness from each other has lost its separateness.... Can
> anything else live this out more than an email "congregation" where we know
> nothing about each other than the common bond of Christ—the bond of LOVE?
> (Email sent to CP, 24 Mar 1998, Subject: school feedback)

Email, it is claimed, causes people to be "stripped of our masks," thus hinting it facilitates genuine community. This member also asserts that online community dislodges members from self-absorption as email prevents people from becoming "isolated in our bubbles." Email is thus seen to encourage a supportive, honest community. Questionnaire respondents (22 of 30) backed this claim when they affirmed that they could have the same degree of honesty and trust online as offline, even with the absence of social cues and the ability to be anonymous. Email is seen to free people to be more honest. One member wrote, "the online medium makes it easier to be open and honest, because any negative body language is done away with" (CP Email Questionnaire Response, 1 Apr 1998). Email allows people to share things that they would have difficulty expressing face-to-face.

High levels of trust and honesty attributed to online communication can sometimes follow disappointing experiences with an offline community or

church. Negative experience offline can encourage members to go online in search of Christians they feel they can trust. One AC questionnaire respondent stated, "I have to say that I do not find a lot of honesty and trust in my present in-the-flesh congregation. I guess some of my online searching for community goes towards compensating for this lack" (AC Email Questionnaire Response, 29 Jul 1999). Based on the premise that it is creating a free and honest communication, email can produce a feeling of acceptance in an online community. As one "introvert" stated in the questionnaire,

> I've found here a place where I can ask questions and share some longings that I've never been able to before.... In fact, as I am able to share some of these things in this safe place, I hope I'll eventually feel freer to discuss them face-to-face with other people, especially people at my own church. (AC Email Questionnaire Response, 23 Aug 1999)

When self-disclosure online is treated with respect, the internet is confirmed as a supportive environment. When this is combined with a member's negative experience of local church, it can reinforce the idea that email is the safer medium for communication and the formation of relationships.

Using Email to Visualize the Invisible

While several of the factors that make email appealing for building community have been highlighted here, evidence also showed that for many it was still an "incomplete" form of communication. Email was described as a "disembodied communication," a mediated form of contact forcing users to interact indirectly with others. The absence of the body produced challenges for members of the email communities. As described in chapter one, online people interact with a "word-body construct," where people become characterized as texts. Email texts lack key nonverbal nuances important for communicating emotion. In order to visualize the invisible online, people construct their texts in unique ways that attempt to bridge this gap. While most questionnaire respondents characterize their computers as a tools for correspondence, many emphasize that more than simply information is exchanged online. Care, affection, and aspects of user's personality are written into email by using different communication strategies and devices such as emoticons, cyberhugs, and anthropomorphizing the computer.

Emoticons

Those who desire deeper connection with others online often try to transcend the limitations of email by adding visual elements to their texts. In the CP

some members began their posts with attempts to "visualize" the group as part of their activation exercises during the prophetic school course. Using pictorial language they described how they imagined the community as: "Everyone was sitting at their computers, hands poised over the keyboard, alert and attentive, listening to the Lord" (Email sent to CP, 10 Feb 1998, Subject: [email-activation] week 5—Mighty Men of Valor). Others provide an image of their personal interaction with their computer while doing the exercises in order to link their experience more closely to the community: "And so I am doing my usual thing, staring at the empty screen and waiting on the Lord" (Email sent to CP, 12 Feb 1998, Subject: [email-activation] 5th Week!).

Frequently members try to deepen their communication through use of emoticons, textual cues used to qualify texts and add a visual element to a nonvisual medium. Emoticons are frequently used to add symbolic content and definition in emails. Commonly used are the smiling face :) and the frowning, unhappy face : (emoticons. This symbolism is also used to more fully express common religious ideas and link individuals to shared beliefs or values. They are often integrated into a member's signature tag, as with this image of a cross:

```
 _
/_/\/\
\_\   /
/_/   \
\_\/\  \
   \_\/
```

Some also serve as specific community identity markers. One such symbol, which was frequently used in the CP and other Christian "renewal" or Charismatic email circles, is meant to represent a person with hands uplifted in praise and worship of God. A CP member described this in a post as a "charismatic head and shoulders shot":

```
\o/
```

Another symbol is used to indicate that someone is "in the river of God" or part of the Charismatic movement linked to the "Toronto Blessing" renewal:

```
~~~\o/~~~
```

Another common way for individuals to define themselves as Christian, especially those who consider themselves evangelicals, is to use the ancient Christian symbol of the fish, from the Greek word *ichthus*:

<>< or ><>

In the context of online charismatic-style prayer meetings associated with the CP, lines of typed random keystrokes such as "josrhsaoinvlkdnruojiaurfa" may be used to represent glossalia, or "speaking in tongues."

Each of these religious emoticons denotes certain beliefs or identities held by the user and shared or understood by the rest of the community. Using these symbols helps members communicate more fully their particular religious ideas. Emoticons can be community-specific; they can be used by a particular group as an identity marker or to communicate ideas specific to that community.

Cyberhugs and Online Affection

While the lack of visual cues can be freeing for some users, it can also cause others frustration when they want to express emotion or concern online. This is true in the OLC, and led to the use of "cyberhugs" as a way to openly express affection towards other members. I first saw cyberhugs in an OLC email during week two of my case study.

> Hi Brothers and sisters, I think we are overdue for a cyber hug.
> ((((((((((((SQUEEZING BEAR HUG))))))))))))))))))))
> Thank you Lord, for my OLC family! And Lord bless my OLC family with whatever they are in need of. (Email sent to OLC, 17 Nov 1998, Subject: Time for a cyber hug)

The cyberhug was happily received by the group and reciprocated. From this point onward members frequently used cyberhugs when others expressed that they were experiencing hard times. Typically they were represented as several sets of parentheses around the word "hug" followed by words of approval:

> Prayers and ((((((HUGS)))))) to a precious, and valued, sister. (Email sent to OLC, 18 Nov 1998, Subject: Re: Depression)

Other times they were expressed by adding extra characters to a word of affection or parentheses surrounding the person's name, such as I received in several personal email messages and questionnaire responses from community members: (((((Heidi))))). One member adopted a "cybersqueeze," a form of the cyberhug, as a trademark ending to her post, as expressed here:

Bunches more lovings and squeeeeeeeeeeeeeeeeeeeeeeeezings for all my Loving Ones. (Email sent to OLC, 18 Nov 1998, Subject: Re: Time for a cyber hug)

Cyberhugs were interpreted as signs of affirmation, concern for an individual or the whole community or, as one OLC member commented in an interview, a way to cheer up people who are "a little bit down." He claimed that this form of care was valued and helpful for members. A cyberhug means,

> "I am giving you a hug, 'cause I don't have the right words for you, so here's a little hug."… [It's] trying to make contact with people in a sort of way which is not possible basically. Sometimes you give people a little touch on the arm and a cyberhug is one way, in my way of thinking. Jesus used to touch people, so that's my way of doing it. (Personal Interview in England, April 1999)

While members recognized that a cyberhug is not the same as a real hug, several expressed that in some ways it is better because it is safer, allowing members to show affection without violating people's personal space or drawing wrong conclusions about male-female interactions. Cyberhugs within the OLC attempt to bridge the gap between online and offline emotional support, in line with the safe and supportive environment the community tries to provide. The limitations of email forced this community to create new ways to express the care and concern they feel for other members. This was central to the identity and purpose of the community.

Anthropomorphizing

For a few members, bridging the gap in communication also involved the anthropomorphizing of their computers. Anthropomorphosis involves projecting human characteristics and qualities onto a nonmaterial or nonhuman object. These members playfully anthropomorphized their computers by giving them personalities and identities, referring to them as "my little guy," " lil' 'puter," or describing it as their "window on the world."

The computer was valued for the access it offers to online friendships. One AC member, Sally, said her computer becomes part of the stories she reads and writes on the AC; it "becomes a part of those relationships and especially the people I haven't met." Sally explained this "connection" with her computer as similar to relationships she had with many of her possessions. It seemed real to her because it connected her to stories and people she cared about. During a face-to-face interview she brought out stones, seashells, and pieces of furniture that she valued because of memories associated with them. Taking me into her office and pointing to her computer, she said,

My computer has that same kind of connection because it's so much a part of that Anglican community which has been at times so important to me. There is a sort of bond there. I don't think the computer is alive or anything, but there is a sort of sense of affection.... It serves as a connection to other people that I really care about and other emotional experiences. (Personal Interview in New York, September 1999)

The way people perceived their computers points to how they perceived the process of communicating online. Imagining computers as linking them to emotional experiences enables some to see online communication as not simply about information exchange but building relationships with people through stories. Playful anthropomorphizing enables them to see the process of exchanging emails as an embodied encounter.

Negative Effects of Disembodied Communication

While the absence of nonverbal cues in email offers members freedom from some forms of stereotyping and new options for communicating, it also enables negative social behavior online. Email offers quick and easy communication. Anonymity online can lower people's inhibitions, making it less risky to violate social and cultural standards. In an offline community specific members' undesirable behaviors can often be hidden or sidelined, but in an email community were everyone receives the same posts, text-based behavior violations are exposed to the entire group, whether or not members want to know about them. These can affect the cohesion or members' reaction towards the community. A few instances of this occurred during my online observations and are worth mentioning, as they show some of the potential negative effects of disembodied communication within an online community.

Spamming and Flaming

Most online communities have a protocol that sets the standard for acceptable and unacceptable behavior within the group. Some of these guidelines or rules are community-specific, referring to the boundaries of topics or discussions, and some are more general online polices, such as the prohibition of spamming or flaming. Two scenarios arose in the CP where the community had to deal with unacceptable behavior.

In week two of the Prophecy 101 course, a spammer made his way onto the community list. A spammer, as defined in a post from the CP leadership related to this incident, is someone who ignores the CP list charter and sends messages outside the stated boundaries on the topic of prophecy (Email sent to CP, 24 Jan 1998, Subject: Spammer Alert). This inappropriate post was a

"public confession of sins in the format of a prayer request," which he posted immediately after joining the list. Not only did he join the CP but, according to the list moderator, also joined several other Christian lists that she was connected to. The CP leadership took a hard-line approach to this incident by naming the offender, highlighting his email address and tagline, commenting on the spammer's character as a Christian and telling the group to "have nothing to do with him." As the list moderator wrote,

> If [the spammer] was really a Christian who desired to behave in a Christ-like manner, he would NOT sneak around in off-hours subscribing to lists (after having been warned about and unsubscribed from these lists less than 24 hours prior for the same inappropriate behavior) and then, ignoring the list's charter, spam them with his own agenda. (Email sent to CP, 24 Jan 1998, Subject: Spammer Alert)

The key to this violation and public denouncement was the fact that he had sent a post "of his own personal agenda," disregarding "the charter and purpose of the list." Naming the spammer and addressing the incident sent a firm reminder to the community, stressing the boundaries of acceptable use of the list. Spamming was common in many online forums, but it would not be tolerated here.

The second incident happened during week four of the course. This involved an individual in the email activation discussion group who violated two counts of the community's charter through flaming. The flame was a "judgmental" prophetic word directed toward two other list members, but received by over 100 people who were part of this particular sub-list. In it, the offender publicly corrected one individual's prophetic word and then attacked another individual's character. Correctional prophecies had been declared off-limits in the school format.

When a member of the CP leadership core contacted this member privately to discuss her behavior, she responded by posting a hostile email to the entire activation group, and then another to the whole community. Shortly after this the individual unsubscribed from the list and the leadership core made a general post to the whole community giving a synopsis of the situation:

> [The flamer] has provided a living object lesson of how character issues can interfere with the prophetic. She did some inappropriate things on the list.... Please be assured that when there are problems, leadership does address them right away. We try to do this quietly and behind the scenes, so those folks will not be unnecessarily embarrassed. But they are addressed. (Email sent to CP, 5 Feb 1998, Subject: A living object lesson)

Email encourages short, immediate responses, which can lead to heated reactions, arguments or off-the-cuff comments that can be harmful or misun-

derstood. The heated nature of this exchange shows how quickly emotional responses can affect an entire online community. The leadership provided the community with information about the situation and how the leadership core deals with "unacceptable" behavior. The incident was used to set distinct boundaries concerning online conduct and expectations of how CP members should interact with one another through email. Both incidents were settled in a direct and public way, in order to restore order and affirm the community as a "safe place" for "prophets-in-training" who follow certain guidelines.

Stalking Online

The ability to hide one's identity online or create a new one can also offer opportunities for mischief. During the AC Great Toronto Listmeet a hot topic of conversation during one meal was the emergence of a "stalker" on the list during the time my online observation was taking place. The estranged husband of one of the list members joined the AC and was an active participant for three weeks on the list using a false identity, disguising himself as a woman named "Haven." It came out that he had joined in order to spy on his ex-wife and learn of her whereabouts, though he had been issued a restraining order. He had also joined under a second alias as a man, and even hacked into a legitimate member's email account in order to send posts directed at his ex-wife. I was not aware of this incident during the observation period, but after this revelation I went back to my research notes to investigate.

Upon closer examination I found several interesting debates that had arisen through posts made by the alias Haven, relating to "her" theology and identity. She did not follow the AC custom of posting an introductory email to the list, and some members did not know how to interpret her confrontational manner. Haven's first posts made sharp comments on other members' religious beliefs. When one member referred early on to "Brother Haven," she sent an email reply stating, "Yikes, I wear panties and a bra. I am a woman" (Email sent to AC, 31 May 1999, Subject: It's Sister Haven!!!!). This perceived mistake was based on the assumption of several members that that name she used was a "handle," or pseudonym. They had surmised, correctly, from the "tone of the posts" that she was male. One member responded, "Oh dear, Haven, I apologize. Sexual discrimination is so difficult online" (Email to AC, 31 May 1999, Subject: Re: It's Sister Haven!!!!). However, one of the AC's original list sibs, a long-standing AC member, soon uncovered the charade, and Haven and other related identities were blocked from the list.

The incident and ensuing conversation in Toronto highlighted a concern many people have about how easy deception can be through an online persona. Several members commented that the idea of online stalking was disturbing,

even if it was only able to go on for a short time. To the question "Can you have the same degree of honesty and trust online?" about as many responded "yes" (18) as "depends" (17). It was recognized that most members had positive experiences of being able to trust others in the AC, but they felt it takes more time to build trust online, and this trust can be more fragile. Still, several AC members reassured others by saying once you have been online for a while it becomes easier to judge the authenticity of people's presented personas. As in the case of Haven, several members felt that something wasn't quite right, and after private email conversations and some online investigation their concerns were proved justified. Special assistance and support was given to the AC member who had been stalked, helping her change her email details and cloak her identity online from her husband. This illustrates not only the power of one individual to deceive online, but the power of a community to discern and take back control after such a violation of trust.

Online Counseling

The unregulated nature of the internet can encourage behavior which on the surface is not negative, but could be unhealthy if unmoderated. This is illustrated by some of the exchanges observed in the OLC. Because email eliminates certain barriers, it often creates a condition in which people feel less inhibited. In the OLC the community became a counseling center for many, with various members taking on the role of counselor. The email list could be characterized as a place of confession, comfort, and advice. This was clearly illustrated by the example in chapter four of the woman whose sister had run off, who received unanimous support from the community about her family's lack of understanding.

Another example occurred in the OLC when one member, in her sixth post in two days, confessed her struggles with depression. She presented her situation as serious saying she was "about at my rope's end" and asked for prayer.

> I don't know where to begin. I have been very depressed lately, and I find myself crying a lot and getting upset about things. I'm also finding it hard to deal with stressful issues here, as well.... Please pray for me. I try to talk to someone here, but he gets mad when I get upset.
> This is nothing new, as it has gone on for years. (Email sent to OLC, 17 Nov 1998, Subject: Depression)

True to form this elicited numerous community emails offering both encouragement and advice. Members' willingness to openly confess their strug-

gles seemed to validate and affirm the community goal of being a caring place. One member responded,

> I'm sorry to hear of your trouble. I'll be praying with all my heart, that God will comfort you during this time. I'll also pray that he will give you much wisdom as to how to deal with all of the stress. You have been so faithful to pray for all of us, and we really appreciate all those prayers. Anyway, PLEASE take good care. (Email sent to OLC, 17 Nov 1998, Subject: Re: Depression)

The OLC sometimes appears inwardly focused, with members being dependent on the online community resources for help. Pointing to resources outside the OLC or the internet for emotional support is infrequent. Rick, who was introduced earlier, expressed this by saying "The internet is like a library, but it is also like a living library because you have real people there that you can get information from." He, too, values the OLC for the support it has given him and compared his first year as a member to having a year of counseling. In an interview he described other OLC members during that time as "my psychiatrists, they were my counselors, they were my social worker. And that was email, that was not face-to-face and not over the phone."

A high number of members seem to suffer from depression from time to time, and the OLC becomes a counseling resource center, a place to turn for coping information that members provide. Messages in the OLC commonly include a mixture of statements of struggles or prayer requests describing their current difficulties. Members posting what appear to be urgent cries for help may on the same day post other emails of upbeat praise or advice to others. Emotional content is played up or down depending on the moment the individual sends the post, and this can make an individual appear emotionally flighty. This problem is compounded by the tendency to send off an email in the heat of the moment, with people unloading their feelings immediately. An online community functioning as a counseling center can be both a positive and negative phenomenon.

Creating Community Through Email

The format and character of email shapes the communication behavior and character of community online in different ways. Email as a textual medium can encourage communication between people, giving introverts or those who feel more at ease with written communication a platform from which to excel and add input. It can pose challenges, as members have to find ways to move beyond disembodied communication to add social cues and personalize their communication. It can also facilitate such negative behavior as spamming,

flaming, or online stalking, which undermine trust and honest relationships online.

The online context not only affects patterns of communication, but also how individuals conceive of or encounter community. For Jonathan, email and the Anglican Communion Online allow him to experience "Christ manifest." In the tradition of the Apostle Paul in the New Testament, who wrote many letters to friends and congregants, Jonathan writes email to connect not just with his friends, but with a larger narrative of the "word made flesh."

> Paul... wrote letters to peoples and they were wide spaced and they were diverse. And now 2000 years later you sit at a community, at a computer and you write letters to other people and again it comes back to the word.... And when you sit down and write to someone and think about these words and read those words and respond to those words, then virtual community is just as much a community as [Paul's] letters were. (Personal Interview in Missouri, September 1999)

The ability to communicate with others with whom they would not have contact in a normal daily context helps members of an email list to expand their view of community. By interacting with "brothers and sisters" from all over the world, members of an online religious community expand not only their social networks, but also their understanding of relationships. For some, email has introduced a new view of the world. In a religious context it has also expanded their concept of the universal Christian community. An email list becomes a tangible manifestation of the idea of the global "body of Christ." As one member of CP from the Philippines said,

> Like in the "real world" community, I meet various kinds of people in the online community so I can relate better to some than others. For me the exciting feature of the "online community" is that it is international in scope so it brings greater immediacy to the "abstract" doctrine of the universal Body of Christ. (CP Email Questionnaire Response, 9 Apr 1998)

The testimony of these witnesses is challenged by many critics of online community, who describe these perceptions as illusionary or misguided. For these critics, online religious communities, like online communities in general, are seen as impoverished; some go as far as to call online relationships inauthentic. Examples of how anonymity breeds deception abound (Dibble, 1996). The blurring of public and private boundaries may result in a fragmented, disconnected self (Stone, 1994; Donath, 1998). The opportunity for multiple identities may encourage users toward experimentation rather than accountability (Turkle, 1995). In the face of these observations and critiques, studies have also found Computer-Mediated Communication (CMC) empowers people to socialize and receive emotional support. While some see online relationships as impersonal or shallow, others argue that the internet liberates

interpersonal relations and creates communities. "One vision is of relationships lost, while the other is of relationships liberated and found" (Parks and Floyd, 1996: 81–3).

One aspect on which both advocates and critics agree is that the appearance of online community is linked to general societal trends in patterns of relating. Wellman highlights the movement of community to inside the home by means of telephone and other media (Wellman in Smith and Kollock, 1998). As a result of this move, people tend to belong to multiple, weakly connected partial communities, "personal communities" rather than a single, tightly interconnected group (Wellman, 1997c). Putnam argues that it is not membership in community groups that has decreased but active involvement in these groups. He links internet socialization to the general decline in social capital in American society, while claiming CMC "inhibits interpersonal collaboration and trust" (Putnam, 2000: 176). While advocates and critics disagree on the outcome of this shift, both acknowledge that our conception of community and patterns of involvement are changing. Online communities have taken root with people who feel disconnected from those with whom they share the same geographical space.

Email provides a form of communication that is quick, powerful and versatile. While it introduces many challenges for building balanced communicative relationships, it also offers new possibilities for creating community networks, which cannot be ignored. Email-based online communities are shaped by both the medium of conversation and the users involved. Just as we saw at the start of this chapter, in the AC group email, conversation within an online community is collaborative and interactive, influenced by participants' conceptions of email, the community where it is exchanged, and their offline engagement. This leads next to an exploration of how members link online and offline community.

Connecting Online and Offline Community

Offline community is often thought of in terms of exchange and structure, yet online community is based on interaction and communication. It is being argued here that what takes place online may be touching at the heart of the original, but often lost meaning of communication, the act of "creating community" (Hamelink, 2004: 24). We have considered how email-based communities utilize a textual format to build relationships, how email can serve as platform that encourages connections between people. The idea that email exchanges can provide a framework for community formation may on the surface seem surprising. Yet recognizing that communication is at the basis of online community acknowledges that it is a fundamentally human phenomenon and not just a technological gathering. Online community involves real people with real hopes and desires, sharing through real, although mediated, interactions. In this understanding, what happens in terms of online community may point toward a reorientation of the notion of community and how it can be created.

The reality of community online was emphasized by a member of the Anglican Communion Online (AC) in an interview at the Toronto Listmeet. Graham, a middle-aged Canadian man, stated "I heard someone say once that TV was like 'Pulp Fiction' and the Internet is 'Pulp non-fiction.'" He explained that while popular rhetoric often represents the internet as a false place, in his experience the AC was a creation that was rooted in truth and reality. He affirmed, as was also seen in chapter five, that deception doesn't go over well in the AC (Personal Interview in Toronto, Great Anglican Listmeet,

Sept 1999). Members are looking for real people they can be honest with and can share about all areas of their lives. The "non-fiction" model was about seeing the internet as a context in which real relationships could be formed and sustained.

Those outside the internet often see a tension between the idea of online community and living in the "real" world. This relates back to the "real vs. virtual" discussion in chapter one, which seems to suggest there are two separate realms of interaction. Life online appears to refer to a technologically constructed sphere where interaction is mediated or distanced. The offline world, then, refers to those experiences that take place through physical contact in our daily lives, making them seem more tangible. By making this distinction, there is a separation of what is perceived as authentic or real interaction from that which is simulated or virtual contact. It would be interesting to investigate how an online community member might distinguish or try to connect seemingly disparate aspects of life, the online and offline.

But this chapter takes a different approach, arguing that the internet is embedded in the everyday lives of users. From this perspective, the notion of two separate conceptual realms is challenged. Evidence from this study suggests that online community members do not maintain a clear distinction between online and offline community. Indeed, many members of these communities referred to online and offline community as interconnected, and consciously linked them through their actions and language. These findings coincide with other studies of online relationships and community being embedded in everyday life, such as Wellman and Haythornthwaite's edited collection of studies, *The Internet in Everyday Life* (2002). They recognized that online and offline relationships cannot be neatly separated. One dominant fear of online community critics is that online socializing will mark the end of "face time." Yet studies have shown internet contact does not weaken face-to-face interaction, and in some cases strengthens or encourages it (Chen, Boase, and Wellman, 2002; Katz and Aspden, 1997). Part of the reason for this is the way individuals characterize their online relationships. The claims and findings that relate to other studies are discussed further at the end of this chapter. Here attention is given to how people understand online and offline community as interconnected in daily life, and how they blend their online and offline experiences.

The ways in which these online religious communities visualize and connect their online and offline experiences is addressed by considering three common links. First, it is evidenced in how each community cares for its members, namely through online prayer support that blends online and offline information and action. Second, it is demonstrated through the way they integrate their online community involvement in their daily lives. Third, a deliberate move beyond-the-screen is demonstrated, as members connect

through face-to-face contact and establish involvement in each others' lives outside of the online context.

Connecting the Offline with the Online Through Prayer

It is difficult to draw a standard profile of a member of an online religious community. The Pew *Cyberfaith* report addressing "How Americans Pursue Religion Online" (Larsen, 2001) used the term "religion surfers," to describe those who solicit religious or spiritual information online and seek to connect with others online in their faith journeys. The report stated the most popular religious activities online were solitary ones, such as searching for religious texts, seeking or offering spiritual advice, and emailing prayer requests. While the report offers helpful insight into the motivation of religious users, it does not address specific reasons that draw people into online communities. Even within this study the task proved challenging. Reasons for joining an online community, length of membership, and commitment varied greatly from group to group, and seemed dependent on the structure and focus of each community.

The Community of Prophecy (CP) was still a newly forming group at the beginning of this study with average membership being three to seven months. Most members had joined specifically to take part in the online prophetic training course the community was offering, and so were quite active during this time period as heavy or frequent posters, but their involvement tapered off to infrequent or minimal after the end of the course. The Online Church had been in existence for about seven years. The average member had been a part for over a year and a half as an occasional or infrequent poster, having joined in search of Christian fellowship and stayed because of the high level of support and encouragement received. The Anglican Communion Online had been active for over a decade and membership averaged at just over three years, with most considering themselves infrequent posters. Most members had come looking for contact with other Anglicans and stayed committed because of the friendships they had built, expanding their awareness and understanding of the Anglican Church. While their levels and reasons for involvement online differed between communities, all expressed a common belief that one can care for members of an online community in similar ways that one does in a face-to-face community. Many indicated this was because the "online community is just as much a part of the real world as a face-to-face community" (CP Email Questionnaire Response, 23 April 1998).

One of the common ways each of these online religious communities demonstrated care and connected their online and offline lives was through sharing prayer requests and praying for one another. This allowed members to share very openly about their lives in what was seen as a safe and acceptable way. This showed that members are real people with real needs, and reinforced the community's interest in members' offline lives by demonstrating willingness of members to invest in each other.

The three online communities provided this prayer support in different ways, mirroring their community's narrative and mission. In the AC several members worked together to compile a weekly prayer request summary based on needs shared in various online discussions. Prayer summaries were written in a liturgical style and posted to the entire list. The intention was for members to be aware of and include the online community's prayer concerns in their personal intercessions. An abbreviated example is as follows:

Almighty and Everlasting God, you have given to us your servant's grace, by the confession of a true faith, to acknowledge the glory of the eternal Trinity, and in the power of your divine Majesty to worship the Unity. (Collect for the First Sunday after Pentecost: Trinity Sunday, ECUSA BCP'79)

We pray that you send your Holy Spirit to guide the hearts and minds of all those searching for and electing new bishops, coadjutors, suffragans, rectors, and assistants. Especially we pray for our brothers, [names of members], who have accepted calls to serve you in new parishes.

We pray for all who seek to serve you in ordained ministry... and for all who work to clarify God's call: [names of members].

We pray for all who seek to follow a Rule of monastic life in community, as oblates, in affiliation with an order, or as solitaries, especially: [names of members].

We pray for our list members, families and friends who face challenges, including employment difficulties and family problems: [names of members and details].

Hear our prayers, O Lord, for the health of family, friends and others known to list members who are ill or injured: [names of members and details].

We pray for list sister [name of member] riding in the AIDS Ride from Raleigh, NC to Washington DC, for the other 2500+ riders and crew, for their health and safety.

We rejoice and give you thanks: with our brother, [name of member], for the birth of his first grandson, and that Sr. [name of member]'s aunt appears to be cancer free.

We rejoice with those who have completed their seminary training, especially [name of member] and [name of member]. As they approach ordination to the

diaconate, give your grace to them and to all who are called to any office and ministry for your people.

O God of all consolation, comfort all those who have lost their loved ones....

++

Assist us mercifully, O Lord, in these our supplications and prayers, and dispose the way of your servants towards the attainment of everlasting salvation; that, among all the changes and chances of this mortal life, they may ever be defended by your gracious and ready help; through Jesus Christ our Lord. Amen. (For Protection, BCP USA)

<><><><><><><><><><><><><><><><><><><><><><><><><><><><>

(Email sent to AC, 30 May 1999, Subject: Prayer Request Summary: Trinity Sunday)

Many who responded to the questionnaire identified prayer support as a key benefit of being an AC member. The majority said online prayers were as effective and meaningful as those from a friend or church member (32 of 38 responded "yes" and 4 responded "depends"). Respondents emphasized that they saw online prayer as being no different from prayer they may receive from others in their churches. They explained prayer as dependent on God's intervention and not whether the prayer is "said or typed." One described benefits of online prayer by saying, "I believe the Net magnifies the number of people remembering you" (AC Email Questionnaire Response, 19 Aug 1999). Answers corresponded with comments on prayer support being a part of community life. One member said, "I have on several occasions known the sense of being 'held' in prayer by list members—this sense is quite awe-inspiring. It's the sheer scope and numbers of the pray-ers that seem to make the difference" (AC Email Questionnaire Response, 28 Jul 1999).

Online prayer connects members with each other; some described online prayer support as more vibrant than prayer in their offline experience. One member commented that AC prayer was more meaningful to him than the "Prayers of the People" said each Sunday in his parish, because those prayers often focus on people he doesn't know or have a relationship with. On the AC, the prayer list is updated weekly and involves people with whom he typically has daily contact.

> Close physical community is important, but I don't get the same feeling for prayer that I do when I am with the AC. And I know when at the AC when someone says they'll pray for me, they will.... That's a trust because I have seen it happen. Whereas at church someone can say "Oh, I'll pray for you" but I don't know that they will. (Personal Interview in Missouri, September 1999)

The AC's prayer summary is not only a venue for members to receive prayer support, but also a way for members to learn about the details of others' offline lives. Similarly, members of the OLC bring aspects of their offline lives into their online conversations relating to prayer. Once a prayer request is posted, members often solicit more information or ask for updates.

Sharing real prayer needs enables members to be become more aware of the lives of others, and consequently more invested in them. It also allows them to form alliances by agreeing with others' actions or perspectives on a given incident. This was illustrated during week four of participant-observation on the OLC, when a discussion thread concerning "new clothes" emerged between four women on the list. It began when one member expressed, as part of an email prayer, her frustration toward her husband who was angry with her for purchasing new clothes through QVC, a television home shopping network. In it she stated: "I also pray that our husbands don't get mad when we buy new clothes for the Holidays, especially when they can be worn any time of the year" (Email sent to OLC, 2 Dec 1998, Subject: Re: prayer). Another member responded to her comment offering details of her own situation:

> I like that idea of praying that our husbands will accept our need for new clothes. I haven't had much new clothes in the last few years. We have been raising a family on a limited income. The two oldest are semi independent so maybe soon I can buy some new clothes again. (Email sent to OLC, 3 Dec 1998, Subject: Re: prayer)

This sharing openly about the financial struggle her family was experiencing solicited email responses from two others about their own financial problems, stating they had difficulties in buying clothes due to their disabilities. Besides serving as a discussion thread, the topic resulted in at least one member responding to the offline needs another expressed an email. In an interview a member from London said she had been sent a cardigan and sweater from a list member in the US, after she posted an email relating how one of her only two good winter suits had been ruined.

In the OLC members not only offer prayer requests, but often solicit them from each other. It appeared that through prayer requests some members were able to keep track of how others are doing, thus deepening their investment in the community. Several times it was observed that members directed posts toward specific individuals, asking them to report on progress of a situation for which they had previously requested prayer. As in the post below, offline situations are not overlooked, but are held onto as a point of contact for members.

> As I was thinking about sending our regular news update, it occurred to me that we haven't heard from some of you these days and I am certainly keen to hear

news because it helps me in my prayers for you. Susan, how's the throat? Tom, how are you coping these days? (Write privately if you wish; it would be good to hear.) Kate, how are things with you and your mother-in-law? What about the eating?.... Rebekah, I know I still have that tape to do.... Hope I haven't missed too many others. Even if I haven't mentioned you by name, you are precious ones! (Email sent to OLC, 18 Nov 1998, Subject: DOES ANYONE HAVE ANYTHING TO SHARE?)

Monitoring prayer requests is not only done through public posts; in various interviews and emails members commented they frequently received private correspondence from other members, checking up on them. Connecting personally with absent or silent members demonstrated the high levels of concern with details of other members' lives and situations.

I've been rather quiet on the list lately. Lots going on. Just the same, I'm praying for you all. Thanks David for checking on me. It just so happens that the thyroid scan is this morning. (Email sent to OLC, 3 Dec 1998, Subject: Re: Update)

Arthur, an OLC member living in southwestern England, referred to these as "emails on the side," explaining these show the community's care is not just demonstrated online, but also through attempts to maintain contact and support outside it. Monitoring prayer requests and members' progress online allows the OLC to support each other with regard to offline problems, and link to or involve themselves in members' daily lives.

In the CP, the community's focus on prophecy and praying for each other go hand in hand. Many CP members described the internet as the ideal forum for "prophetic prayer" as it forced members to "hear from God" when they prayed, rather than depend on detailed information or details gathered from the physical presence of the person. While prophetic prayer is central to the CP, most personal prayer takes place in special groups, often run in selected chat rooms each week. These are facilitated by designated CP members and overseen by a member of the CP leadership core. The focus and structure of the group is determined by the facilitator. Sometimes these are run in conjunction with specific courses offered by the community, while others are informal meetings that often attract a group of regular attendees from among the CP. Over a period of thirteen weeks, I engaged in participant-observation of a weekly "prophetic prayer group," about twenty CP members who met in an IRC (Internet Relay Chat) forum through Undernet connections for two hours every Thursday. Online meetings began with a period of "praise and worship," where members shared portions of scripture, comments about the character of God, words of adoration, and even "speaking in tongues" through emoticons, as described in chapter five. This was followed by instructions from the prayer leader or facilitator about the focus of that week's meeting,

and then the group was often divided into smaller groups and sent to separate chat rooms to pray in relation to a specific theme or focus. After a period of a half hour or more, members came back together to share their experiences and insights with the group. This was followed by a time of corporate prayer.

Periods before and after these meetings often revolved around members sharing personal information about themselves and their lives such as their physical location, details of involvement in their church, the ways they functioned or struggled in their prophetic ministry, and other personal circumstances. These issues shared informally often became the focus of prayer during the meeting. Other times, requests would be brought from the leadership core to the group to "pray into" and "hear from the Lord" concerning issues such as illnesses, financial problems, or upcoming ministry trips. Through these interactions I became better acquainted with Charlotte, a regular attendee at these meetings, whom I later interviewed on her involvement in the CP.

She felt her involvement online, both on the email list and in the chat room, provided her with a more complete picture of prayer and its ability to impact not just her family or church, "but the whole body" of believers. She said when a need or issue is shared online, and community members unite together in prayer, "you feel like you are all in the same room." Prayer draws people into a deeper connection with one another. Charlotte spent an average of seven hours a week emailing and has a "handful of intimate" internet friendships, many of whom she has met on the CP. She considers these part of her Christian community because they share what she described as a "connection of the heart," connecting to God through sharing each others' lives and faith commitment. For her, involvement in prayer and interaction through the CP has made the "body of Christ" a reality. Online prayer not only provides information or a fuller picture of other members' offline lives, it also serves as a way to conceptually connect online friendships into one's larger social network.

The Online in Daily Life

When trying to highlight the inconsistencies between life online and offline, critics often cite problems of trust and honesty as inhibiting the construction of authentic relationships online. Critics often perceive online communication as encouraging deception. Contrary to this assertion, members in these online religious communities were confident about the authenticity of the relationships being constructed. They felt the religious focus of their online community meant members were more accountable or deliberate about constructing and maintaining an open and honest environment online. Online community members wanted to trust the representations they had of each other; as one CP member asked, "why would anyone 'bother' to be dishonest, in this par-

Yet the notion of online community becoming a key part of everyday life can be challenging for friends and family members who are nonusers. Howard, a CP member, said his enthusiasm for the internet is not shared by many of his associates, especially his wife, who is ambivalent about his involvement. During the interview she looked at us blankly as we talked about the CP and other online interactions, often excusing herself to the kitchen. "Your being here this weekend has been a good thing. It brings some reality to the online for us, especially for my wife," commented Howard. "I hope she can see that it's not just exchanging information, it's about fellowship and sharing ourselves with one another."

Howard feels that the idea of the "virtual" community is misleading, suggesting there is something false about it, rather than seeing it "as a community of people in real relationships" (Personal Interview in Devon, England, July 1998). Because of this, Howard keeps his email use limited to work, except on the weekends or holidays, going in to work early or spending his lunch hour online so as not to take time away from his family. This situation limits the number of posts he can respond to, so he finds his interaction online must be "intentional," focused and purposeful.

Members build bridges between online and offline interaction through the language they employ, the behaviors they adopt, and how they conceptualize their communities. The high value members place on online community involvement influences how they integrate this participation into their daily routines.

Sharing the Online Offline

The importance members place on online community participation also influences how they interact with their local church. One way this has happened is through applying or sharing information they have received online with their friends. Sometimes online community members become online advocates or internet ambassadors, encouraging their nonuser friends to come online by extolling the virtues of having access to useful information, international connections, and people. Online community is perceived as offering advantages and tools not available in many local communities or churches.

This was most clearly illustrated in the CP where members describe the internet and the community as a place to be "equipped for service." Members often shared how they tried to inform their local church about events and ideas circulating in the wider Christian or Charismatic/Renewal community to which they were exposed online. As one CP member, who is active in prayer ministry with her church in the United States, commented:

It has definitely impacted the intercessors in my congregation because I bring what I have learned to them—also to others in the body who move in prophecy— I am a walking pool of information and most of it I got over E-mail! Things the Lord is telling them I can confirm that others around the world have heard the same thing from the Lord in a given time. (CP Email Questionnaire Response, 9 Apr 1998)

Other members reported how they used activities they had learned from the CP in their local churches to teach others about prophecy. A CP member and missionary in the Philippines said, "I've already tried an exercise from the CP with some Bible College students" (CP Email Questionnaire Response, 31 Mar 1998). This was similar to the accounts of several OLC members who found that Bible material and related information they gleaned from the list provided "tools for teaching and sharing with fellow Church members" in various "ministry-related" activities, (OLC Email Questionnaire Response, 11 Mar 1999). AC members active in church leadership positions (lay readers, deacons, priests) found that email discussion provided fertile ground that "helps me in my Parish work either with sermon thoughts/ideas and more practical things such as liturgy, mission statements and prayer" (AC Email Questionnaire Response, 8 Aug 1999).

Members also reported details of experiences they had in their offline church in emails to illustrate how online information supported offline experiences. On a Monday morning it was common on the CP list to read reports from members about how they "experienced God speaking" to them during church services they attended over the weekend. Frequently these comments affirmed that what they learned online validated what they experienced and observed offline in church. One example of this was an email post in which a CP member responded to those on the list who had sent input concerning a dream she had shared. She said online interpretations had been confirmed through an experience she had at an offline prophetic conference which she had attended with other CP members.

Thank you so very much all of you for your sharings (sic) regarding "Jesus on a Horse" because they have added so much vision and understanding to what I thought I heard the Lord say Tues. night, on the last night of a Prophetic Conference that our (CP) Activation Group had gone to. (Email sent to CP, 10 Mar 1998, Subject: Jesus on a Horse)

Interaction online can also shape how members relate to their offline Christian community. In the AC discussion threads on issues of church practice and politics consistently solicited testimonies of how things are done in different parishes and comparisons among members. Grounding online discussion in offline practice was seen as essential in discussions of such issues

as how lay Eucharist ministers should administer communion and the use of parish facilities by other groups. Hearing how others responded to such issues provided input and ideas to other members, especially those who were part of their church vestry, about how to address similar situations.

In the CP most members (22 of 30 questionnaire respondents) also said participation online had positively influenced their attitude and behavior in their local church. Several said it influenced the ways they "minister" by giving them more confidence and boldness to function in the gift of prophecy or prayer. One member who attends a Pentecostal church in the United States said he had been "spiritually uplifted" through the CP, and this has changed the way he prays for others in his local church.

> This is the first time that I have studied/experienced this level of persistent contact with other Christians in a common project.... I am in a prayer team after services. I find that since I've begun to see how God moves prophetically—sometimes in prayer I am "carried along by the spirit" and have a word or two for those I am praying with. (CP Email Questionnaire Response, 01 Apr 1998)

Others claim online involvement encouraged them to interact more positively with other local church members. The CP allowed them to see prophecy as a "body ministry" and not just for a select few. One member said it "has caused me to encourage others in the church to be aware of the gifts they have" (CP Email Questionnaire Response, 30 Mar 1998). As internet ambassadors some felt it was their role to provide a wider perspective of Christianity by sharing content from the CP with their churches. In an interview one member spoke candidly about bringing information into her church prayer meetings to "help bring some perspective to the church" and contextualize what was happening in her local fellowship, relating it to what is "being stirred up all over the world" (Personal Interview in Michigan, June 1998).

Information and experiences encountered online can inspire members to forge links or share these with their offline Christian community. The online context also becomes a way to extend one's sphere of ministry as the two areas become blended. These two themes illustrate how members of online religious communities may integrate aspects of their online lives into their offline activities, as well as integrate their offline lives to their online correspondence.

Going Beyond the Screen

The blending of online and offline context, where online connections also become offline associations, is most vividly illustrated in the ways community members take these relationships beyond the screen. This moves past

a conceptual linking through language or even integrating online or offline information into other contexts, and instead involves finding ways to make direct offline contact with other members and share in their lives. While this face-to-face interaction was not experienced by all community members, it was encouraged and even consciously facilitated through the activities of these online communities.

Caring Beyond the Screen in the OLC

While online encouragement is a hallmark of the OLC, members also demonstrated a willingness and desire to go beyond email to help other OLC members. Online cries for prayer elicited more than email responses; OLC members tried to bridge the gap by offering help offline. This was demonstrated clearly in two instances during my participant-observation period.

In week one, a member from the rural midwestern United States shared news of an impending eye surgery. Without asking, the sharing of her news elicited numerous offers of prayer, consistent with the supportive character of the OLC. One member from the UK asked if there were ways she would like support from her OLC family during this time. Three others expressed concern whether or not she would be able to keep the community informed about her surgery and progress while she was absent from the OLC. Specifically they asked if she would have computer access during this time, as consistent email contact and information are so important within this community. One email stated:

> Thanks for reminding us about your eye surgery. Is there anyone near enough (from OLC) I wonder who can keep in touch with Lisha during this time by phone, or whatever? Tell us again, where you are. How long do you expect to be in hospital or away from the computer? Will you have access to a computer in hospital, or a phone? This may help us in keeping in touch. (Email sent to OLC, 18 Nov 1998, Subject: Re: update)

Due to this expressed need for information, Lisha responded to the community by creating an announcement email list, where she could provide a journal account of her progress. Three weeks later when she underwent the surgery, the OLC was kept up-to-date about her recovery progress through the efforts of a member who subscribed to this journal list and consistently forwarded these posts to the community. In these posts the recovering OLC member commented that she received numerous notes from the community wishing her good health and offering prayer, but was unable to respond to many of them due to eyestrain and pain. I do not know whether any OLC member ever made offline contact with her during her surgery or recovery period, but

this desire was expressed by several members in public posts to the OLC. This challenges earlier research that suggests people do not want to take online relationships offline. Instead, OLC members seem to want relationships to be as truthful and transparent as possible.

A second instance of this online-offline interaction occurred when the list owner, Stuart, posted a prayer request concerning a financial need in his church. Up until this point in the case study he had not posted any personal information. The email stressed that his local church owed a significant amount in bills that needed to be paid within a month's time.

> We need about 1500 dollars. Last week, we raised about 500 dollars. Please pray this money comes in before mid December. There are a few retired elderly people in the church and no one makes much money. (Email sent to OLC, 2 Dec 1998, Subject: prayer)

Several OLC members quickly responded with offers to pray that God would bless his church's efforts and provide the finances. Later in an interview Stuart said he felt the prayer the church received from people all over the world contributed to their eventual success in raising the money. But the OLC's support extended beyond prayer. Stuart recounted his surprise when he received in the mail a check for $100 from an OLC member toward his church's bills. Several months later, when the donor was in the area on business, he attended church with Stuart. During the testimony time in the service he was introduced and this, Stuart said, made quite an impression on his church as "everybody got to meet the guy that [sic] sent the church $100 through the Internet."

> He came and visited and sang in the church and brought his wife and so everybody in the church was able to meet, you know somebody real.... They weren't just electronic people on the internet; they were real people. (Personal Interview in Colorado, September 1999)

While face-to-face contact is infrequent for most members within the OLC, mostly due to members' physical limitations, this incident demonstrated to Stuart and others the high level of investment members were willing to make in each other's lives. When one member of the OLC rejoices, all rejoice. This was demonstrated by a number of email responses to Stuart's news that the bill was paid, such as:

> Can you imagine what I'm doing right now? Bouncing, trying to shout (with little voice) and unable to elap because I'm typing; but my heart is praising and saying all those things I cannot express in words. Thank you, Lord, for your faithfulness in answering our prayers and for providing for this group of your believers. (Email sent to OLC, 15 Dec 1998, Subject: Re: Church Update)

Two others commented during interviews that they maintained frequent telephone contact with various OLC members. Stuart said the reason for this was that once people develop a friendship online they typically want to get to know one another better. Telephone interaction provides a fuller sense of a person, and enables members to develop closer friendships. Stuart said he would consider several of his internet friends to be close personal friends through the process of taking the relationship from online to the telephone, which he and others seemed to consider a higher or more intimate form of communication.

Though many OLC members are bound by physical limitations, they are not limited in emotional investment in the lives of others in the community. Members provide more than just words of support; through personal contact via private email or phone, and even in some instances providing material assistance to others, they demonstrate caring behavior that strengthens community investment and relationships.

Meeting Offline Strengthens AC Connections

Of the three communities studied, the AC is the most deliberate in pursuing face-to-face meetings with other members. "Listmeets" are regular occurrences and can involve large groups meeting for a specific event, such as the Great Anglican Listmeet, or a small casual gathering at a member's home. The largest listmeet on record took place in 1997 in Washington, DC, at the installation of the presiding bishop of the American Episcopal Church. Over forty AC members attended this ceremony, which was followed by a party at a member's apartment in the area. This was a time of food and fellowship with the highlight being a visit by building security, when the group was reported to be making too much noise during an impromptu hymn sing.

Listmeets are often tagged onto other Anglican gatherings. Documenting these gatherings online is considered important. Email reports of listmeets include who met whom, where and when they took place, as well as comments on the character of individuals met. These face-to-face gatherings are valued because the basis of relationship is already established, so conversation can proceed quickly and easily. One listmeet report commented, "I was also happy to meet Simon and to see Timothy again. At one point I found them in intense conversation. They said it was easier than typing" (Email sent to AC, 14 Jun, Subject: Re: Living the Covenant NAAD/AP Meetings and Listsib Gathering).

Descriptions of these events are not simply mini-reports; often they try to draw other list sibs into the event by incorporating personal reflections on the people encountered. Listmeets are frequent and encouraged by members. As one member commented,

And meeting a List-Sib is an amazing experience, because we have so much in common, know so much about each other, and yet... we've just met! What fun! I recommend such meetings to all. (Email sent to AC, 30 May 1999, Subject: A Most Delightful Meg)

It was also often joked that photos are necessary to provide próof of a face-to-face meeting. In a medium that thrives on anonymity, the AC emphasizes disclosure and visual evidence of offline meetings of online contacts.

I may be wrong but I believe that in order for it to be an official AC list party, photos are required. Viv needs to record the meeting for all to see, no pictures—no party ever happened. (Email sent to AC, 31 May 1999, Subject: Re: List party! Last call!)

Photographs are frequently placed on the "kiosk" section of the community website, offering proof of various gatherings. It was recounted at the beginning of chapter five that at the Toronto Listmeet members took numerous photos that were later transferred to the online kiosk. Having proof of meetings may be symptomatic of the desire to recognize and connect with other list members.

Online anonymity contributed to several "accidental" listmeets recorded during the online case study period as AC members found themselves at the same event. One instance was described as follows:

One of my tablemates at Cursillo last weekend was none other than listsib Heather, whom I "discovered" when she explained to everyone about her Cyberparish and mentioned with gratitude that folks on the AC were praying for her over the weekend. I asked for her e-signature, told her mine, and said, "I'm one, too"—and we sat there, just beaming. What a delightful surprise! (Email sent to AC, 7 Jun 1999, Subject: surprise "listmeet")

Members also spoke of organizing holidays specifically around visits with other list members. One member reported plans for a UK holiday scheduled around visiting various British AC members. She emailed the AC her itinerary, saying "My schedule's fairly booked already, but I might be able to work a cup of tea with another listsib in yet!" (Email sent to AC, 06 Jun 1999, Subject: off to see the listsibs... and a few sights). She told the list she could be contacted through another member at whose home she would be staying for most of her time away.

In email conversation some members shared how their family and friends had a hard time understanding their commitment to these online relationships. One member said her husband referred to the AC as her "imaginary friends." In an interview Sally said it has been hard for her best friend to understand her spending time online talking and praying with people. She said, "I know my

best friend gets jealous of my online girl friends. 'Cause she says, 'well I'm your best friend.'" Sally explained these close relationships have formed over time, as certain members have become "spiritual soulmates" challenging and encouraging her faith. While her best friend does have email, she is not part of the AC and is not active in a church. "It's just not as big a part of her life as it is mine," explained Sally. Relationships through the AC meet her need for spiritual input from close friends (Personal Interview in New York, September 1999).

An interesting account of a listmeet occurred around Sally's ordination as a deacon was a highlight of discussion during week five of my case study. Eight list sibs traveled from Canada and as far away as California to attend the New York event. Sally and other list sibs sent email and pictures of the event to the list. Many reported they came not just to attend the ordination, but to join in the celebration as a "cyber-family." One member called the event a "metaphysical day of meeting":

> After this hallowed happening, we met all, ALL the listsibs present, it was like a party, meeting for the first time wonderous [sic] humans in the flesh... and fleetingly thoughts of, is this what you all mean about heaven, a meeting place, with a prior knowledge, yet, the new sensation of the touching, the hugging, laughter and caring fun. Of course, there were other people, but, the sibs made it for me. (Email sent to AC, 27 Jun 1999, Subject: The Spiritual dance)

Several list sibs described the event as being about celebrating a key moment with a friend who was more than just a "cyber-contact." A priest from Canada, and self-proclaimed lurker on the AC, wrote the day had given him a new appreciation for the AC and its members.

> Having known Sally for what seems a long time in cyberspace... having heard of the joys and struggles in her life: My wife and I having prayed so many times for her and for members of her family; and having the knowledge of her prayers for us, it was truly a family experience to share in that service. (Email sent to AC, 27 Jun 1999, Subject: Re: Waiting patiently)

Sally even took a break away from her own party to send an email to the AC during the event. While admitting to being in "a bit of the daze" from the activities, it was important to her to share her experiences with the list while they were fresh in her mind. She wrote, "All of you were much in my heart and on my lips today, were part of my 'communion of saints'" (Email sent to AC, 27 Jun 1999, Subject: Waiting patiently).

This type of communal celebration was not unique. Another email account under the subject line "The transfiguration of Sister Mary" described the celebration of an AC member as she took her formal vows as a solitary. After the ceremony the seven AC members who attended gathered together to compose an email describing the event.

We are all sitting in Malcolm's office—Sister Mary in a daze.... now she wants to say something—and I quote: "I love you all. Thank you for your prayers. Jesus is the best husband in the world. Lesley—don't put that in. (Sorry!) When I get it processed, even minimally, I'll let you know." (Email sent to AC, 6 Jun 1999, Subject: The transfiguration of Sister Mary)

Sister Mary later posted an extensive email to the list reflecting on the ceremony. It was obvious she valued the support of the list sibs present as well as the prayer support of those absent. Several members participated in the actual ceremony, and one even wrote and performed a song for her. Listmeets show that many AC members are committed to the online friends in ways that reach far beyond the screen. Face-to-face contact deepens members' commitment to the AC and extends relationships into their spiritual and social support networks.

CP Online Becomes Offline Ministry

In the CP, face-to-face meetings are not as highly promoted, but I observed that they became a more frequent occurrence as the list grew and developed. In spring 1999 an informal face-to-face gathering of the CP took place in the UK, when two members of the leadership core had an eight-hour layover en route to South Africa for a ministry trip. They arranged to rent a room at a Christian conference center near Heathrow airport and invited CP members in the UK to join them for a time of fellowship and prayer during their brief stop. Twenty people gathered for a four-hour meeting, which involved a communal meal, members introducing themselves and sharing testimonies about the impact of the CP in their lives. After speaking about the history of the CP, the two members of the leadership core individually prophesied over each person there.

This face-to-face gathering provided an opportunity not only for people to meet each other, but also for the leaders to "impart destiny" and "stir up the gift of prophecy" in the lives of the community members. This occurred through prophetic praying and the "laying on of hands," a common practice in many Pentecostal or Charismatic churches. Physical contact, laying hands on and praying for an individual, is viewed as important in order for spiritual gifts to be imparted or released in the life of the believer. The gathering allowed the leaders to affirm each member's place in the learning community as a "prophet-in-training," and to see them empowered for prophetic ministry in the offline world as well. This physical contact was therefore in some ways seen as vital for life both online and offline. Since then the CP has sponsored several offline prophetic conferences open to CP members and invited guests. The first of these was held in southern Ohio in the United States in

the summer of 2000. Meetings like these involve times of teaching and pro-
phetic impartation led by members of the CP leadership core.

In the profile of the CP in chapter four, the ways in which online involve-
ment can spill over into offline ministry were illustrated in the emerging role of
the list moderator. Carla began by moderating the email list, which led to her
becoming a conference speaker, writing a book on training people in the gift
of prophecy, and finally starting an offline ministry that organizes conferences
and hosts healing or evangelistic meetings worldwide. The moderator's on-
line involvement provided a springboard for training and eventually launched
an international ministry connected to the topic of the online community.
Testimonies and reports from these offline ministry trips are frequently shared
on the list, from weekend events in the United States to weeklong ministry
trips to India and Africa. These examples illustrate how the CP has extended
its ministry from being a purely an online entity to being an offline ministry
as well.

For each of these communities, involvement online means developing re-
lationships that cannot be confined or limited to email communication. By
reaching beyond the screen through other forms of communication and face-
to-face interaction, members demonstrate concern about one another's lives.
Sharing with each other through prayer support keeps members informed
about the lives of other members offline. It also encourages spiritual invest-
ment in the community. Listmeets extend members' emotional investment
in relationships as well, because they begin to see one another as more than
"those who live in my computer," as one AC member playfully put it. They
see each other as part of the global church to which they have access through
the internet.

Online versus Offline

Up to this point a very positive picture has been presented of community life
online. The strengths of online relationships have been emphasized through
examples of how members demonstrate care, invest time and resources in the
community, form friendships, and create opportunities for ministry. The ap-
peal of online community is exemplified by the testimony of Colin, a retired
priest who spent many years in church life and ministry, and described the
AC as a "real community." Online community is appealing because it creates
behaviors that allow members to identify with others, both on an individual
and a group level. "The world of the AC can be more real than the world of an
office or church... because of the level of commitment members have to each
other" (Personal Interview in Toronto, Great Anglican Listmeet, Sept 1999).
Colin compared his experience of community in the AC to a church retreat

he once led in his local parish that generated a similar feeling of closeness and intimacy among church members. After spending a weekend of intense fellowship together he remembers several people saying "this is a real community" and "the care and concern we share together... is something we need to extend into the world." For him the AC represented such an extension, a lived reality of community.

What online community does well has been underscored, but the question must be asked, do members recognize the limits or constraints of their online community? Do they acknowledge its problems? While many online community members identified online community as important in their personal spiritual lives and spoke of the benefits it could bring to the "body of Christ" as a whole, many said this with a hint of hesitation. What seems to be needed is a balance between online and real-world community involvement, by recognizing the strengths and weaknesses inherent in both.

While online community meets certain needs of members, such as fellowship or information, they noted limitations, especially relating to embodied interaction. Touch, body language, and nonverbal exchange are obviously absent from online communication. This was especially evident for the CP, a community that values the ability to express spiritual experiences. While seeking prophecy in the realm of the unseen, members have a strong desire to share the experience with others in an embodied way. For this reason several CP members described email as "incomplete" communication. The inability to put a hand on someone during prayer or show facial expressions of concern seemed a serious shortcoming.

The limits of disembodied interaction online were described by a computer network administrator from the eastern United States as the "Chocolate Chip Cookie Factor." He stated:

> I believe a person can care and minister as much (but) not in a complete way. It would be difficult to email you a plate of chocolate chip cookies, or help you move to a new apartment. But listening, praying and communicating can be carried out online. (CP Email Questionnaire Response, 30 Mar 1998)

Email offers instantaneous communication; thus many online community members indicate they have a higher frequency of contact with Christians online than in their local church. Yet the "Chocolate Chip Cookie Factor" highlights the limits of care online. The lack of physical interaction in an online forum causes many to describe it as "incomplete" communication. It also leads to debate concerning the depth of online relationships. Online anonymity might enable people to be more open, but trust in a relationship takes time. Without being able to look someone in the eyes, this process might be extended. "Trustworthiness must be demonstrated... because of the lack of

connection, trust is more difficult, but not impossible to build" (CP Email Questionnaire Response, 30 Mar 1998).

This gap was also noted in OLC member comments about online community. While the internet is seen as a tool to facilitate the formation of "a loving Christian family" (CP Email Questionnaire Response, 30 Mar 1998), members also identified distinct limitations of the medium. Some were frustrated by constraints on their involvement in other members' offscreen lives. These limitations are addressed in chapter seven in a discussion of the role and relationship of online Christian community to the local church.

Bringing Online and Offline Together

Many who have studied the internet as a social technology have observed that people often conceptually integrate their online and offline social activities and experiences. Online social networks are not seen as isolated, simply located online, but are considered embedded in the "real," or offline, world. This means people are active participants in both realms and move seamlessly between the two. They do not consider their internet friendships to be only online, but see them as part of their general social network. Online communication often creates a desire for individuals to go beyond the screen and transcend the limitations of online textual interaction. This can occur simply by adding emoticons in texts, or orchestrating face-to-face meetings with online friends (Campbell, 2001). Though the internet is often characterized as information-driven, increasingly its social side is being highlighted. "The social" is the glue that binds the task-oriented aspects of Computer-Mediated Communication (CMC) together. Although people are information processors, online they are "more fundamentally social beings who need to affiliate" (Katz and Rice, 2002: 203; also Sproull and Faraj, 1995).

Katz and Rice also found in their survey (2002) that people's primary online activity was sending and receiving email, especially to family and friends. Online relationships are not just with "virtual friends"; a large part of online communication is spent in maintaining preestablished relationships. Many internet users identify their online relationships as part of their everyday lives, rather than being separate (Wellman and Haythornthwaite, 2002). Online relationships are "real" relationships to users (Rheingold, 1993a), though the interaction might be mediated via computers. These connections are conceptually incorporated into their daily friendship networks (Parks and Floyd, 1996). It is also misleading to identify online interaction, especially online community relationships, as mutually exclusive, distinctly separate from an individual's offline relationships. Many have described online community as complementary to offline relationships. Hampton and Wellman in their

"Netville" study of a wired suburb in Toronto found online users were more active neighbors, having a greater face-to-face recognition and contact range with their neighbors (Hampton and Wellman, 2002).

Although research has shown the internet is not bringing an end to face time, the absence of embodied interaction still suggests to some that it must be a weaker form of communication exchange. Yet Pew demonstrates that internet users are no less sociable than nonusers. Twenty-six percent of internet users surveyed said they used the internet to connect with or get information about local groups (Horrigan, 2001). The report also stated the internet had become an important tool for some 90 million people to connect with those of shared interests globally and locally. Horrigan describes online communities as "virtual third places," which are different from home or work, allowing people to engage with others or groups.

Critics who fear online religious communities will cause people to leave their churches in favor of screen-based interaction need to consider the Pew findings that 44 percent of long-term internet users belong to offline faith-based, community groups (Horrigan, 2001). Going online allows these users to extend their community participation, as 43 percent of users employ email to communicate with their social or religious connections. Twenty-one percent of online joiners choose to connect with some sort of religious online group. These findings suggest, in relation to religious community membership, individuals use online community to enforce or extend their already established faith memberships. Virtual third places do not replace or become separate spheres from "real" community. They are used to strengthen existing ties and beliefs. Therefore the online and offline community ties cannot be completely separated.

This study found "religion surfers" who become members of an online religious community weave aspects of their online and offline lives together in a variety of ways. While distinctions are sometimes made between online and offline activities, many users do not separate their online and offline relationships in the same way. Instead they seek deliberate and creative ways to connect the two both conceptually and through their actions. CP members see online and offline as interconnected in relation to the community focus on prophecy. The internet, like the realm of the spirit, is an otherworldly space that transcends offline experience. Their understanding of the spiritual world facilitates their motivation to blend their online and offline actions. In the OLC members readily obtain and offer online advice concerning other members' offline struggles. In spite of the physical limitations many OLC members attempt to become involved in one another's offline lives. AC members also consciously bring aspects of their offline church and life experiences into online communication. Their merging of online and offline relationships

is seen clearly through listmeets and other face to face meetings with other members. In these ways each community adapts and connects its relationships and experiences online and offline.

On Being the Church Online:
Reflections on Online
Religious Community

an email list becomes a community as its members devote their lives to one another both online and beyond the screen. Previous chapters have provided examples of the high levels of investment and participation evidenced in the online communities in my study. Online religious communities provide new opportunities for connecting with like-minded believers, new forms of Christian ministry and the prospect of experimenting with how communities can congregate or behave. Yet the question must now be asked: Does a person's experience in an online religious community influence his or her interaction with an offline religious community? How do members truly see online community in relation to their offline counterparts? What is the connection between online and offline expressions of church?

Pew's study of religious use of the internet addresses some of these questions by affirming that most active religious surfers are also offline participants in their faith (Larsen, 2001). Pew found for religious users the internet functions as a "supplemental tool that enhances already deep commitments to their churches, synagogues or mosques." Pew also reported that religious surfers credited the internet with improving their spiritual life (27%) or having a "mostly positive" effect (35%). Many even expressed the belief that spiritual resources are more easily available online than offline (especially educational material and prayer support). These results indicate those who use the internet for religious purposes are also committed to offline involvement in religion, but find some aspects of religion online more conducive to spiritual

engagement. In light of this, chapter seven considers how religious engagement online influences perceptions of religious community offline.

Over Brunch at the Great Anglican Listmeet, Terry, an AC list member from Pennsylvania, spoke candidly about his search for "true community" over the past 15 years. After reading Scott Peck's book *The Different Drum*, he began a personal quest for a place to experience community in his local area or church. Yet it was online where: "I have come to realize in the last three years that the AC is what I have been searching for... a place of encouragement, prayer, identification... a home" (Personal Interview in Toronto, Great Anglican Listmeet, Sept 1999). He called the listmeet a highlight in his life because it brought together an online experience with an image of the church he had held for a long time. "The AC is about being a Christian community, recognizing God in the group and in each other," he explained. "What keeps us together is that mystical element, of it being something bigger than ourselves." He said he helped start a men's group in his home parish with the idea of trying to replicate in the "real world" the type of community support he found online.

The ways online religious community members come to reflect on ideas of Christian community and their local church is the focus of this chapter. It has been repeatedly emphasized that people may join an online community for information, but often stay invested because of the relationships they form. The potential exists, as in the testimony of Terry, for online involvement to inform how people see and even interact with offline religious community. This study observes that, as members identify reasons for becoming involved in a Christian online community, they highlight strengths or characteristics they value in their online community. These characteristics provide an evaluation tool or marker, defining attributes members desire in their offline church. In some cases members stated their offline church lacked these characteristics, but their online community meet these criteria. Others provided a critique of the offline church, not through specific descriptions, but through their behavior toward their local congregation and in the way they compared the online community to their local church.

How these particular online religious communities reflect on and even critique offline church and Christian community is discussed in two respects. First, how online Christian community mirrors the practice and mission of the dominant offline faith community to which its members belong is addressed. There is evidence that the Community of Prophecy (CP), Online Church (OLC), and the Anglican Communion Online (AC) import specific theological understandings concerning the offline role and nature of the church into their online community structures. Second, how members conceptualize and utilize online religious community as a supplement or substitute in relation to

their offline church is explored. Analysis and observations of these case studies show that evaluation and critique of Christian community and local church are often based on members' experiences of community online.

Connecting Online Religious Community to Offline Church

As discussed in chapter two, religious community is recognized as a relationship formed between the human and divine communities. Human community is called to emulate and live out the relational focus of the divine community, the Trinity, in the world. The human community is meant to experience communion with God through fellowship with one another. This relationship includes both the idea of the church (*ekklesia*) as the assembled people of God, and community (*koinonia*) of unbroken fellowship of believers. Religious community is concerned with both the act of forming a congregation and its state of being in fellowship with others.

Different convictions exist about what should be the central focus and form of religious community. In relation to Christian community each interpretation comes with distinct beliefs about how the local church should operate. Dulles's models of the church characterized this, and present a range of ways the mission or purpose of the church is portrayed. Though these models were constructed around observations of offline church, they can also be used for the online versions of church or Christian community. In some cases these models of the church seem to be simply transported online. In other cases these models are altered online. Yet these adaptations often mirror traditional forms of offline church.

A significant finding in this study is that online religious community practices can be linked to the mission of offline faith communities to which members subscribe or affiliate. This relates to the argument that the internet is embedded in the practices and beliefs of everyday life. Online religious community is similarly rooted in offline expressions of religion. Members of the three online Christian communities studied here directly transferred their convictions about the ministry of the local church into the online context. In many respects, their offline understanding of religious community or ecclesiology (study or understanding of church) shaped their use of the internet for religious purposes.

Comparing Dulles's models to the practices of these three online communities helps to illustrate how offline understandings of church are found in the online context. Though an online Christian community might appear quite different from a local church of a similar theological background in its form

and structure of communication, it can be argued that its ministry, focus, and message are often quite similar.

CP as Mystical Communion

While the Community of Prophecy (CP) differs from some offline churches that practice the gift of prophecy, it is not completely separated in its underlying theological beliefs and ideals. The CP can be linked to Dulles's model of the "church as mystical communion," where church is characterized as being a relationship, not simply a community of relationships. It focuses on the image of communion in relation to the Trinity, with special attention given to the role of the Holy Spirit, a mystical force seen to direct relationships.

The "church as mystical communion" is an interpersonal model, stressing that relationship between the individual and the collective comes through engagement with God through the Holy Spirit. This is a common focus among Charismatic or Pentecostal churches, which emphasize engagement with the Holy Spirit through prayer and the use of spiritual gift. Individual experiences with the Holy Spirit provide a common ground for communication. Sharing these experiences within the community is seen to minister healing to members and encourages those on the outside to enter into wholeness.

The CP subscribes to a similar understanding of the church, as outlined in this model and linked to the beliefs of many Pentecostal or Charismatic groups. Although CP members do not come from a single denomination, most subscribe to a common set of beliefs, articulated in the list charter, that can be associated with churches from this tradition.[24]

CP members agree on several key points. The focus of the CP is learning to function in the gift of prophecy; thus a central belief is that the gifts of the Holy Spirit are still active in the church today. This belief is voiced in the group's charter, where the "indwelling of the Holy Spirit" in the lives of Christians is emphasized. Most members and the leadership core use the word "Christian" rather than their church affiliation to describe themselves. They emphasize belief over belonging; emphasis is placed on the common beliefs, while membership in specific denominations or groups is downplayed.

Some CP members associate themselves with more than one church group when describing their spiritual development or journey. One member from Minnesota stated she is a member of a Congregational church, but often attends a local Charismatic fellowship. She explained:

> I'm very happy with the church in all its forms including denominational and non-denominational. The CP was just another expression of a relationship with Jesus Christ and His Church and His calling of us to be ministers of the gospel. (CP Email Questionnaire Response, 30 Mar 1998)

Like other members she is comfortable floating between different church traditions, giving loyalty to her conviction about how faith should be lived out, rather than to one group. This links to the mystical communion model, where the church is a union of mystical connections that are fluid, not bounded. Community focuses on relationships. It is not strictly participation in institutional structures; it is communion with like-minded believers and God.

Focus on prophecy brings a platform of unity to members from diverse backgrounds. Relationship emerges as the Holy Spirit connects believers together. The CP maintains some local churches might find this idea difficult.

> There is a foundation of understanding of the prophetic (in the CP) that is not present in my home church. For this reason there is a mutual understanding of the terms, foundations and theology... of the Spirit that my pastor would have trouble identifying with. He doesn't understand where I'm coming from and how I can love my non-Charismatic, non-Prophetic Church and still belong to prophetic groups. (CP Email Questionnaire Response, 30 Mar 98)

The CP, similar to Dulles's model, holds a belief that church should be a community based on experiential relationships. Common experience and communion with the Holy Spirit unites the community. Members are encouraged to engage with the Spirit on an individual level, in ways that correspond with communal experiences of faith. These shared experiences give community members a basis for dialogue and breed connections between them. This was described in an interview as a "heart connection" between believers, enabling them to relate to one another and mirror the character of God. The internet simply facilitates a connection already present between believers.

> I am sensing the Spirit of the Lord in people across the country and around the world.... It's like, yes, you are the same family, we have the same dad.... That's what I am experiencing on the internet.... It makes the Bride of Christ more feasible... not just something to read about. (Personal Interview in Illinois, June 1998)

Online fellowship that transcends geographical boundaries relates well to the idea of the church as a mystical communion, a community transcending structural boundaries. It also links to the CP's view of the church as a community of the spirit. One CP member, a middle-aged woman from England, described the internet and the CP as able to break down barriers within Christianity, which otherwise would limit God to certain spheres.

> The Lord is not confined to the same geographical space.... But so often I think we get bogged down by thinking that actually having a person there and laying hands on them makes it more likely to touch them by the Holy Spirit.... When it comes to online ministry, why should we suppose the anointing cannot come as we type the words we are speaking to the Lord on a keyboard, and someone many

miles away, reading those words can Amen the prayer? (CP Email Questionnaire Response, 9 Apr 1998)

Many of the CP's practices are similar to what one might observe in a typical Charismatic gathering, such as the above description of "laying on of hands" in prayer. The CP supports a view of church that stresses the role of the Holy Spirit as a facilitator of the common experiences that unify the community.

OLC as Herald and Servant

In the OLC, community members can be seen to live out the traits of two models: "church as herald" and "church as servant." Unlike the Community of Prophecy, the OLC cannot be neatly linked to one denominational classification. Questionnaire data showed members belong to diverse Christian affiliations, from Catholic to Baptist. Yet the OLC demonstrated similar beliefs about the nature of the church that can be related to these models.

The church as herald model sees the church as a congregation gathered around the scriptures. The primary task of church is proclamation of the biblical scriptures, specifically the gospel story of Jesus. Inside the church the congregation gathers around preaching of "the word." Outside the church members are messengers responsible for sharing the word with others. This model is the focus of many evangelical and mainline Protestant churches, such as Presbyterians.

In the OLC this model emerges through the community's focus on heralding ideas related to scripture. This is demonstrated as members frequently forward online devotional and Bible teachings from other lists to the community. Although the list moderator discourages this forwarding, others often thank members for sharing these teachings on the list.

Members also emphasize the importance of Bible study and exposition in their posts. Though Katie commented in an interview that the OLC had never sustained an in-depth Bible study for any extended period, discussions related to Bible studies emerged twice during my period of participant-observation. One instance involved people sharing examples of their personal studies, which evolved into members exhorting one another to spend more time "in the Word."

> I have a question for every one here. How much time each day would you say that you take for bible studies? I know that some times we don't get to do as much as we should, and then there are times that we let things get in the way of doing what is really more important than anything else that we do when we should be concentrating more on the Lord. (Email to OLC, 10 Dec 1998, Subject: bible studies)

Evangelism online and sharing testimonies of God's influence in members' lives are also emphasized. Rick, an OL member from St. Louis, stressed that the opportunity to share his beliefs was one of his main motivations for getting online. He even referred to it as "a calling" saying,

> I just felt that I needed to be on there. To me this is fellowship. I mean, I notice when I read something out of the Bible I can't stay bottled up with it, I have to spill it out. I have to tell somebody, you know. (Personal Interview in St. Louis, Missouri, September 1999)

Publicly sharing one's testimony and speaking of Christ, he felt, should be focus of a person's Christian life both online and offline. Due to his disabilities, he had limited experience with church offline, but he believed that the internet could facilitate testifying, and that the OLC should encourage online proclamation.

> On OLC I see that, on the internet, there's a lot of places that have Christian websites and Christian chat rooms and you see that desire to help somebody, to share. In the church I don't often see that. (Personal Interview in St. Louis, Missouri, September 1999)

Members frequently used the OLC as a tool to encourage other believers in their faith. Several also spoke of deliberate involvement in "witnessing" online, especially in chat rooms. For some the OLC creates an "electric church" where focus on proclamation is central.

The "church as herald" is not the only model of church at work in the OLC; the "church as servant" model is also strongly emphasized. Dulles's servant model emphasizes creating a "church for others," where focus is on identifying with Christ as the suffering servant. The church is to be active in service to others by providing help without regard for personal gain. It is to serve all humankind, especially those outside the church congregation. The church as a servant community is called to minister in Christ's name wherever it can identify a need in society. Churches subscribing to liberation theology and those that focus on reconciliation or advocacy on behalf of the marginalized especially seek to live out this model.

The OLC displays a "servant" ethic in the way members advocate serving those suffering within the community. Several members described their OLC involvement as a ministry. One member in London defined her role in the community as a giver, meeting others' needs by offering prayer and advice.

> I know most people are on the list because, for some reason or other, they need a bit of extra support, a bit of extra sharing. So I am there primarily to encourage. It would be wrong... of me if I felt I was there for my gain. I am not, although I

do gain.... I am there primarily because of what I hope to give for other people. (Personal Interview in London, April 1999)

Members not only acknowledge the needs and prayer requests of others, but as has been shown, they actively seek out opportunities to encourage others and share in their suffering through personal email contact. OLC members are often limited to email encouragement because of physical or geographic barriers; still, the OLC can be seen as a church of servants, seeking to assist one another online to the best of their abilities and resources. Service to others is typically limited to those within the OLC, yet they enthusiastically welcome newcomers into the community. They are often reluctant to let go of members who choose to leave, even for a short time. This was demonstrated when an infrequent poster announced that he was leaving the list.

> We are sorry your work prevents you from reading all the messages but do understand. May God continue to bless you in whatever you do in His service.... We shall miss your contributions. Come Back when you have a chance. (Email sent to OLC, 24 Nov 1998, Subject: Re: Update)

The OLC exemplifies the church as servant model as it strives to be a servant community in spite of various constraints. Images of herald and servant highlight areas of church life important to members. As servant the OLC community seeks to minister to those in need. As herald it promotes biblical teaching and sharing within the community, though the actual living out of this aspect in the community is quite limited.

AC as Sacrament

The strong links between the AC and the Anglican Communion have been highlighted. This means it can be most closely associated with Dulles's "church as sacrament" model, which depicts the church as a symbolic community emphasizing participation in sacramental acts. Sacraments such as Baptism or the Eucharist are meant to represent Christ's active presence within the church (Dulles, 1974: 62). These symbolic acts are not solitary; they take place in a communal context. The "church as sacrament" model transforms rituals and symbols into "events of grace" in which God is present. By sharing these events, members are communally transformed. In this model, the focus is on external acts of community worship, which give meaning to the community and individuals.

Online community, for AC members, addresses the desire for engagement in personal or spiritual issues which enlarge their experiences with others affiliated with the Anglican church. Yet most do not see online involvement as

a suitable substitute for the worship experience. One focus of Anglo-Catholic liturgical worship is the Eucharist; through bread and wine Christ is understood to be present within the congregation. While AC members said they experienced Christ through fellowship with the AC, many were adamant this was not a complete experience of worship.

Sally, an Episcopal deacon, adamantly stressed that the internet does not provide a complete "sacramental" context and that worship in a "real world church space" is crucial (Personal Interview in New York, September 1999). Attempts have been made to incorporate the sacraments in several online events linked to the Anglican church, including the installation of the new American presiding bishop in 1997, when a computer up-link website was made available for those who wanted to watch via the internet. Arrangements were also made for people to celebrate the Eucharist at home at the same time it was being celebrated in the National Cathedral in Washington, DC. Yet as far as she was concerned this was not a "real Eucharist," because "if there is not someone who is ordained there laying their hands on those elements they are not consecrated." She believes, as other AC members articulated, that it should be important for Anglicans "to be in a space worshiping with other people live and in person."

The sacrament of communion emerged as a theme in several online discussions. A discussion thread in weeks three and four of my online participant-observation concerned whether or not lay Eucharist ministers (LEMs) delivering communion to housebound parishioners should partake of communion with the recipient. Extensive debate emerged on how communion should be served along with personal stories of sharing communion or serving as an LEM. The presence of such discussion illustrates that the AC upholds a specific theological context and religious tradition. Even a "drivel" thread, deriving from a passing comment on Anne Rice's novels brought about a playful discussion of "vampire theology" that evolved into a serious discussion of theological ideas associated with the symbols of the body and the blood.

Members also spoke openly about the centrality of the Eucharist in their faith and worship. One member, confessing how she had missed Mass for the first time that year, stated:

> That led me to thinking about my previous denominational affiliation where we only celebrated our hyper-Zwinglian "Communion" service four times a year. We were told over & over again how the awful Papists had ruined the deep significance & meaning of Communion by "doing it" every week. Poppycock, I say. I find myself joyfully racing toward my parish church each Sunday, my heart literally singing at the thought of "doing it all again." (Email sent to AC, 19 Jun 1999, Subject: Missing A Sunday & the Big Lie)

The value placed on sacramental worship means for many the AC remains limited as a community. A member from Canada said the AC had been valuable for her self-esteem since she was judged by "the ideas I put in print" and not her clothes or mannerisms. Yet she said the AC remained a "supplement" because, "I can't share Communion with the List, and I can only very rarely hug them" (AC Email Questionnaire Response, 28 Jul 1999). For this reason, the Mass was a central activity of the "Great Anglican Listmeet" in Toronto, as the official "order of service" bulletin stated:

> This "listmeet" in Toronto is an opportunity for many to celebrate together face-to-face, but in our hearts, in our prayers, and over the electrons, our beloved community worldwide celebrates this holy meal with us. ("Introduction" in Saturday Evening Mass Order of Service, Great Anglican Listmeet—Toronto, September 1999)

The Eucharist service brought together the variety of worship styles and liturgical backgrounds of those present. Organizers spent significant time beforehand emailing attendees in attempts to incorporate personal requests into the service, and 12 members took lay or pastoral roles in the service. As the bread and the wine were shared, the officiating priest emphasized that the AC was being transformed in the act of sharing together into one body. Physical presence and physically partaking of communion together was interpreted as connecting those present.

Members also described the dinner at a jazz club following the Mass as a "holy meal" and a fellowship feast. In accounts of other listmeets, sharing a meal with members and breaking bread was often compared to or seen as an extension of communion.

> It truly gives me a sense of the body of Christ being more than just the church in my little corner of the world to sit and break bread with people who did not know my face but who came to find me when I was lost, opened their home to me, fed me, and delivered me safely back to my hotel. (Email sent to AC, 17 Jun 1999, Subject: Re: listmeet)

The "church as sacrament" model emphasizes sharing in communal symbolic rituals. The sacrament of communion, in its various expressions, is seen to unite the AC with the global Anglican Communion.

While emphasizing the sacraments such as the Eucharist, AC members also place high value on the embodied gathering and communal sharing of communion with others. They value the ability to share fellowship with brothers and sisters in the faith online and learn about Anglicanism, but worship without physical presence is seen as incomplete. Because of the primacy of the Eucharist celebration, the AC can never be a complete substitute worshiping

community for AC members. The AC becomes characterized as one part of the larger Anglican "family of God," as one of many expressions of the church in the world today.

Through considering the narratives of these online Christian communities in light of Dulles's models of the church, the focus and understanding of the church within each community is clearly demonstrated. This shows that offline beliefs about religious community are often transferred online. While practices may need to be adapted online, the underlying traditions from which they stem often change very little. Therefore, online religious community cannot be neatly separated from offline expressions of church. Instead, online community must reflect core convictions similar to its offline counterparts. In this way online Christian community can be understood as embedded in the real world.

Supplement, Substitute, or Something Else?

Observing patterns of behavior within three online communities and how members compared or contextualized life online in relation to their offline church participation proved instructive. Most members clearly valued their online relationships and stressed the benefits online communities afforded them. Yet comparing the two realms proved challenging and even difficult for some.

Survey questions asking members to compare levels of intimacy, trust, and care between relationships online to those in their local churches drew mixed responses. Individuals who identified their online relationships as less intimate cited factors such as the time it takes to exchange emails and other limits of online expression. Those who felt their online relationships were more intimate stressed they experienced a lack of fellowship, support, or open communication in their local churches. One CP member from the UK who exemplified this, stated:

> I have been dealing with very deep issues in my life this past year and have found that people in my local church (which is small and a recent plant out) don't really understand. I have joined specific lists on the net and found these a lifeline! (CP Email Questionnaire Response, 12 Apr 1998)

Yet, rather than criticize their offline churches outright, most provided stories of how they negotiated or justified their participation online. These stories also supported the overarching claim made by members that online community was a supplement to, not a substitute for, offline church involvement.

CP as Altar of Remembrance

While some critics argue online involvement encourages people to leave the local church for fellowship through their computers, most CP members stressed that online Christian community supports the local church rather than becoming its replacement. Observations and comments made in the CP suggested online community could even encourage involvement in the local church. By providing a ministry outlet and forum for learning that was unavailable offline, the CP helped ease members' feelings of restlessness and resentment toward the local church. "I have been more content with my local church, for one thing, because my need in the area of being discipled and having prophetic fellowship is being met through the CP" (CP Email Questionnaire Response, 28 Mar 1998).

One clear example of this was Louise, a single lawyer from a rural area of Michigan. She referred to the internet as an "altar of remembrance," a place she continually returns to in order to remember "God is in control and at work in the world" and relive the times when she has personally experienced this (Personal Interview in Michigan, June 1998). Louise became part of the CP as a result of a visit to the Toronto Airport Christian Fellowship, the church linked to the "Toronto Blessing" Charismatic Renewal movement. Her pilgrimage to Toronto made a profound spiritual impact on her. She described it as an experience of inner healing of her childhood pain and encountering "the love of the Father [God]" for the first time. When she returned home and shared this experience with her church friends she felt she was speaking a foreign language to them. She wanted a place where she could talk about these experiences with others who could relate and be supportive. A friend in Colorado introduced her to a Christian email list. For her, "getting on the mail list was a continuation of what I saw in Toronto." A few weeks later she heard about the CP online and joined the prophetic training class.

Interacting with the CP allows Louise to stay "plugged in," reminding her "there is a 'move of God' happening" and she is part of it.

> We build our little altars of remembrance... when you are plugging into that on the internet, and you are seeing that God is saying the same thing to other people and he is working in the same way you are going, you know this is a real thing. It's really happening and God is really moving.... It really is a lifeline in a lot of ways, 'cause it keeps you plugged in. (Personal Interview in Michigan, June 1998)

When Louise returns to this altar of remembrance, her experiences with God and the worldwide church are made alive again. However, this online involvement did eventually breed discontent within her toward her church. It is a small, rural, independent, Charismatic fellowship of about 30 people, which

she described as having a narrow "us and no more" mentality. The church's activity revolves around the Sunday morning meeting, with no organized opportunities for fellowship, prayer, or Bible study beyond that.

She finds being single in a small church composed mostly of families difficult. After church on a Sunday morning, "I am always standing there like... let's talk... what is God doing in your life this week. But everybody is kind of wandering to their cars and leaving and so I kind of feel like I am left standing there." The year preceding the interview was a "time of crushing" for the fellowship, as the group experienced several significant relational problems. Tensions mounted until she felt she could no longer remain part of the fellowship. The internet, instead of drawing Louise away from her local fellowship, became a tool to encourage her to remain committed. It was a word shared on the CP that challenged her not to leave.

> I was getting ready to leave [my church] and then one day on the CP a word came forth that talked about not forsaking your local fellowship. It actually used the word fellowship... not church... so I felt that it was directly for me, just encouraging me to hang in there and not be so discouraged. (CP Email Questionnaire Response, 30 Mar 1998)

She printed off the post and placed it on her refrigerator for several months to remind her of the importance of commitment to a local church. This online exhortation motivated her to remain an active member and worship leader at her fellowship, and not to give up trying to build deeper relationships with others. In the meantime the CP helped meet her need for greater connection and support. She said, "It really can plug you in when you are in a place where really that is all the fellowship that you have."

Louise admitted that online community does not completely satisfy her desire for demonstrations of "loving one another." As an example she recounted a story of a family knew she who lost their home and a child in a fire. At that moment emailing words of encouragement was not enough. "They needed people who could physically put their arms around them and cry with them." While grateful people around the world were praying for them, "When you've just lost a child, it's hard to be comforted online." So while the CP can provide fellowship she feels is lacking in her local church, she also needs "real life community." As an altar of remembrance, the internet can be a place to reconnect with experiences of God by communicating to others with similar experiences and convictions. More importantly, it can encourage people to maintain offline connections by highlighting what the internet does well, connecting people, and what it lacks, physical support.

OLC Replaces Offline Church?

A majority of the OLC questionnaire respondents (10 of 12) viewed participation in their list as a supplement to local church involvement. However, the actions and behaviors of many of its members challenged this claim. Relational support was the main thing online community added for list members. As has already been discussed, the ability to develop Christian friendships and receive support were valued characteristics within the OLC. A majority described these relationships as more dynamic than those they had offline. As one OLC member active in a church commented, "OLC members know how I feel, because they feel much the same. I do not have a chance to share at this level in my local church" (OLC Email Questionnaire Response, 12 Feb 1999).

Viewing the OLC as supplement meant members charged online community and offline church with different roles or tasks. Local church was portrayed as the place where members received teaching, and the OLC where they found Christian friendships and spiritual or emotional ties. Members distinguished the roles of online and offline church in terms of the types and quality of experiences they encountered in those contexts. Members saw these as interconnected yet distinct spheres of interaction. Few (4 of 12) indicated the OLC influenced their local church involvement. Those who did stressed that the OLC supplied them with information they could bring to their churches or provided another venue for prayer. These qualifications about the supplemental nature of the OLC seemed linked to members' level of dependency on the OLC for fellowship and support. This was directly tied to members' current or past church experiences.

For Arthur, online friendships tend to be more "informal, because I can switch them off at any time." He doesn't feel "the same heavy obligations" for OLC members as compared to people in his local church. His involvement in the local community happens throughout the week, while he devotes much less of his time to the OLC. Yet because he believes Christians should be in daily contact with other Christians, he feels that the OLC can be an important place for fellowship. "Jesus is still alive here at OLC," Arthur says, but this does not replace his involvement in the local Baptist church and his "special ministry," focusing on one-to-one encouragement and support to marginalized people. It is not a formal church ministry, but one of his church leaders confirmed Arthur's "ministry of encouragement," by giving examples of his "coming alongside people who need a listening ear or encouragement, Arthur has a special gift for that." Arthur also attends a weekly prayer meeting and helps out with regular Alpha courses.[25]

While committed to his local church, Arthur understands this kind of involvement is not possible for some OLC members. Physical limitations and

the failure of some churches to accommodate or support those with special needs means many of Arthur's OLC friends feel distanced from or antagonistic toward church. Many OLC members indicated that offline church had not been an easy place to find acceptance, and offered examples of their struggles to find a church community they felt comfortable in. Three questionnaire respondents indicated they were currently not involved in a church. Two others indicated they were not satisfied with their churches due to a lack of support.

Rick described his experiences visiting churches as disappointing, as people he met did not live up to the Christian standards he has read about in the Bible. Church members, he said, had often been awkward toward him due to his blindness and hearing problems, either ignoring him or speaking to his wife instead of directly to him. By contrast, the OLC functions in the way he believes the church should behave, and he uses it to evaluate his face-to-face church experiences.

> Anytime I am involved with the church I hardly hear anybody speak like a Christian person would do, like you see on the OLC. People still have the nature to complain or the nature to gossip and I hear that and I see that at church, my wife's church.... When people get together at church, it's pretty much business. Where OLC is more social, but it goes deeper than social, it's just like family. It's really like family. (Personal Interview in St. Louis, Missouri, September 1999)

Because his online friends seem "more real" and his face-to-face contact at church has been so disappointing, he prefers to stay at home while his wife and children attend a local Catholic church.

Disappointment is also the story of Katie, who told of several failed attempts to become involved in local churches where she lives in London. Due to their blindness she and her husband have found it difficult to physically locate churches, having to rely on public transportation or rides from others. Also, having two guide dogs has caused problems, as some church members have reacted negatively toward them.

> You've not just got the barrier of introducing yourself to Christians who can see and being on a different playing field to them.... having guide dogs.... All these other barriers put together have made it very difficult to get into a local church and make friends. (Personal Interview in London, April 1999)

Six years of feeling unaccepted and unable to integrate into a church have left Katie and her husband frustrated. At the time of the interview they had taken a hiatus from church searching, opting instead for listening to tapes, radio, or visiting websites to receive Christian teaching. Katie joined the OLC to be part of a Christian community with other visually impaired Christians who can relate to "the same sort of difficulties that I have known in becoming integrated

in a main stream church situation" (OLC Email Questionnaire Response, 13 Feb 1999).

In Katie's experience, local churches often lack the ability to provide the acceptance and assistance that blind people require. The OLC meets the need to be understood and to be able to talk about these issues. Her infrequent attendance is not because of a lack of desire to be involved in a local church; rather it has been a "long saga" of finding it hard to fit in. This was illustrated by an incident when she and her husband had just started to attend a local church. One Sunday they got lost and were unable to find the church building, when they tried to make their own way to church after their ride did not show up. Katie later learned that several church members passed them on their way to the service and saw them going the wrong way, but no one stopped to ask if they needed help.

A contrasting incident occurred just before the interview, when she decided to take a break from the OLC due to an illness and a need to be offline and spend "more time directly with God." This break lasted only two weeks, because she received numerous personal emails from OLC members asking her to come back. Several members continually forwarded her the list messages, and one OLC friend emailed her every day.

> It indicated clearly to me the love and support of my OLC friends.... So I think if anything I saw that they weren't going to let me go easy and they still wanted to communicate with me. I kept getting the "come back" messages. (Personal Interview in London, April 1999)

While Katie emphasized that the OLC has become a significant part of her Christian support structure, it could not be a complete substitute for church. "The fact that I do not have a regular church at present is of great sadness to me, but the OLC does not take the place of a local church for me and never will." The OLC meets her need for the caring aspect of church, but not her desire for teaching. "You can't live a total church life within OLC.... You don't run Sunday school classes. You don't involve yourself singing, in leading music." Katie values the role the OLC plays in her life, but still wishes she could find a church home.

Stuart, the list owner, agrees that ideally OLC members would be part of a local body of believers, but recognizes it is very hard for some to be involved in a church. "I would hate to... use an electronic church as my only source of contact with other Christians, but if that's all a person has, then it can be a ministry to them as well" (Personal Interview in Colorado, September 1999). For him the OLC and the local church should work together, the electronic church serving as an extension of the church by connecting believers from all over the world and providing encouragement for those isolated from Christian

contact. The difference is that a local church is community-minded, while an online community offers a global perspective. "On OLC there's an atmosphere of fellowship that is generated just by the nature of the list itself and that's true in a local New Testament church."

The OLC may be described as supplement to local church involvement, but in reality, for some members it becomes a substitute. Overall what the OLC supplements is a listening ear, understanding based on similar experience, Christian counsel, and an opportunity to serve and support one another. What the OLC lacks is significant Bible teaching, opportunities for proclamation or evangelism, and the opportunity for local involvement in other members' lives. These are aspects of church that members see as important.

AC Online and Offline

As in the other case studies, AC members indicated that online Christian community supplements church relationships, and not involvement in a local parish. High levels of participation offline were evident among the AC, as many members held leadership positions as deacons, priests, lay ministers, and Christian educators.

The AC played a special role as a bridge between the local and global church, linking members to the larger Anglican Communion. This was illustrated in a discussion thread where the Anglican church was described as "the family" and the AC was identified as simply one expression of the family. "This Anglican Church of ours is getting more and more like one big family. You don't suppose this list could have anything to do with it, do you?" (Email sent to AC, 13 Jun 1999, Subject: post from rich woman). The family image was frequently used to explain the interaction of the Anglican Church with the AC. In light of this many members articulated the AC's purpose as strengthening links with the larger Christian community outside the local church. Helen said the AC had taught her that the Anglican faith community "is much larger than I would have thought it was; I am not sure I would have stopped and thought about it, but I would have felt more alone" (Personal Interview in St. Joseph, Michigan, August 1999). Yet while the AC can bring awareness of the breadth and diversity of the Anglican Communion, it can also stir up discontent concerning aspects not experienced locally.

Some experience deeper fellowship within the AC than in their local parishes for several reasons. A few find there is greater freedom online because they are involved in church leadership and cannot be as open or intimate in their home parishes because of their roles. Others commented the diversity and commitment to church-related discussion created deeper levels of

dialogue in the AC than those taking place in their local parishes. One active church member commented,

> The list enables me to engage in levels of thinking and listening that aren't possible in parish life. The topics are often not of the sort one finds in parish gatherings and of course there's no clergyman leading the discussion! (AC Email Questionnaire Response, 28 Jul 1999)

Several others echoed this, as another said, "I know more about many of the people on AC than I do members of my parish" (AC Email Questionnaire Response, 11 Aug 1999).

The uniqueness of AC relationships was explained in saying online community involves dialogue at a level many find hard to facilitate in offline parishes. Helen, who strongly advocates commitment to the local church, did concede, "It takes a very, very long time in a parish face-to-face to talk with people about the kinds of things we talk with each other instantly about online." The local parish, she said, presents barriers to deep conversation. Until someone participates in church ministry or attends numerous adult education groups, there is little opportunity to discuss personal issues of faith and theology.

> This group (the AC) cares a great deal about theology, talking a lot about their religion or their faith. In a parish you may have a handful of those people, but those people will not have worshiped in a thousand different churches, in different countries.... You don't get to know people in a parish (at this level), so it is much easier to become part of the AC community than it is to become a member of a parish. (Personal Interview in St. Joseph, Michigan, August 1999)

At the time of the interview Helen said she was too busy to "relax with the list" due to a recent move and new job, but felt the AC community was important, especially being in a new community with few friends. Over the past five years she has grown quite comfortable with many AC members, saying "we now also pick up the phone and call too." The intimacy she experiences with members is linked to numerous face-to-face meetings she has attended. Helen has met at least 75 list sibs at various conventions, organized gatherings, and meetings at train stations or airports.

The AC facilitates an atmosphere that has been described as a "global coffee hour," referencing the fellowship times some churches hold between or after services on Sunday, and highlighting friendly communication between members. Jonathan, who serves on his parish vestry and is also training to become an Episcopal deacon, said his AC interactions are often more vibrant and enjoyable than those in his church. "The AC refreshes me. The vestry gets me down." On the AC he describes himself as providing "friendly support,"

whereas on the vestry he is often frustrated by his role as simply a respondent in business meetings, which may not allow for personal interaction.

High levels of trust on the AC have been attributed to the commitment of many members, and frequent face-to-face meetings, which strengthen investment in one another's lives. Also, as in the OLC, a few members' disappointing experiences with offline church have encouraged them to go online in search of fellow Christians they can trust. As one member stated, "I have to say that I do not find a lot of honesty and trust in my present in-the-flesh congregation. I guess some of my online searching for community goes towards compensating for this lack" (AC Email Questionnaire Response, 29 Jul 1999). In the questionnaire three members indicated the AC was their primary faith community, emphasizing they had been damaged by the church and were not ready to reinvest themselves in a local parish. The AC provided a safe way to stay connected to the Anglican Communion, while "healing" from bad experiences of offline church.

Although the AC provides aspects of community articulated as lacking for some, most members were adamant that it cannot substitute for participation in a worshiping community where sharing the sacraments is highly valued. The AC highlights people's desire to be part of something larger than their local churches, to be connected to like-minded worshipers from a similar tradition. It highlights how individuals transfer and adapt their denominationally focused beliefs online. While members described the AC as an important sphere for connections with other Anglicans, most recognized it does not provide embodied sacramental worship, and labeled it as a supplement to local parish involvement. For those in certain sacramental traditions, online Christian community will always be limited in its worship experience, yet limitless in the connections it can provide with other believers.

Online Community on Offline Church

Examining how each online community compares or contrasts experiences online with those in the offline church provides a valuable insight into how Christian community and church are conceptualized in the age of the internet. Online religious communities observed here are valued because of the friendship, Christian support, and encouragement they provide. These are also attributes some members identify as lacking or weak in their local churches, such as Helen's experiences of finding deeper theological dialogue online or Rick's experience of being treated poorly offline. Online community members also value opportunities to receive teaching or serve others in ways unavailable to them in the offline church, whether by developing a "prayer counseling" ministry within the OLC even while housebound, or by

learning about prophecy in the CP while being part of a local church that is open and receptive to "gifts of the spirit."

In these respects online religious community can provide what Howard, a CP member from England, described as "a taster of what the real world church should be like" (Personal Interview in Devon, England, July 1998). Like others in the CP and OLC, he attributed much of his spiritual growth in the last few years to his involvement in various online communities and relationships. Online community allowed him and others he knew to "minister, pray, prophesy, give and receive teaching online," with a wide variety of contacts and contexts. In the past he had been active in an Anglican church, serving on various church committees and leading children's church. However, because he could not openly share or "minister" in "spiritual gifts," he had pulled back in his participation. During the interview we visited a local church he had connections with as a leader of the local YMCA. Though Howard appeared to have many Christian contacts in his community, he described himself as "church-less."

His experiences, and the testimonies of others such as Rick, Katie, and Louise, raise questions about the long-term effects of online religious community participation on local churches. If online community appears to meet more core emotional needs than offline community, it is understandable that members might become more invested in online relationships. Disappointing or limiting experiences in the offline church may also lead to dissatisfaction with the offline community, and consequently encourage increased online community involvement. A claim of this study is that many members use online community as a benchmark for evaluating offline community. Identifying desired relational qualities found in online community, such as emotional intimacy, trust, honesty, and openness, provides a general critique and redefining of the concept of community. When the internet produces relationships described as more intimate than those in the church, the question must be asked: Could online community become a substitute for offline community?

While more reflection and attention need to be given to the long-term effects of online participation, current research suggests that online community in itself is not perceived as complete. As encapsulated in the idea of the "Chocolate Chip Cookie Factor," online community can be an effective and cherished supplement, but because of lack of physical presence and embodied expressions of care, it cannot be a full substitute for involvement in a local church. Even in the face of strong critiques of offline church, the internet only partially meets members' needs for Christian fellowship.

Online involvement expands people's notion of "Who is my neighbor?" from a local to a global perspective, so conception of the "body of Christ" includes Christians with whom they communicate both online and offline.

Online community members are not content to be involved solely in a local church, but see church to be what has been referred to as the "g-local," the global community accessible through a local communication medium. In this way, the global church with localized involvement is becoming a reality. Yet involvement in a church reaching all around the world is tempered by the "Chocolate-Chip Cookie Factor," which keeps individuals seeking relationships offline as well.

This was clearly voiced by one CP member:

> I have found once again that God has no limits and have discovered spiritual reality in cyberspace. Live church can be "dead" or even bring death in empty exercises.... likewise cyberspace participation sows death or life depending on whether the individual is sowing into his flesh (death) or into the Spirit (life). To set the mind on the flesh is death, but to set the mind on the Spirit is life and peace (Romans 8:6 RSV). (CP Email Questionnaire Response, 30 Mar 1998)

The influence and power of online religious community lies in the narrative and corresponding behaviors of its members. At the Great Anglican Listmeet, Tom from New York stressed that not all online communities are like the AC. He named other Anglican email lists that attend more to theological debate and where "you get the sense of a lot of bitterness, and it makes it an uncomfortable place to be." These lists, he said, offer a distorted, negative picture of Christian community because "people could stumble onto a list like that to find out about the church and they might get a bad impression" (Personal Interview in Toronto, Great Anglican Listmeet, September 1999). Not all religious email lists create a community that others would want to emulate offline, but in this study several distinct and valuable characteristics of community have surfaced. These are worthy of greater exploration.

We Are One in the Network:
Understanding Religious
Community Online

In the last three chapters we have charted the online narratives and practice of three particular Christian email lists, to see how members conceptualize community online and the effects this has had on their perceptions of church and religious community. Evidence has come from observing and engaging with the lives of several hundred online community members. At the Great Anglican Listmeet, the halfway point of this study, several AC members who were curious about the outcomes of my research cornered me. I emphasized that my two main findings at that point were that online Christian community was used as "supplement" rather than a substitute for an individual's involvement in the local church. Also what I had found as surprising, and even a bit concerning, was that it was personal or relational input and not simply information that was being supplemented for most users. None of those who raised this question seemed surprised about the supplemental nature of the online community, as one middle-aged man from New York stated "that's why we are here this weekend, to get some actual face time with each other." The relational focus of online community was seen as a healthy and expected by-product of investing in the lives of others online, something local churches, unfortunately, do not always facilitate. As an elderly woman from Minnesota announced to the AC members over the Sunday brunch with tears in her eyes, online community is "ordinary people who love each other a great deal.... The more I get near you lot, the more I cry... at what we have.... I see people here and I can not only relate to them face-to-face, now I can see their faces when I read their posts."

After seven years of research these initial assessments about the nature of online community have not changed. Instead, they have been reinforced through examples and testimonies from various emails, questionnaires, and interviews. Many of these claims about internet use were startling and poignant. Some affirmed the perceived importance of online experience.

> I am a raging extrovert married to a raging introvert...The cyberworld has allowed me to have hundreds of people over to our house without making (my husband) uncomfortable. I appreciated that—It has helped us stay happily married. (AC Email Questionnaire Response, 28 Jul 1999)

Other remarks were challenging, offering critical reviews of offline community and church.

> I think OLC's strength and why a lot of blind Christians go to OLC is that there is there a community who not only cares but understands what blind Christians in particular are going through...I don't know that a local church could do any better. (Personal Interview with Katie from OLC in London, April 1999)

Comments like these call for serious reflection on how online community influences and challenges traditional forms of religious community. Much discussion about online community involves advocates emphasizing how it will reinvigorate modern society's lost sense of community, and critics arguing about how it encourages people to withdraw from face-to-face interaction. In contrast, my research has sought to approach online community as a critical friend, seeing it as a new social formation that is changing our understanding of social relationships in significant and often unintended ways.

The presence of online community forces a discussion about the nature of contemporary community as seen through the eyes and experiences of those who participate in community life online. After journeying through the practices and stories of three online religious communities, I now turn to the task at hand: to encapsulate this emerging shape of community. This chapter provides a summary and synthesis of the key findings about the nature and character of religious community online, along with the lessons and challenges it poses to offline religious community and church.

Embodied Church versus
Disembodied Congregation

Through this exploration, we have considered how three online religious communities present themselves online, use email, connect their online and offline activities, link themselves to specific narratives of the Christian church, and

compare their online and offline religious engagement. These online communities function as a social network, using the internet to build and sustain relationships. Each also presents a unique narrative rooted in a particular religious and social purpose, used to bring a cohesive identity to the community and a sense of worth or place to its members.

The Community of Prophecy (CP) gathered as a prophetic learning community. A key concern of the leadership core was how members treated each other in this pursuit, and thus providing boundaries that frame it as a "family" and a "safe place" to learn. As a "spiritual network" the group saw online community as designed and initiated by God for a specific spiritual purpose. Members were "pioneers" on a divine mission, a narrative that empowered them to see their community as having the potential to influence the global Christian community.

The Online Church (OLC) presented itself as a "place of refuge," with the role of encouraging and nurturing its members. Value judgments were avoided, and positive, supportive posts were encouraged. As "support network" it served as a support group, where an individual's problems became the community's problems, emphasizing transparency and disclosure. Many members shared common physical limitations and struggles. As a place of "blind" acceptance, providing members support, which was often unavailable to them offline, it encouraged a tight cohesion and often inward focus.

The Anglican Communion Online (AC) gathered for dialogue and debate on issues related to the Anglican Communion, but it provided connection with people and not just with the institution of the church. The craving for connection to "something bigger than ourselves" created investment in the community by its members. As a "religious identity network," the community was identified as a microcosm of the larger Anglican Communion as members emphasized their commitment to these distinct beliefs and practices. This enabled members to see their online involvement as an opportunity to be "interconnected sacramentally" with others from the same tradition.

Email encouraged brief, direct, and frequent communication as well as created distinctive patterns of communication. Members, especially self-described introverts and those with physical limitations, felt that email provided a new kind of freedom in their communication, allowing more time for reflection and providing greater access to social contacts. Yet, the technology's lack of visual, nonverbal boundaries also elicited antisocial online behavior such as spamming, flaming, deception, and confrontational exchanges. While members appreciated the benefits of email, they voiced a longing for more personal expression than the internet allows, and attempted to bridge this gap through emoticons, cyberhugs, and sharing of personal information in email.

Members also connected their online experiences with offline relationships and interactions. Internet use became a fixed part of many members' daily routines. Members desiring more intimate contact with their online friends attempted to reach beyond the screen by establishing phone contact or arranging face-to-face meetings with others. Sharing personal details about individuals' offline lives was encouraged. In a few instances offline needs shared online resulted in members sending financial or material support to others. As well as bringing offline information into online conversations, members brought online information to their local churches. Online community involvement extended members' spheres of influence and opportunities for ministry.

Online community was also used as a baseline by members to describe or even critique offline church. By highlighting specific, positive characteristics they saw online, members identified online community as a valuable part of their spiritual lives, enabling them to connect with God by sharing with others of similar experience or convictions. For many, the online community appeared more honest and supportive than the community of their local church. Members also valued online prayer support and access to teachings or discussions not available in their offline churches. However, most stressed that online fellowship was "incomplete" because it lacked nonverbal feedback and touch.

Another key finding was that online Christian community structures mirrored manifestations of local church that came from similar theological traditions in their ministry focus and message. The Community of Prophecy exemplified the interpersonal "mystical communion" model, which stresses unity and the role of the Holy Spirit in the life of the church. The Online Church represented both "herald" and "servant" models, encouraging members to share "testimonies" of faith, and trying to be a "church for others" by offering assistance to those who were hurting. The Anglican Communion Online exemplified the "sacrament" model, placing high value on Anglo-Catholic liturgical worship and sharing communion. Because it was recognized by many that "breaking bread" is not possible online, that became the focus of many of the community's face-to-face listmeets. In light of these findings, three conclusions about the nature of online religious community can be drawn.

Claims about the Nature of Online Religious Community

A Supplement, Not a Substitute for Offline Church

> You can't live a total church life within OLC. You can't be involved in Sunday School classes...in leading music.... The fact that I do not have a regular church

at present is of great sadness to me. The OLC is not something which takes the place of a local church for me and never will be. (Personal Interview with Katie from OLC in London, April 1999)

From this exploration of online religious communities it can be concluded that internet use is not causing most people to leave their local churches or to shy away from face-to-face community participation. The majority of community members described their online involvement as a "supplement" rather than a substitute for local church involvement. Most indicated they were active in a local congregation, with many holding leadership positions such as Sunday school teachers, lay readers or ministers, prayer team members and even members of the clergy. Others also indicated they frequently shared with their churches the teaching and prayer requests they received online.

For members, participation in these online communities served as a supplement or bridge to certain aspects of community life from which they felt disconnected in their offline lives. Community of Prophecy members were cut off from what they saw as prophetic input and engagement. Online Church members were isolated from people due to their sensory impairments. Anglican Communion Online members felt a need to connect with people and information related to the wider Anglican Church.

Online community was described as adding to the experience of the local church. One AC member used the phrase "companion parish" to describe how it enabled him to connect with the global church online and the wider body of Christ. Another AC member said online community had been valuable for her self-esteem since she was judged by "the ideas I put in print" and not her clothes or mannerisms. A Community of Prophecy member described online community as a "sounding board," a place to ask spiritual questions, receive advice, and stay "up-to-date on what God is saying all over." What it supplements is spiritual information and, more importantly, interaction. This is expanded upon in the next conclusion.

Those few individuals who indicated online community served as "substitute" for offline participation indicated they had a need to be part of the local church, but their current circumstances prevented it. Members gave three reasons for not being involved in local church: being unable to locate churches that would accept them; being unable to find a church that could provide the teaching or interaction they wanted; and being unable to overcome previous negative church experiences. As OLC member Katie affirmed, she missed participating in live worship, singing, and receiving regular teaching, but until she was able to find a local church willing to accept her and her disabilities, the online community met her need for the "caring and sharing" part of church.

While online Christian fellowship was valued, most members stressed that participation in local churches was also important. Many noted the lack of

physical contact during times of crisis as a disadvantage of online community. Email and the internet facilitate frequent contact with others, often more consistent than what members experience in their local churches. However, this is a limited form of contact, typically text-only. The "Chocolate Chip Cookie Factor" describes members' desire for face-to-face and physical contact with one another. Touch is an important part of expressing care. As one AC member said, "I can't share Communion with the List, and I can only very rarely hug them." This is the main reason that online community does not usually become a full substitute for local church participation.

A Supplement to Offline Relationships

> They were my psychiatrists. They were my counselors. They were my social workers, and that was email. That was not face-to-face and not over the phone, that was email. (Personal Interview with Rick from OLC in St. Louis, Missouri, September 1999)

Online community provided a supplement in the area of relationships. While members emphasized online community is supplemental, what they noted, as being supplemented was personal interaction and friendship, and not simply information exchange. While some initially join online Christian communities for information, they typically remain members because of the friendships they form. Whether it was interaction through CP teaching, input from others in the OLC or fellowship with those who share common beliefs in the AC, each online community valued the way the internet facilitates relationships.

The CP created a teaching platform that encouraged members to interact with other would-be prophets while learning to function in the gift of prophecy. Members valued the opportunity to practice ministering to other members all over the world. Prophetic ministry encourages speaking into the lives of others and personal prayer, which can quickly generate emotional attachment to others. This attachment bred affinity for community, as people interconnected in a divine mission.

OLC members noted relational support as the primary component supplemented by online community. The OLC provided a "listening ear," people who understood their physical limitations, Christian counsel, and a place to receive support and encouragement. Many described online relationships as more dynamic for those with sensory impairments than those found offline. The local church was described as a place where they received teaching, but the OLC was where members found Christian friendships and spiritual and emotional input.

In the AC the ability to interact at a deeper level online was highlighted. Several members commented that they knew AC list sibs better than members

of the local parish, because online community focuses on dialogue at a more profound level than offline parishes. One member noted that the local parish facilitates few opportunities to discuss personal issues of faith and theology in depth unless you are involved in church ministry. Individuals became committed to online Christian community through forming relationships with people who seemed to care for them.

Online community provides members with a sense of belonging. The importance individuals placed on online relationships and socializing was dependent on members' past or current church experiences and job circumstances. Online community can be described as the search for a "virtual *Cheers*." (*Cheers* was a television sitcom that revolved around the lives of a group of characters who gathered daily at the same local bar.)[26] Online community touches on people's desire to belong; as the show's theme song says, people want to go, "where everybody knows your name, and they're always glad you came." Online community becomes a place people value because they experience friendship, affirmation, and emotional investment there.

Descriptions of Online Relationships Highlight Desired Qualities of Religious Community

> In your own parish and in your own small little world you don't find that many people who are highly literate. This group (the AC) cares a great deal about theology, their religion, their faith. In a parish you may have a handful of those people, but those people will not have worshiped in a thousand different churches, in different countries.... You don't get to know people in a parish (at this level), so it is much easier to become part of the AC community than it is to become a member of a parish. (Personal Interview with Helen from AC in St. Joseph, Michigan, August 1999)

When members described the benefits they received from online community or gave reasons for their online involvement they often identified characteristics that came from a definition of a distinct kind of community. Members, in some instances to critique their experience of offline church, also used these characteristics. These three online Christian communities described themselves as families, and consciously tried to create a kindred atmosphere. In each case, the description of online community as family was qualified; a particular type of family or narrative was highlighted by each group: the CP as a prophetic family, the OLC as a supportive family, and the AC as a church family. Each description stressed the community's story and their self-perception as a healthy family in which people care for one another. The online family was seen as part of the larger Christian family, enabling members to engage with Christian brothers and sisters from whom they would normally be separated due to geographic or physical limitation. This description paints a positive

image of online relationships. Descriptions of online community as family also implied in several instances that offline community was unbalanced or unable to meet certain needs that were being met online.

People are drawn to online community for a variety of reasons. Those who are housebound or have limited time for offline socializing valued the ability to "talk" to others online and develop friendships. Offline church was often criticized for not facilitating times for discussion or opportunities to form intimate relationships. Several members referred to online community as a 24-hour church, offering instant access to other Christians any time of the day or night, filling the gaps between church services and events. Also the instant access to sharing and receiving prayer online was a desirable trait of online community. Prayer support was noted by some as the primary reason they were active online. Members said they felt they could trust those who committed to pray for them online, unlike local church members with whom they had little relationship. Therefore, online communities were perceived as more accessible and open than local churches.

Another key benefit of online religious community was the internet's ability to expand the members' vision of what it means to be part of the "body of Christ." As one CP member said, "online community... is international in scope, so it brings greater immediacy to the 'abstract' doctrine of the universal Body of Christ." Many members articulated frustration at their church's internal or local focus, and others' apparent lack of interest in or awareness of the wider Church. Online community was seen as "glocal," having a global awareness within a local context.

While these comments tend to paint a completely negative picture of the offline church, it is important to note that most members, while praising their online community, also qualified these claims. Some online community members shared distinct reservations about the extent of honesty and trust individuals could achieve online. Comments about the limits of intimacy and depth of relationship online were also noted. Those who emphasized the benefits online community could bring to the "body of Christ" as a whole often did so with a hint of hesitation. A balance between online and offline community and church involvement was said to be needed, recognizing the strengths and weaknesses of both environments. Both can invigorate or stifle relationships depending on how they are structured and focused. As a CP member explained: "Live church can be 'dead' or even bring death in empty exercises... likewise cyberspace participation sows death or life depending on whether the individual is sowing into his flesh (death) or into the Spirit (life)" (CP Email Questionnaire Response, 30 Mar 1998).

Descriptions of online community critiqued the offline church in several ways: (1) by stressing the ways it functioned as a family; (2) highlighting op-

portunities it provides for interaction; (3) emphasizing the ability to facilitate caring relationships; and (4) demonstrating in a concrete way the idea of being part of the global body of Christ. When describing an email list as a community, members often said the internet facilitated higher levels of intimacy, care, and commonality than they experience in their offline faith communities. Members pointed out several common characteristics that distinguished their online relationships, including the ability to be transparent online, frequent contact, demonstrating care and intimacy through open communication, acceptance by others from differing backgrounds, and being "known" within the group. These traits lead toward a redefinition of what community means to people in a digital age.

Attributes of Religious Community Online

While observing and interviewing online community members, I found that several key attributes were noted as desirable in an online community. These attributes become defining characteristics of community in general, and serve as baseline qualities people hope to encounter in a local church. Online community members as part of their experience of community online noted that they appreciated attributes such as relationship, care, value, connection, and intimate communication. Shared faith was also noted as a distinguishing quality of religious community online. This attribute, defined by members' interpretation of a shared story and contextualized by certain religious practices, offered a unique picture of how individuals conceptualize Christian community. Identifying and expounding upon these characteristics, one begins to form a distinct conceptualization of community.

Relationship

> What I am experiencing on the internet... it makes the whole thing of the Bride of Christ more feasible... not just something to read about. (Personal Interview with Charlotte from CP in Illinois, June 1998)

Online community was noted for its ability to provide and support relationships. Members gave evidence that they experienced close relationships with others online. Many definitions of community provided by online community members were people-focused and relationship-centered. Common phrases noted in several interviews were "bound together by beliefs and interests," "a group of people who gather for fellowship," "come together for a common purpose," and "have a common sense of care for one another." Essentially, these definitions described community as people focused on building and

maintaining relationships directed toward a common purpose. Christian religious community was expressed as "a group of people who recognize that connection of being in the body, and see themselves as brothers and sisters in Christ, supporting one another in their worship and devotion" (Personal Interview with Gail from AC in Virginia, July 1999). In this form of religious community, people describe God as the central focus of relationships, and God is active in supporting the network of relations formed. Community is described as God-created friendship bonds.

Relationships formed through communication are central to online community. Email-based communities allow members to learn about others through their postings, without having direct contact. This creates a sense of knowing one another, even if it is actually limited contact. A local church's focus is divided among a variety of tasks such as service preparation, maintenance of buildings, budgets, and other structural duties. The facilitating of relationships within the offline church is often limited to select Bible study or small groups, and seen as the responsibility of individual members rather than of the church organization. People may feel limited in the number of relationships they can develop due to other duties and responsibilities within church life. Online relationships are self-selected based on personal preference. Contacts through offline church can be seen as a by-product of church participation, but people want to have relationships with others, not just contact. They crave the chance to connect with other people and to allow others to become involved in their own lives. While not all members experienced close personal relationships online, the majority reported observing such relationships.

Care

> I've had communication online where I've really felt "hugged" when I really need it. (Personal Interview with Louise from CP in Michigan, June 1998)

Care, evidenced by the ability to give and receive support and encouragement, is another valued quality of online community. Members provided many examples that indicated they felt cared for and accepted by their online communities. Email enables individuals to receive frequent and instantaneous responses to their prayer requests or confessions of personal struggles. Self-disclosure online can be easier for some individuals than face-to-face confessions. Members observe the online community's ability to care for one another through reading public posts of encouragement directed toward specific individuals. In this way, the online community seems to be a supportive place where people are loved and understood. Individual and communal expressions of care and acceptance create a unified and "safe" environment.

Some indicated offline church was not an easy place to find acceptance, especially when one is disabled or hold different views. Online community provides a social outlet where people are judged on the basis of their written words and not physical appearance or ability to speak articulately. Online community becomes a place people go to in search of sympathetic Christian support, which many identified as lacking in their offline interactions. Individuals want to be cared for. They want to know their voices will be heard, their opinions supported, their need for encouragement met, and their self-disclosures protected. Evidence of care is also given through members identifying with one another's weaknesses or longings. Feeling cared for encourages members to display empathy for others in the community. People desire to be cared for, and in exchange, care for others.

Value

> I really love (most) of the folks on the list! It's very difficult to leave the list. I've left twice over frustration (we run cycles where the same threads get hashed out over and over again when new folks come on board...) and once because the volume of mail simply became overwhelming. Since I joined 2-1/2 years ago I've left three times and the longest time away was about three weeks. I've always rejoined because I miss the people, I miss the banter, I miss learning new things and I miss what's happening in the lives of my list mates! (Email sent to AC, 26 May 1999, Subject: Web page and the AC)

Active members want to be valued by their online community as individuals with something to say and contribute. A sense of being valued seems to encourage contribution and investment in communal conversations. When others respond to their posts, members feel their place in the community is affirmed. As posting equals presence online, a member's sense of value can be correlated to the frequency or transparency of posts made. Testimonies of members' struggles often elicit prayer or supportive comments; this validates the member's personhood and presence within the community. Feeling valued in return encourages them to value other members of the community. Many online communities have a long-term, established membership where people are consistently encouraged to stay committed and involved. The value of members is also tied to their emotional attachment to the group. It is not simply group pressure that maintains membership, but a combination of personal emotional investment and public participation that affirms their place in the greater community.

Experiencing and bestowing value also involves people recognizing each others' names and roles in the community. Individuals often gain identity through taking on a specific role or perceived task within the community—whether it is an official role such as prayer list coordinator, discussion

moderator, or technical consultant, or a self-selected role of encourager, information source, or counselor. One CP member described herself as a "walking pool of information" on select topics she writes about online and gleans from the community in order to inform her local church.

People also desire to be part of a community that has perceived importance. Communities with a clearly defined mission or purpose offer value to their membership by providing the opportunity to be a part of something of larger significance. Members who see their role and involvement within a group as purposeful often endow their online community with greater significance, which is often transmitted through a communal narrative. People seek purpose online, to be valued and to see their community as valuable.

Connection

> Close physical community is important, but I don't get the same feeling for prayer that I do when I am with the AC. And I know when at the AC when someone says they'll pray for me, they will. That's a given. That's a trust because I have seen it happen. Whereas at church someone can say "oh I'll pray for you" but I don't know that they will. (Personal Interview with Jonathan from AC in Missouri, September 1999)

Members of online community desire connection through frequent communication. They crave the ability to maintain consistent contact with their valued online relationships, a trait easily facilitated through the internet. Accessibility 24 hours a day is a unique aspect of online community; individuals with internet access have the potential for fellowship with Christians at any hour of the day or night. This is especially valuable to those who experience an unexpected crisis or struggle with emotional issues such as loneliness or depression that often surface late at night. The internet provides a "seven days a week ministry" that is often unavailable from the local church due to time pressures and resource limitations. Online communication is used to fill the gaps between scheduled church meetings and times of fellowship with other Christians. Email is a quick way to check in on others, share a concern, or ask for prayer as needed.

Many people desire persistent contact with Christians in a common project. They want to be able to connect with others publicly and privately on issues of faith. Email creates a written record of words of advice or encouragement, a visual artifact that can be referred to later. It also allows people to be part of a discussion with the benefit of not having to congregate at a specific time. Online connections also offer freedom of choice: people can choose when, for how long, and to what extent they want to be involved, unlike a face-to-face church meeting, which is limited to a specific time and place. This

fits in with many people's hectic lifestyles and busy schedules. People desire frequent and consistent contact with others who offer them support and a listening ear, even a "cyber" one.

Intimate Communication

> WE have been absolutely amazed at how the Holy Spirit can use something like email to touch the hearts of folks half way around the world even to the point that they weep. For this we praise Jesus, knowing that He has touched them through electronic email. That is a miracle. (Email sent to CP, 22 Mar 1998, Subject: How did the course go?)

Intimate communication that provides a safe place for transparency and encourages accountability was another noted factor of online community in these studies. Online interaction is described as intentional, purposeful, and focused. Some find it is easier to "go deeper" more quickly online, as small talk is not essential for establishing relationships and interaction. Online community members felt that many relationships in their local churches were limited to small talk, with in-depth discussions of beliefs being limited to select Bible studies or adult education groups. Online it can be easier to find others who share commonality of experience and belief and to discuss these in an open forum. Those who desired to talk about specific issues, whether spiritual or emotional, perceived online communities with a clear mission as an ideal space for intimate and in-depth communication.

Some online community members had been disappointed with church offline; this encouraged them, they said, to go online in search of Christians they could trust and with whom they could be honest. People desiring to be part of a community also look for honesty and transparency in communication. They want to be with others who are willing to share personal details of their lives, and hope they might express themselves in personal ways, while knowing this disclosure would be honored and treated with respect. In a sense, people are searching for a communicative place of refuge where they can find nurture, respect, understanding, and like-minded individuals.

Members said they also longed for "significant spiritual friendships" and "spiritual soul mates" who would challenge, encourage, and keep them accountable in their spiritual growth. When people find these relationships they exhibit high levels of dedication to the context in which they are formed. When relationships are formed online, face-to-face meetings can be deeper and richer because a general knowledge about the person and his or her convictions has already been established. Intimate communication online also increases individuals' desire to have face-to-face contact, to extend their relationships to a new level. People want intimate, safe relationships that exhibit high levels of

self-disclosure and shared beliefs. They also long for honest communication with individuals they feel they can trust.

Shared Faith

> The CP was just another expression of a relationship with Jesus Christ and His Church and His calling of us to be ministers of the gospel. (CP Email Questionnaire Response, 30 Mar 1998)

Online religious community is different from other forms of online community in that it is a gathering around a shared faith. This differs from other topics or foci in that it is linked to a common search for meaning and purpose, in light of a distinct interpretation of life and reality. Members connect not only to the specific community, but also to a larger community and meta-narrative that provides meaning. This spiritual narrative informs members' choices and beliefs about the world, both online and offline. It determines the practice the community pursues, such as online prayer ministry, as well as the topics of discussion. While online religious communities differ based on the particular religious traditions to which they ascribe and their interpretation of that tradition, they do share a common conviction in the search for transcendent meaning that goes beyond the screen and even beyond the offline world, touching on another recognized level of reality.

Within the context of Christian religious online community, members share a common view that God transcends the internet and is at work and in control, both online and offline. They also share a common understanding that Christian community online is just one part of an unseen network of believers. Experiencing community online helps them to conceptualize this larger global body of Christ. They are co-laborers with Jesus Christ in community, charged to build a community that mirrors the divine community of love, equality, and unity.

The shared faith of members informs their behavioral expectations of other members, including expectations of truthfulness, compassion, fairness, and tolerance. Online community members are to be treated with respect as people made in the image of God. The act of communicating or interacting online can also be interpreted as an act of worshiping God, through caring for others and ministering to those in need in the community through prayer or spiritual gifts. This shared faith also provides a common language, which supports members' identification and investment in one another. It provides a framework for interpreting conversations, images, and even emoticons online. Being online can be seen as empowering members in their spiritual journey and reinforcing their distinct beliefs about life and the world, online and offline.

Attributes of Online Community

This section details six attributes that people desire in a community, based on observations from this study. People look for relationship, to be connected and committed to others. They desire care, to be cared for by their community. They desire value, to be seen as valuable as an individual and part of a community of value. They seek consistent communication with members of their community. They long for intimate communication, where individuals share openly about their beliefs and spiritual lives. Finally, they gather around a shared faith that influences how they see others online and how they understand the interconnection between online and offline aspects of life. This presents a picture of community based on communication, commonality, cooperation, commitment, and care. It portrays community as more concerned about how individuals are treated than about the structure or focus of the community.

These characteristics correlate to the findings of other studies seeking to identify and evaluate criteria for online community. Blanchard and Markus (2004) pinpoint six categories and three community-like processes in their "sense of virtual community" index. Their index is based on work done by McMillan and Chavis (1986), who developed a conceptual model for how people differentiate between neighborhoods and true communities, or how individuals identify an authentic sense of community. They underscored feelings of membership or belonging, influence through participation, fulfillment of needs, and shared emotional connections as important elements of community.

Blanchard and Markus applied this approach to a study of online community in a newsgroup for those participating in and training for multiple sport events such as triathlons. This was a longitudinal study of observations and semi-structured interviews with members of the newsgroup focusing on how they conceptualized the newsgroup as a community. They determined that a "sense of virtual community—a feeling of belonging and attachment" does not occur in all online social groupings, but when it does distinct social processes and behaviors mark it. The social categories identified were: *recognition*, members could recognize each other; *identification*, creation of personal identities which members could attribute to themselves and others; *relationship*, linked to personal friendship, private online communication, and face-to-face interactions; *emotional attachment*, to the community as a whole and not just to individual members; and *obligation* to the community. The community-like processes identified by Blanchard and Markus showed an integration of the social categories. First, *exchanging support* in public and private acts showed the community was "something one belonged to and to which one had a sense of

attachment or obligation" (Blanchard and Markus, 2004). Second, the process of creating identity and *making identification* showed personal investment in the community and others. Third, the *production of trust* reinforced the idea of being in relationship. Overall, they found a sense of virtual community was determined by the presence of specific processes and characteristics present and maintained over time. Blanchard and Markus's indicators, which are similar to the ones synthesized from this study, provide a useful assessment of community online. They show that the characteristics of online community relate directly to the desirable social process of community in general.

This also correlates to desired qualities of religious community and church. In a 1998 Barna survey, Christian church-goers were asked to rate the importance of a variety of factors related to whether or not they would return to a church they have visited. Among the prime areas assessed were church relationships and interaction. Over half the respondents indicated friendliness and how much people demonstrated care for one another as a key factor in determining whether or not they would return to the church. Online community, in many respects, magnifies these desired traits of religious community. It also presents traditional religion with several lessons about the features of contemporary community and the potential challenges that are emerging from the phenomenon of religious community online.

We Are One in the Network:
Two Lessons and Two Challenges

LESSON 1:
Contemporary Community Functions as a Relational Network

The idea of community as a relational network underlies many of the claims being made about the nature of contemporary community. Community is defined as a network of relationships of people who share a common purpose. In relation to the internet this translates as online community being a social network. Shared interests and goals may motivate users' initial choices for membership, but based on attributes of community outlined in this chapter, it seems that once members become invested in an online community it is the social interaction they experience that solidifies their participation. As noted in chapter six, social engagement online "binds the task-oriented aspects of CMC together" (Katz and Rice, 2002: 203).

A principal argument presented here is that development in online community reflects changes within greater society toward social networks over fixed community groupings. Using the internet as a social or even as a spiritual network demonstrates the shift toward loose, dynamic, and self-regulated forms of socialization. Relationships are seen as fluid and changing, depending

on the needs of the individual. Geography becomes irrelevant; commonality is highly specialized and changeable. Online communities present a new sphere outside work and home to create selective friendships and new family-like relations. Instead of destroying neighborliness and sociability, online community encourages social relations, as "Internet users are, on average, not socially isolated, but quite to the contrary a relatively socially active group" (Spooner and Raine, 2001).

In *Life on the Screen*, Turkle concludes that internet usage reshapes the ways people conceive of individual and corporate human identity. She argues as social beings "we are trying to (as Marshall McLuhan said) 'retribalize' and the computer is playing a central role" in this process (Turkle, 1995: 178). These attempts to retribalize online seem to highlight basic emotional needs of humanity to be connected to others, to know and be known. This longing for connection is illustrated as individuals move from being solitary web surfers to investing in "virtual third places" or online communities, where relationship is based on communication. Attaching oneself to an online community provides definition and boundaries for the self within the vast online world; the identity of the individual becomes rooted in the community's ethos. The internet, Turkle suggests, becomes a space for humanity to examine and reflect on itself in light of its relationships.

The internet, as the "network of all networks," is characterized as more than a communication tool; it becomes a social network facilitating new forms of spiritual as well as social interaction. Online community as a network of "shared relationships among people" provides a contrast to offline communities, which involve "shared communication in the same physical space" (Pullinger, 2001: 76). Describing community as a network of relationships provides a metaphor easily transferable into the online context and is exemplified in this book as the internet as social network.

The conception of online community as a digital relational network is therefore offered as a new starting point for discussing community. This relates to the suggestion offered by Bell, noted in the introduction, of finding alternative ways to describe forms of community in a digital culture. Lorne Dawson similarly suggests that discussions of religious community online might need to utilize new understandings of social bonds and relationships (Dawson, 2000). Thus, definitions of religious community may be invigorated when informed by a social network approach.

LESSON 2:
Online Religious Community Is a Storied Network of the Faithful

An online community has been defined as individuals who not only assemble through internet technology and form a network, but also construct inter-

dependent relationships based on care, value, and intimate communication. Online religious communities differ only in that members also share a common faith-based commitment. They involve a shared religious narrative that directs both discussion topics and how they believe a religious community should function.

Online community narratives form the underlying motivations of members, based on social and spiritual meaning attributed to these networks of relationships. Online religious community has been described as a storied network tied to a larger faith narrative. Hauerwas similarly described Christian community as a meeting of "storied people" (1981: 3). In the online Christian communities studied here it is noted that the connection to the biblical story is central. The story of the divine and human community is focused on relationship: relationship formed, lost, recaptured and seeking full restoration in heavenly unification.

A connection to this faith-based story binds each community together. Members gather around a common interpretation, often rooted in a particular historic religious tradition, which creates a shared narrative connecting members to each other and the group. A certain level of agreement must be maintained with this interpretation of the story in order to build individual relationships and consolidate the community. When members fail to live by the story framework, conflict arises. The story brings unity and meaning to the community members. In a storied network of Christian believers, the mission is tightly linked to connections the members make to the wider faith community. How online religious community narratives are lived out can also serve as a prototype of community, as the local church is compared or validated on the basis of relationship qualities experienced online. Through exploring three online religious communities we see have seen how the community's stories are formed both by the members' beliefs about the nature of religious structures and their unique online practices.

Discussing religious community as a network can be problematic in some contexts. David Pullinger, who writes about the internet influence on Christian community, questions the depth of relationship that can be cultivated merely through words. Yet he sees these "new patterns of relating" as having the potential to create new communities of faith for the digital age (Pullinger, 2001: 87). He argues that communities of faith should function as "networks of concern," grounded in a "situated knowledge" of both the technology used and a shared morality coming from "lived experience" (p. 133). Internet-based faith communities must learn to utilize technology in ways that allow individuals to communicate truthfully and "establish a morality appropriate to 21st century life" (p. 133).

Other notable scholars of media and religion have voiced similar concerns (Monsma et. al., 1986; Schultze, 2002). While the terminology of a "network" may not encapsulate classic or idealistic forms of religious community, it does serve as a useful descriptor of the form and function of many group relationships in contemporary society. It should also be noted that the network metaphor and social network analysis do not stand in complete contradiction to religious understanding of community. Religious images, definitions, and models of community can be utilized within a network understanding of community. Work on community as Trinity, mystical communion, and people of God (Volf, 1998; Dulles, 1974; Campbell, 2001a) demonstrates images of relationships that are flexible and adaptable, while maintaining bonds of commitment through dynamic interaction with one another and the divine.

Still, a faceless of group of people who connect through computer terminals and telephone wires and not through physical presence can be troubling, especially to those who hold fast to the idea of church as linked to a building with face-to-face interaction. Thus, the idea and presence of online religious communities presents several areas of challenge.

CHALLENGE 1:
Online Religious Community Supplements, Enhances, and Transforms Offline Church Participation

The supplemental nature of online community has been stressed throughout this study. These findings show the majority of online community members described participation in a Christian email-based community as supplementary to, not a substitute for, offline church involvement. Online religious community was valued because it met specific relational needs, but could not satisfy members' desire for face-to-face interaction and an embodied worship experience. Online religious community and activities simply represent one part of an individual's overall religious involvement.

While some still fear that internet use will encourage a mass exodus from churches and temples, there is little evidence to support such claims. Several studies have affirmed the internet does not reduce social engagement. Katz and Rice's *Synoptia Project* found that being an internet user was positively associated with being a member of a social or religious community group, as users were slightly more likely than nonusers to belong to a religious organizations (2002: 155). Overall, the findings of Katz and Rice demonstrated that involvement in religious organizations seems unaffected by internet usage across the years, neither encouraging nor distracting from participation in offline religious groups (2002: 160). The internet, they state, "does not supplant communication forms, but rather supplements them." Katz and Rice

found no reduction in overall levels of communication among internet users (2002: 329). This research seems to suggest the internet encourages and even stimulates social interaction, and it calls into question claims that the internet detracts from community involvement and religious participation.

Some research suggests internet usage may have a positive influence on organized religion. Rather than technology driving people away, religious groups are using it to stay more connected. In the Pew Internet and American Life survey of churches' use of the Web (2000), 83 percent of polled churches and temples online reported that internet usage has aided congregational life by "strengthening the faith and spiritual growth of its members" through the activities and practices it facilitates. Helping church staff and members stay more connected, giving pastors access to more in-depth research for sermons, and enabling the church to stay more connected to the local community were some of the primary benefits cited. The internet thus can be used to help maintain existing offline communities through sustaining and building new interactions online.

While the internet may only supplement and enhance offline religious community participation, there is evidence internet use may transform the ways people conceive of religious community and local church. It has already been argued that online community presents a new conception of religious community as a social network. This shift is in line with general trends in society toward relationships that are fluid and dispersed. The internet presents a clear conceptual model for describing and illustrating how these networks of relationships function. The internet may also present new models or platforms for defining spirituality and religiosity.

As the internet and online religious community are essentially relationship focused, they offer an alternative model to many forms of traditional religiosity, which are structure- or service-oriented. This network and interactive focus sits well with Net-Gen, the emerging generation of young internet users, who are relationship-oriented rather than hierarchy-oriented (Tapscott, 1999). Experiential or "sensual spirituality" (Beaudoin, 1998) is increasingly the preferred form of spiritual engagement for Generation X and Y spiritual seekers (Sample, 2000). Opportunities for personal experiences of the sacred in a mediated environment are accepted and embraced by the young, and the internet becomes a new place to experiment with spirituality in a safe and self-directed manner. Research highlights trends toward online personal spiritual experiences. Katz and Rice found the internet "to have the twinned effect of making religious expression easier but more individualistic" (2002: 296). This mirrors effects seen in other domains: "it lowers barriers to participation and expression and weakens the traditional hold that cen-

tralized authorities (the gatekeepers) have over the production of social and intellectual capital" (2002: 296).

Other Pew data (Hoover et al., 2004) also found the internet encourages personalized spiritual "seeking" and "multi-sourcing." Hoover, of the 2004 "Faith Online" study, described religious internet use as "more of a Protestant phenomenon" because the largest user group, people who describe themselves as religious and spiritual, are increasingly going online for personal rather than institutional reasons. This indicates a trend toward individualism through internet use. Additionally, their patterns of seeking challenge traditional church authority structures, in line with the Protestant tradition, as they seek out unmediated material and consult multiple sources to create new platforms of spiritual authority and experience. How the internet and online community may in the long-term transform and challenge traditional forms of religiosity is worthy of more detailed investigation.

CHALLENGE 2:
The Coming Cyberchurch and Religion Online

The Barna Research Group's 1998 proclamation that "The Cyberchurch is coming" is poignant. Since this initial report, additional studies have confirmed this steady rise in people pursuing religious faith online. In 2001 the Barna Group's *Cyberchurch Report* on 11 net-based faith activities found that while online worship was the least appealing of possible options (among others such as reading online devotionals, listening to archived religious messages, searching for religious articles, buying religious products), they predicted by 2011 over 50 million Americans would seek spiritual experiences solely through the internet, rather than in churches. They also asserted 100 million Americans would rely upon the internet for some aspects of their religious experience. Pew surveys have also shown a continued increase in the number of internet households who go online in search of religious or spiritual information, from 23 percent in 2000 to up to two-thirds of all users in 2004 (Larsen, 2000, 2001; Hoover et al., 2004) .

While the shape religion may take online still needs careful observation, it must be recognized that religion online is thriving. Since the mid-1980s religious groups have run faith-based discussion lists and communities online. Still, after two and a half decades of different forms of religion online, questions about what kind of religious environment the internet can support are contentious. What is the shape of the emerging cyberchurch?

Religion online reflects a general shift toward relationships over structures in traditional religious practice. A study of US congregational websites by the Hartford Institute for Religion Research found that increased reliance

on the internet is changing congregational power structures. This includes empowering previously marginalized "techies" with new leadership roles, such as becoming "church webmaster" (Thurman, 2000). Their study stated, "maintenance of these sites puts public relations responsibilities in the hands of members who previously might not have played a role in constructing and retaining a congregation's image." Besides refiguring institutional structures, religious practice online can draw people toward spiritual encounters outside traditional religious institutions. In chapter three, the internet was presented as a sphere to help people reconnect with the spiritual side of life, which is often disregarded by modernity (Wertheim, 1999; Brasher, 2001a). For example, Cobb (1998) believes online technology and spirituality are mutually reinforcing and convergent. Using the internet for spiritual purposes promotes an experience of cyberspace, which is otherworldly and personal.

These shifts raise a concern about the potentially individualized and self-selecting nature of online relationships. Wellman describes this as "networked individualism," a heightened ability of users to rapidly switch between social ties and networks. He argues that individuals are able to connect with "multiple social milieu," yet have limited involvement in each one, which "diminishes the control each milieu exercises over the individual, and decreases its commitment to the individual's welfare" (Rheingold, 2002: 195). This suggests people's motivation for using the internet as a social network might be primarily for personal benefit. In *The Internet in Everyday Life* Wellman and Haythornthwaite stress that the "personalization" and "portability" features of online communication also promote "networked individualism" as the basis for community. Their research shows individuals are now the primary unit of connectivity, not households or groups (2002: 34).

The potential effects of this move toward personal communities and ego-centered networks is an area for further investigation, to address offline religious community fears of "online individualism" negating or failing to foster such communal virtues such as "empathy, reciprocity and humility" (Schultze, 2002: 182). Religious media scholar Quentin Schultze believes "information technologies carry an instrumental bias in favor of individualism and against shared moral understanding" (2002: 181). In other words, the online environment is seen as promoting individual choice and freedom at the expense of community. If religion is in its essence about relationship with the divine and other believers, then situating it in an environment that exalts the individual and free choice could be problematic.

For religious groups who use the internet, networked individualism raises issues such as accountability, investment, and reciprocity. How will long-term involvement in online communities shape people's understanding of membership in a local church or even their connection to the global community of

faith? The connection between online community involvement and lived faith will be an important area for future research and reflection.

Becoming the Network

Online community is a story-formed community, where members co-create a communal identity which brings personal and corporate meaning. The attributes of online community outlined here—relationship, care, value, connection, intimate communication, and shared faith—along with other corroborating research present a framework for evaluating perceptions and qualities of online religious community. Each community investigated also constructed a community-specific narrative, providing cohesion, meaning, and tools to evaluate its authenticity. These narratives highlight different uses or models of online religious community that could be used to identify or even critique forms of online community in other religious traditions—identifying online religious community as a spiritual network, a support network, or a religious identity network. There are other potential models emerging from this discussion of religion online. These include seeing and studying online religious community as a worship space or a ritual platform.

This exploration of spiritual and social relationship building through computer networks provides a snapshot of the social changes occurring not only within religion, but also within wider society. I hope by holding a magnifying glass up to specific examples of religious networks online to compel both religion and social researchers to reexamine their current conceptions and descriptions of religious community. The internet and online community offer a valuable space for reflection on the evolving shape of religious culture, contemporary society, and on what it truly means to be in community. The internet can connect us in new, dynamic ways to both the human and the transcendent other. The way in which we are becoming one in the network is an unfolding tale, linked to an age-old story of humankind and the search for a place to call home.

notes

chapter one

1. For a detailed analysis of differing accounts of the history of computing and development of the internet, consult: Roy Rosenzweig. "Wizards, Bureaucrats, Warriors and Hackers: Writing the History of the Internet." *American Historical Review* 103.5 (December 1998): 1530–1552.
2. Information on the development of email taken from: Katie Hafner and Matthew Lyon. *Where Wizards Stay Up Late: Origins of the Internet.* New York: Simon and Schuster, 1996: 189–196.
3. For a more in-depth discussion of the roots of Message Groups (MsgGroups) and Online Community formation, see: Hafner and Lyon, 200–218.
4. For details on the UNIX system and Usenet, see: Paul Salus. *Casting the Net: From ARPANET to Internet and Beyond.* Reading, MA: Addison-Wesley Publishing, 1995: 127–140.
5. A helpful survey of evolution of media innovation is given in: Richard Campbell. *Media and Culture: An Introduction to Mass Communication.* Boston: Bedford/St Martin's Press, 2000: 38.
6. This point that technological innovation typically creates oversimplified, polarized reactions is raised in: Barry Wellman. "The Road to Utopia and Dystopia on the Information Highway." *Contemporary Sociology* 26.4 (July 1997): 449.
7. Reference to "reflection" as a middle-ground perspective is taken from: Douglas Groothuis. *The Soul in Cyberspace.* Grand Rapids: Baker Books, 1997: 155.
8. Metaphoric image taken from: Michael Benedikt. "Introduction." *Cyberspace: First Steps.* Cambridge: MIT Press, 1991: 2.
9. Terminology attributed to Amy Bruckman's study "Identity Workshop: Emergent social and psychological phenomena in text-based virtual reality." *Amy Bruckman's Papers* 1 (4 May 1992). http://www.cc.gatech.edu/~asb/papers/old-papers.html#IW.

chapter two

10. For an overview of these and other sociological approaches to the study of community, consult chapter two of: Bell and Newby, *Community Studies*. London: George Allen and Unwin, Ltd., 1971.

11. For more detailed discussion of Durkeim's views on religion, consult: W.S.F. Pickering. *Durkheim on Religion. A Selection of Reading with Bibliographies*. London: Routledge and Kegan Paul, 1975: 120–125.

12. Practical application of social network analysis is seen in studies such as the Toronto Wired Suburb (Hampton and Wellman, 1999) and the Cerise Research group (Garton, Haythornthwaite, and Wellman, 1997) involving multiple personal and organizational relationships. Information is gathered through questionnaires, interviews, diaries and, in the case of online community studies, computer monitoring. Ideally all members of a given network are surveyed regarding their interactions with others. Questions typically focus on such issues as with whom individuals communicate, frequency of communication and methods, along with relational content of communications such as with whom members socialize. Then relationships are charted within the network, often with the help of a computer program. A matrix representing each relation or area of inquiry portrays information flow or social connections made under a given topic. This can take the form of a map, called a sociogram, depicting network communication structure. Such diagrams help the researcher visually identify emerging clusters of social interaction. The study by Garton, Haythornthwaite, and Wellman (1997) also provides a helpful illustration of how social network analysis is applied within online research.

13. For a much fuller discussion of Hauerwas's views of social ethics and community, consult: Samuel Wells. *Transforming Fate into Destiny: The Theological Ethics of Stanley Hauerwas*. Carlisle, UK: Paternoster, 1998.

14. Other well-known spokespersons and researchers of the online community in the 1990s were Amy Bruckman, professor at Georgia Tech, and Marc Smith, researcher at UCLA's Center for the Study of the Online Community. Consult: Scott Kirsner. "Virtual Communities: The Next Hot Major." *WIRED News* (7 Nov 1997). http://www.wired.com/news/culture/0,1284,8363,00.html.

chapter three

15. Example of a Technopagan Blessing is found online at: http://www.hyperreal.org/raves/spirit/technoshamanism/Technopagan_Blessing.html.

16. For a detailed account of the development of Christian internet usage, see: David Lochhead. *Shifting Realities: Information Technology and the Church*. Geneva: WCC Publications, 1997: 42–54.

17. For findings on the effects of TV evangelism, consult: Stewart Hoover. "Ten Myths About Religious Broadcasting." *Religious Television: Controversies and Conclusions*. Eds. Robert Ableman and Stewart Hoover. Norwood, NJ: Ablex, 1990.

18. Comments taken from a Marketing Letter sent out 9 March 1998 from the Toronto Airport Christian Fellowship in Toronto, Canada.

chapter four

19. Community of Prophecy charter and list information found online at CP website; address has been withheld for confidentiality reasons.
20. Information found online at AC website; address has been withheld for confidentiality reasons.
21. "Via Media" relates to John Henry Newman's writing on the Via Media, discussing his approach to doctrine and the Anglican Church. Consult: John Henry Newman. *The Via Media of the Anglican Church.* Trans. H. D. Weidner. Oxford: Clarendon Press, 1990.
22. According to the Church of England website, the basic tenets of Anglicanism are: a view of the Old Testament and New Testament of the Bible "as containing all things necessary for salvation," the Apostles' Creed and the Nicene creed as sufficient statements for Christian faith, the administration of the sacraments of Baptism and the Lord's Supper, and the historic episcopate as the means for administering the church. *Church of England: What it means to be an Anglican.* http://www.england.anglican.org/about/means.html.

chapter five

23. Survey data figures are based on a sampling of 10 percent or more of the membership of each of the three online communities. The total sample population of the email survey was 84 respondents.

chapter seven

24. The questionnaire respondents listed 19 different denominational groupings; over half of these (18 out of 30) could be considered Pentecostal-Charismatic (e.g., Assembly of God, Elim, Vineyard, and Non-Denominational) with a range of other mainline churches being represented, including Anglican, Baptist, Catholic, Congregational, and Nazarene.
25. Alpha courses are evangelistic outreach courses featuring fellowship meals, videos, and small group discussions.

chapter eight

26. *Cheers* is an American TV situation comedy which ran from 1982 to 1993, starring Ted Danson, Shelley Long, and Kirstie Alley, and directed by Michael Zinberg and Tim Berry.

bibliography

Agre, Phil. "The Internet and Public Discourse." *First Monday* 3.3 (2 March 1998). www.firstmonday.dk/issues/issue3_3/agre.

Alexander, Brooks. "Virtuality and Theophobia." *Virtual Gods*. Ed. Tal Brooke. Eugene, OR: Harvest House, 1997: 157–169.

Ammerman, Nancy Tantom. "Religious Identities and Religious Institutions." *Handbook for the Sociology of Religion*. Ed. Michele Dillon. New York: Cambridge University Press, 2003: 207–224.

———. *Congregation and Community*. New Brunswick, NJ: Rutgers University Press, 1997.

Bainbridge, W. S. "Religious Ethnographers on the World Wide Web." *Religion on the Internet: Research Prospects and Promises*. Eds. J. K. Hadden and D. E. Cowan. New York: JAI Press, 2000: 55–86.

Baker, Jason. *Christian Cyberspace Companion*. Grand Rapids: Baker Books, 1995.

Barna Research Group. "More Americans Are Seeking Net-Based Faith Experiences." Barna Research Online Home Page. 21 May 2001. http://www.barna.org/FlexPage.aspx?Page=BarnaUpdate&BarnaUpdateID=90.

———. "The Cyberchurch is Coming. National Survey of Teenagers Shows Expectation of Substituting Internet for Corner Church." Barna Research Online Home Page (5 May 1998). http://www.barna.org/cgibin/PagePressRelease.asp?PressReleaseID=9&Reference=C.

———. "Relationships: Choosing a Church." Barna Research Online Home Page (1998). http://www.barna.org/cgi-bin/PageCategory.asp#TOP.

Barry, John. *Technobabble*. Cambridge: MIT Press, 1993.

Baudrillard, Jean. *Simulations*. New York: Semiotext(e), 1983.

Bauwens, Michel. "Spirituality and Technology: Exploring the Relationship." *First Monday* 1.5 (November 1996). www.firstmonday.dk/issues/issue5/bauwens/index.html.

Baym, Nancy. *Tune in, Log On: Soaps, Fandom and Online Community*. Thousand Oaks, CA: Sage Publications, 1999.

———. "Interpreting Soap Operas and Creating Community: Inside an Electronic Fan Culture," *Culture of the Internet*. Ed. Sara Kiesler. Mahwah, NJ: Lawrence Erlhbaum Publishers, 1997.

———. "The Emergence of Community in Computer-Mediated Communication." *CyberSociety*. Ed. Steve Jones. Thousand Oaks, CA: Sage Publications, 1995: 138–163.

Beaudoin, Tom. *Virtual Faith*. San Francisco: Jossey-Bass, 1998.

Bell, Colin, and Howard Newby. *Community Studies*. London: George Allen and Unwin Ltd., 1971.

Benedikt, Michael. "Cyberspace: Some Proposals." *Cyberspace: First Steps*. Ed. Michael Benedikt. Cambridge: MIT Press, 1992a: 119–224.

———. "Introduction." *Cyberspace: First Steps*. Ed. Michael Benedikt. Cambridge: MIT Press, 1992b: 1–29.

Bilezikian, Gilbert. *Community 101*. Grand Rapids: Zondervan, 1997.

Blanchard, Anita, and M. Lynne Markus. "The Experienced 'Sense' of a Virtual Community: Characteristics and Processes." *ACM. SIGMIS Database* 35.1 (Winter 2004): 64–79.

Block, Justine. "The Internet Relationship." *Overland* 143 (1996): 4–10.

Bonhoeffer, Dietrich. *Letters and Papers from Prison*. New York: MacMillan, 1967.

Boshier, Roger. "Social-psychological Factors in Electronic Networking." *International Journal of Lifelong Education* 9.1 (1990): 59–75.

Brasher, Brenda. *Give Me That Online Religion*. San Francisco: Jossey-Bass, 2001a.

———. "A Quick Question: How can I get 'that online religion'?" *Hartford Institute for Religion Research*. 2001b. Accessed 1 June 2003. http://hirr.hartsem.edu/research/quick_question11.html.

Brooke, Tal., ed. *Virtual Gods*. Eugene, OR: Harvest House, 1997.

Brown, Colin., ed. *The New International Dictionary of New Testament Theology*. Exeter, UK: Paternoster Press, 1975.

Bruckman, Amy. "Identity Workshop: Emergent social and psychological phenomena in text-based virtual reality. *Amy Bruckman's Papers* (4 May 1992). http://www.cc.gatech.edu/~asb/papers/old-papers.html#IW.

Bruckman, Amy, and Michael Resnick. "The MediaMOO Project: Constructionism and Professional Community." *Convergence* 1.1 (Spring 1995). http://www.cc.gatech.edu/~asb/papers/old-papers.html#convergence.

Buick, Joanna, and Zoran Jevtic. *Introducing Cyberspace*. New York: Totem Books, 1995.

Bunt, Gary. *Virtually Islamic: Computer-Mediated Communication and Cyber Islamic Environments*. Lampeter: University of Wales Press, 2000.

Campbell, Heidi. "A Review of Religious Computer-Mediated Communication Research." *Mediating Religion: Conversations in Media, Culture and Religion*. Eds. S. Marriage and J. Mitchell. Edinburgh: T & T Clark/Continuum, 2003: 213–228.

———. *An Investigation of the Nature of Church Through an Analysis of Christian Email-Based Online Communities*. Unpublished PhD thesis. University of Edinburgh, 2001a.

———. "Connecting to the Spiritual Network: Spiritual Communities within the Online Context." Paper presented at the "Religious Encounters in Digital Networks" Conference on Religion and Computer-Mediated Communication, University of Copenhagen, 2001b.

Carega, Andrew. *E-vangelism: Sharing the Gospel in Cyberspace*. Lafayette, IL: Vital Issues Press, 1999.

Castells, Manuel. *The Internet Galaxy*. Oxford: Oxford University Press, 2001.

Ceruzzi, Paul. *A History of Modern Computing*. Cambridge: MIT Press, 1999.

Chama, Joshua Cooper. "Finding God on the Web." *Time* (16 Dec 1996): 52–59.

de Chardin, Pierre Teilhard. *The Phenomenon of Man*. New York: Harper Torchbooks, 1959.

———. *The Future of Man*. New York: Harper & Row, 1964.

Chen, Wen, Jeff Boase and Barry Wellman. "The Global Villages: Comparing Internet Users and uses around the world." *The Internet in Everyday Life*. Eds. B. Wellman and C. Haythornthwaite. Oxford, UK: Blackwell, 2002.

Chidley, Joe. "Jesus on the Net. A new platform for believers and heretics alike." *Macleans* (15 Dec 1997).

Cobb, Jennifer. *Cybergrace: The Search for God in the Digital World.* New York: Crown Publishers, 1998.

Ciolek, T. M. "Online Religion: The Internet and Religion." *The Internet Encyclopedia.* Vol. 2. Ed. Hossein Bidgoli. New York: John Wiley & Sons, 2004: 798–811.

Collins English Dictionary. New York: Collins, 1992.

"Communing with John Perry Barlow." *Educom Review* 32.5 (September/October 1997). http://www.educause.edu/pub/er/review/reviewArticles/32516.html.

Curtis, Pavel. "Mudding: Social Phenomena in Text-based Virtual Realities." *Culture of the Internet.* Ed. Sara. Kiesler. Mahwah, NJ: Lawrence Erlbaum, 1997.

Davis, Erik. *TechGnosis: Myth, Magic, and Mysticism in the Age of Information.* New York: Random House, 1998.

———. "Technopagans." *Wired* 3.07 (June 1997). www.wired.com/wired/archive/3.07/technopagans.html.

Dawson, Lorne. "Researching Religion in Cyberspace: Issues and Strategies." *Religion on the Internet: Research Prospects and Promises.* Eds. J. K. Hadden and D. E. Cowan. New York: JAI Press, 2000: 25–54.

Dawson, Lorne, and Douglas Cowan., eds. *Religion Online: Finding Faith on the Internet.* New York: Routledge, 2004.

December, John. "Notes on Defining of Computer-Mediated Communication." *Computer-Mediated Communication* (January 1997). Accessed 4 November 1997. www.december.com/cmc/mag/1997/jan/december.html .

De Kerckhove, Derrick. *The Skin of Culture.* Toronto: Somerville House, 1995.

Denning, Dorothy. "Concerning Hackers Who Break into Computer Systems." *High Noon on the Electronic Frontier: Conceptual Issues in Cyberspace.* Ed. Peter Ludlow. Cambridge: MIT Press, 1996: 137–164.

Dibble, Julian. *My Tiny Life: Crime and Passion in a Virtual World.* London: Fourth Estate, 1999.

———. "A Rape in Cyberspace; or How an Evil Clown, a Haitian Trickster Spirit, Two Wizards and a Cast of Dozens Turned a Database into a Society." *High Noon on the Electronic Frontier: Conceptual Issues in Cyberspace.* Ed. Peter Ludlow. Cambridge: MIT Press, 1996: 375–395.

Dixon, Patrick. *Cyberchurch, Christianity and the Internet.* Eastbourne, UK: Kingsway Publications, 1997.

Donath, Judith. "Identity and Deception in the Virtual Community." *Communities in Cyberspace.* Eds. Peter Kollock and Marc Smith. London: Routledge, 1998: 29–59.

Dulles, Avery. *Models of the Church.* New York: Doubleday, 1974.

Dyson, Esther et al. "Cyberspace and the American Dream: A Magna Carta for the Knowledge Age" Release 1.2 (August 22, 1994). *The Information Society* 12.3 (1996): 295–308.

Feenberg, Andrew. "From Information to Communication: The French Experience with Videotex." *Contexts of Computer-Mediated Communication.* Ed. Martin Lea. London: Wheatsheaf/Harvester, 1992: 168–187.

Fernback, Jen. "The Individual within the Collective: Virtual reality and the realization of collective principles." *Virtual Culture.* Ed. S. Jones. Thousand Oaks, CA: Sage, 1997.

Garton, Laura, Caroline Haythornthwaite, and Barry Wellman, "Studying Online Social Networks." *Journal of Computer-Mediated Communication* 3.1 (June 1997). Accessed 12 February 1998. www.ascusc.org/jcmc/vol3/issue1/garton.html.

Gates, Bill. *The Road Ahead.* New York: Viking-Penguin Books, 1995.

Gibson, Wiliam. *Neuromancer.* New York: Ace Books, 1984.

Gray, C. H. *The Cyborg Handbook.* London: Routledge, 1995.

Groothuis, Douglas. *The Soul in Cyberspace.* Grand Rapids: Baker Books, 1997.

Gunkel, David. "Second Thoughts: Toward a Critique of the Digital Divide." *New Media & Society* 5.4 (December 2003): 499–522.

Hafner, Katie, and Matthew Lyon. *Where Wizards Stay Up Late: Origins of the Internet*. New York: Simon and Schuster, 1996.

Hakken, David. *Cyborgs@cyberspace? An Ethnographer Looks at the Future*. London: Routledge, 1999.

Hamelink, Cees J. "Grounding the Human Right to Communicate." *Many Voices, One Vision: The Right to Communicate in Practice*. Ed. Philip Lee. Penang, Malaysia: Southbound, 2004: 21–31.

Hammerman, Joshua. *thelordismyshepherd.com: Seeking God in Cyberspace*. Deerfield Beach, FL: Simcha Press, 2000

Hampton, Keith, and Barry Wellman. "Netville On-Line and Off-Line." *American Behavioural Scientist* 43.3 (November 1999): 475–492.

Hampton, Keith, and Barry Wellman. "The Not so Global Village of Netville." *The Internet and Everyday Life*. Eds. Barry Wellman and Carolyn Haythornthwaite. Oxford: Blackwell, 2002: 345–371.

Haraway, Donna. *Simians, Cyborgs and Women*. London: Free Association Books, 1991.

Hauerwas, Stanley. *In Good Company: The Church as Polis*. Notre Dame, IN: University of Notre Dame Press, 1995.

———. *Community of Character: Toward a Constructive Christian Social Ethic*. Notre Dame, IN: University of Notre Dame Press, 1981.

Helland, Chris. "Online-religion/religion-online and virtual communitas." *Religion on the Internet: Research Prospects and Promises*. Eds. J. K. Hadden and D. E. Cowan. New York: JAI Press, 2000: 205–223.

Henderson, Charles. "The Emerging Faith Communities of Cyberspace." *Computer-Mediated Communication* (March 1997). www.december.com/cmc/mag/1997/mar/hend.html.

Hetherington, Kevin. *Expressions of Identity: Space, Performance, Politics*. London: Sage Publications, 1998.

Hewitt, Steven. "Can there be a REAL Internet Church?" *Christian Computing Magazine* 10 (September 1998). http://www.gospelcom.net/ccmag/articles/cov0998.shtml. No longer available online.

Hiltz, Starr Roxanne. "Constructing and Evaluating a Virtual Classroom." *Contexts of Computer-Mediated Communication*. Ed. Martin Lea. London: Wheatsheaf/Harvester, 1992: 188–208.

Hodgson, Peter. *Revisioning the Church: Ecclesial Freedom in the New Paradigm*. Philadelphia: Fortress Press, 1988.

Hoover, Stewart, Lynn S. Clark, and Lee Rainie. "Faith Online: 64% of Wired Americans Have Used the Internet for Spiritual or Religious Information." *Pew Internet and American Life Project* (April 7, 2004). http://www.pewinternet.org/PPF/r/126/report_display.asp.

Horrigan, John. "Online Communities: Networks that nurture long-distance relationships and local ties." Pew Internet and American Life Project (October 31, 2001). http://www.pewinternet.org/PPF/r/47/report_display.asp

Horsfall, Sarah. "How Religious Organizations Use the Internet: A Preliminary Inquiry." *Religion on the Internet: Research Prospects and Promises*. Eds. J. K. Hadden and D. E. Cowan. New York: JAI Press, 2000: 150–182.

Houston, Graham. *Virtual Morality*. Leicester, UK: Apollos, 1998.

Huxley, Julian. "Introduction." *The Phenomenon of Man*, by Pierre Teilhard de Chardin. London: Harper Torch Books, 1959: 11–30.

Internet for Christians (IFC), "Scottish Villagers Pray for the World." Email newsletter 84 (May 24, 1999).

Jankowski, Nicholas. "Creating Community with Media: History, Theories and Scientific Investigations." *Handbook of New Media: Social Shaping consequences of ICTs*. Eds. L. Lievrouw and S. Livingstone. London: Sage, 2002: 34–49.

Johnny Mnemonic. Film based on the book by William Gibson. Robert Longo, Director. Twentieth Century Fox, 1995.

"Join the Internet or become a ghetto, pastor tells Christians." *Ecumenical News International* (26 May 1998). Accessed 26 May 1998. No longer available online.

Jones, C., G. Wainwright, and E. Arnold. *The Study of Spirituality*. London: SPCK, 1986.

Jones, Steve, ed. *CyberSociety 2.0*. Thousand Oaks, CA: Sage, 1998.

———, ed. *Doing Internet Research*. Thousand Oaks, CA: Sage, 1999.

———. "The Internet and its Social Landscape." *Virtual Culture*. Ed. S. Jones. Thousand Oaks, CA: Sage, 1997: 7–32.

———. "Understanding Community in the Information Age." *CyberSociety*. Ed. S. Jones. Thousand Oaks, CA: Sage, 1995: 10–34.

Katsh, M. E. "Lawyers in the Networld." *Journal of Computer-Mediated Communication* 2.2 (1996). http://www.ascusc.org/jcmc/vol2/issue2/katsh.html.

Katz, J., and P. Aspden. "A Nation of Strangers?" *Communications of the ACM* 40.12 (1997): 81–86.

Katz, James, and Ronald Rice. *Social Consequence of Internet Use: Access, Involvement and Interaction*. Cambridge: MIT Press, 2002.

Keeble, L. "Why Create? A Critical Review of a Community Informatics Project." *Journal of Computer-Mediated Communication* 8.3 (2003). http://www.ascusc.org/jcmc/vol8/issue3/keeble.html.

Keene, Michael L. "The Church on the Web." *The Christian Century* (20 August 1999). http://www.christiancentury.org/features.html. No longer available online.

Kellner, Mark "Losing Our Souls in Cyberspace: Douglas Groothuis on the Virtues and Vices of Virtual Reality." *Christianity Today* 41.10 (1 September 1997): 54–55.

———. *God on the Internet*. Foster City: IDG Books, 1996.

Kiesler, S., J. Siegel, and T. McGuire. "Social Psychological Aspects of Computer-Mediated Communication," *American Psychologist* 39.10 (1984): 1123–1134.

Kirsh, E. M., Phillips, D. W., and D. E. McIntyre. "Recommendations for the Evolution of Cyberlaw." *Journal of Computer-Mediated Communication* 2.2 (1996). http://www.ascusc.org/jcmc/vol2/issue2/kirsh.html.

Kirsner, Scott. "Virtual Communities: The Next Hot Major." *Wired News* (7 Nov 1997). http://www.wired.com/news/culture/0,1284,8363,00.html.

Kollock, Peter, and Marc Smith. "Managing the Virtual Commons: Cooperation and Conflict in Computer Communities." 1994. http://www.sscnet.ucla.edu/soc/faculty/kollock/papers/vcommons.htm.

Kraut, R. E. et al. "Internet Paradox: A Social Technology That Reduces Social Involvement and Psychological Well-Being?" *American Psychologist* 53.9 (1998): 1017–1031.

Kraut, R. E. *HomeNet Project* website. 1998. http://homenet.hcii.cs.cmu.edu/progress/index.html.

Larsen, Elena. "CyberFaith: How Americans Pursue Religion Online." *Pew Internet and American Life Project* (December 23, 2001). http://www.pewinternet.org/report_display.asp?r=53.

———. "Wired Churches, Wired Temples: Taking Congregations and Missions into Cyberspace." *Pew Internet and American Life Project* (20 December 2000). http://www.pewinternet.org/report_display.asp?r=28.

Lawrence, B. B. *The Complete Idiot's Guide to Religions On-line*. Indianapolis: Alpha Books, 2000.

Lea, Martin. *Contexts of Computer-Mediated Communication*. London: Wheatsheaf/Harvester, 1992.

Lemos, Andre. "The Labyrinth of Mintel." *Cultures of the Internet*. Ed. Rod Shields. Thousand Oaks: Sage, 1996: 33–48.

Levy, Steven. "Glorifying the Obvious." *Newsweek* (30 March 1998): 74.

Linderman, Alf, and Mia Lövheim. "Internet and Religion. The Making of Meaning, Identity and Community through Computer-Mediated Communication." *Mediating Religion: Conversations in Media, Culture and Religion*. Eds. S. Marriage and J. Mitchell. Edinburgh: T & T Clark/Continuum, 2003: 229–240.

Lochhead, David. *Shifting Realities: Information Technology and the Church*. Geneva: WCC Publications, 1997.

Madden, Mary. "America's Online Pursuits: The Changing Picture of Who's Online and What They Do." *Pew Internet and American Life Project* (2003). Accessed 31 Jan 2004. http://www.pewinternet.org/pdfs/PIP_Online_Pursuits_Final.PDF.

Markham, Annette. *Life Online: Researching Real Experience in Virtual Space*. Walnut Creek, CA: AltaMira Press, 1998.

Martin, Ralph, and Peter Davids, eds. *Dictionary of the Later New Testament and Its Developments*. Downers Grove, IL: InterVarsity Press, 1997.

Massey, Doreen. "A Place Called Home?" In *Space, Place and Gender*. Minneapolis: Univ of Minnesota Press. 1992: 157–173.

The Matrix. Andy and Larry Wachowski, Directors. Village Roadshow Pictures, 1999.

May, Timothy. "A Crypt-Anarchist Manifesto." *High Noon on the Electronic Frontier: Conceptual Issues in Cyberspace*. Ed. Peter Ludlow. Cambridge: MIT Press, 1996.

McClellan, Jim. "Log on, all ye faithful." *The Guardian Online* (9 December 1998). http://online.guardian.co.uk/theweb/913212249-spirit.html No longer available online.

McHoul, Alec. "Cyberbeing and ~space." *Postmodern Culture* 8.1 (1 September 1997): 40–55.

McCorduck, Pamela. "America's Multi-Mediatrix." *Wired* 2.03 (March 1994). http://www.wired.com/wired/archive/2.03/anderson.html.

McLaughlin, Margaret, Kerry Osborne, and Christine Smith. "Standards of Conduct of Usenet." *CyberSociety*. Ed. Steve Jones. Thousand Oaks, CA: Sage, 1996: 90–111.

McMillan, D. W., and D. M. Chavis. "Sense of community: A definition and theory." *Journal of Community Psychology* 14 (1986): 6–23.

Middleton, J. Richard, and Brian Walsh. *Truth Is Stranger Than It Used to Be: Biblical Faith in a Post Modern Age*. London: SPCK, 1995.

Migliore, Daniel. *Faith Seeking Understanding*. Grand Rapids: Eerdmans Publishing, 1991.

Miller, Leslie. "Religious groups find revival on the Web." *USA Today Tech Report* (30 March 1998).

Mnookin, Jennifer. "Virtual(ly) Law: The Emergence of Law in LamdaMOO." *Journal of Computer-Mediated Communication* 2.1 (1996). http://www.ascusc.org/jcmc/vol2/issue1/lambda.html.

Monsma, Stephen, Christians, Clifford, Dykema, E., Leegwater, Aire, Schuurman, Egbert, Van Poolen, L. *Responsible Technology. A Christian Perspective*. Grand Rapids: Eerdmans Publishing, 1986.

Morris, Bonnie Rothman. "Surfing Their Way to the Holy Land." *The New York Times on the Web* (28 January 1999). http://www.nytimes.com/library/tech/99/01/circuits/articles/28jeru.html.

Nardi, Bonnie, and Vicki O'Day. *Information Ecologies: Using Technology with Heart*. Cambridge: MIT Press, 1999.

Newman, John Henry. *The Via Media of the Anglican Church*. Trans. H. D. Weidner. Oxford: Clarendon Press, 1990.

NightMare, M. Macha. *Witchcraft on the Web: Weaving Pagan Traditions Online*. Toronto: ECW Press, 2001.

Numes, Mark. "Jean Baudrillard in Cyberspace: Internet, Virtuality and Postmodernity." *Style* 29.2 (1995): 314–328.

O'Donnell, Mike. *A New Introduction to Sociology*. 2d ed. Surrey: Thomas Nelson and Sons, 1987.

The Oxford Dictionary. Oxford: Oxford University Press, 1979.

The Oxford Dictionary of Quotations. 3rd ed. Oxford: Oxford University Press, 1979.

Paccagnella, Luciano. "Getting the Seat of Your Pants Dirty: Strategies for Ethnographic Research on Virtual Communities." *Journal of Computer-Mediated Communication* 3.1 (June 1997). http://www.ascusc.org/jcmc/vol3/issue1/paccagnella.html.

Parks, M, and K. Floyd. "Making Friends in Cyberspace." *Journal of Communication* 46.1 (1996): 80–97.

Peck, Scott M. *The Different Drum: Community Making and Peace*. New York: Simon and Schuster, 1987.

Postman, Neil. *Technopoly*. New York: Vintage Books, 1993.

Pullinger, David. *Information Technology and Cyberspace: Extra Connected Living*. London: Darton, Longman and Todd, 2001.

Putnam, Robert. *Bowling Alone*. New York: Simon & Schuster, 2000.

Reid, Elizabeth. "Communication and Community on Internet Relay Chat: Construction Communities." *High Noon on the Electronic Frontier: Conceptual Issues in Cyberspace*. Ed. Peter Ludlow. Cambridge: MIT Press, 1996: 397–411.

———. "Virtual Worlds: Culture and Imagination." *CyberSociety*. Ed. Steve Jones. Thousand Oaks, CA: Sage, 1995: 164–183.

Rheingold, Howard. "Which Part Is Virtual? Which Part Is Community?" (1995). http://www.well.com/user/hlr/tomorrow/vcreal.html.

———. *The Virtual Community*. New York: HarperPerennial, 1993a.

———. "A Slice of Life in My Virtual Community." *Global Networks, Computers and International Communication*. Ed. Linda Harasim. Cambridge: MIT Press, 1993b: 57–80.

———. *Smart Mobs: The Next Social Revolution*. Cambridge, MA: Perseus, 2002.

Ribadeneira, Diego. "Clergy click with cyberworshipers." *Boston Globe* (26 August 1998): A01.

Rice, Ronald. "Contexts of Research on Organizational Computer-Mediated Communication: A Recursive Review." *Contexts of Computer-Mediated Communication*. Ed. Martin Lea. London: Harvester-Wheatsheaf, 1992: 113–144.

———. "Computer-Mediated Communication and Organizational Innovation." *Journal of Communications* 37 (1987): 65–95.

Rosenzweig, Roy. "Wizards, Bureaucrats, Warriors and Hackers: Writing the History of the Internet." *American Historical Review* 103.5 (December 1998): 1530–1552.

Roszak, Theodore. *The Cult of Information*. Los Angeles: University of California Press, 1986.

Rushkoff, Douglas. *Cyberia*. New York: Harper Collins-Flamingo, 1994.

Salus, Paul. *Casting the Net: From ARPANET to Internet and Beyond*. Reading, MA: Addison-Wesley Publishing, 1995.

Sample, Tex. *The Spectacle of Worship in the Wired World: Electronic Culture and the Gathered People of God*. Nashville, TN: Abingdon, 1998.

Sardar, Ziauddin. "alt.civilizations.faq: Cyberspace as the Darker Side of the West." *Cyberfutures*. Eds. Z. Sardar and J. Ravetz. London: Pluto Press, 1996: 24–36.

Schroeder, R., N. Heather, and R. M. Lee. "The Sacred and the Virtual: Religion in Multi-User Virtual Reality." *Journal of Computer-Mediated Communication* 4 (1998). http://www.ascusc.org/jcmc/vol4/issue2/schroeder.html.

Schultze, Quentin. *Habits of the High-Tech Heart*. Grand Rapids: Baker Academic, 2002.

Seabrook, John. *Deeper*. London: Faber and Faber, 1997.

Shallis, Michael. *The Silicon Idol*. New York: Shocken Books, 1984.

Sherman, Barrie, and Phil Judkins. *Glimpses of Heaven, Visions of Hell: Virtual Reality and Its Implications*. London: Coronet Books, 1992.

Silverstone, Roger, and Leslie Haddon. "Design and the Domestication of Information and Communication Technologies: Technical Change and Everyday Life." *Communication by Design: The Politics of Information and Communication Technologies*. Ed. Robin Mansell. Oxford: Oxford University Press, 1996: 44–74.

Slouka, Mark. *War of the Worlds: Cyberspace and the High-Tech Assault on Reality*. New York: Basic Books, 1995.

Smith, Marc, and Peter Kollock., eds. *Communities in Cyberspace*. London: Routledge, 1998.

Snyder, Howard. *Liberating the Church: The Ecology of the Church and the Kingdom*. Basingstoke, UK: Marshall Paperbacks, 1983.

Spears, R, and M. Lea. "Social Influence and the Influence of the 'Social' in Computer-Mediated Communication." *Contexts of Computer-Mediated Communication*. Ed. M. Lea. London: Wheatsheaf/Harvester, 1992: 30–65.

Spooner, Tom and Lee Raine. "Hispanics and the Internet." Pew Internet and American Life. (July 25, 2001) www.pewinternet.org/reports/pdfs/PIP_Espanol.pdf=.

Sproull, Lee and Samar Faraj. "Atheism, sex, and databases: The net as a social technology." *Public Access to the Internet*. Eds. Brian Kahin and James Keller, pp. 62–81. Cambridge: The MIT Press, 1995.

Sproull, Lee, and Sara, Kiesler, eds. "Electronic Group Dynamics." *Connection: New Ways of Working in the Networked Organization*. Cambridge: MIT Press, 1991: 57–77.

Stacey, Margaret. "The Myth of Community Studies." *The Sociology of Community*. Ed. C. Bell and H. Newby. London: Franks Cass, 1974.

Star, Susan Leigh. *The Culture of Computing*. Oxford: Blackwell Publishers and Sociological Review, 1995.

Stoll, Clifford. *Silicon Snake Oil: Second Thoughts on the Information Highway*. New York: Doubleday, 1995.

Stone, Allucquere. "Sex and Death Among the Disembodied: VR, Cyberspace, and the Nature of Academic Discourse." *The Culture of Computing*. Ed. S. L. Star. Oxford: Blackwell Publishers and Sociological Review, 1995: 243–260.

———. "Will the Real Body Please Stand Up?: Boundary Stories and Virtual Cultures." *Cyberspace: First Steps*. Ed. M. Benedikt. Cambridge: MIT Press, 1994: 81–118.

Tapscott, Don. *Growing Up Digital: The Rise of the Net Generation*. New York: McGraw-Hill, 1999.

"Technorealism: get real! A manifesto from a new generation of cultural critics." *The Nation* (6 April 1998).

The Terminator. James Cameron, Director. Orion Pictures, 1984.

Tönnies, Ferdinand. *Community and Associations*. Trans. Charles Loomis. London: Routledge, 1887/1957.

Tron. Steven Lisberger, Director. Walt Disney Video, 1982.

Turkle, Sherry. *Life on the Screen: Identity in the Age of the Internet*. London: Phoenix Paperbacks, 1995.

———. *The Second Self: Computers and the Human Spirit*. London: Granada Publishing, 1985.

van Dijk, Jan. *The Network Society*. Thousand Oaks, CA: Sage, 1999.

———. "The reality of virtual communites." *Trends in Communication* 1.1 (1998): 39–63.

Volf, Miroslav. *After Our Own Likeness: The Church as the Image of the Trinity*. Grand Rapids: Eerdmans Publishing, 1998.

Ward, Keith. *Religion and Community*. Oxford: Oxford University Press, 1999.

Warren, Michael. *Seeing Through the Media: A Religious View of Communications and Cultural Analysis*. Harrisburg, PA: Trinity Press, 1997.

Wellman, Barry, and Carolyn Haythornthwaite, eds. *The Internet in Everyday Life*. Oxford: Blackwell Publishing, 2002.

Wellman, Barry. "The Road to Utopia and Dystopia on the Information Highway." *Contemporary Sociology* 26.4 (July 1997a): 445–449.

———. "The Privatisation of Community: From Public Groups to Unbounded Networks." Unpublished paper presented at ASA/ISA North American Conference in Toronto (8 August 1997b).

———. "An Electronic Group Is Virtually a Social Network." *Culture of the Internet*. Ed. S. Kiesler. Mahwah, NJ: Lawrence Erlbaum, 1997c: 179–205.

———. "The Community Question Re-evaluated." *Comparative Urban and Community Research* 1 (1988): 81–107.

Wellman, Barry, and Barry Leighton. "Networks, Neighbourhoods and Communities. Approaches to the Study of the Community Question." *Urban Affairs Quarterly* 14.3 (March 1979): 363–390.

Wertheim, Margaret. *The Pearly Gates of Cyberspace*. London: Virago, 1999.

Wilson, Walter. *The Internet Church*. Nashville: Word Publishing, 2000.

Winner, Langdon. "Technology Today: Utopia or Dystopia?" *Social Research* 64.3 (1997): 989–1118.

Wolf, Mark., ed. *Virtual Morality: Morals, Ethics and New Media*. London: Peter Lang Publishing, 2003.

Woolley, Benjamin. *Virtual Worlds*. Oxford and Cambridge: Blackwell, 1992.

Young, Jeffrey. "Technorealists Hope to Enrich Debate Over Policy Issues in Cyberspace." *The Chronicle of Higher Education* (3 April 1998). http://chronicle.com/data/internet. dir/itdata/1998/03/t98032301.htm.

Young, Kimberly. *Caught in the Net: How to Recognize the Signs of Internet Addiction and a Winning Strategy for Recovery*. New York: Wiley and Sons, 1998.

Zaleski, Jeff. *The Soul of Cyberspace: How Technology Is Changing Our Spiritual Lives*. San Francisco: Harper, 1997.

Websites

Aish Ha Torah's Window on the Wall http://aish.com/wallcam/
The Blessing of Cyberspace http://www.namgyal.org/DailyLife/blessings_of_cyberspace.htm
Beliefnet http://www.Beliefnet.org
Billy Graham Center http://www.gospelcom.net/bgc/
Brigada's Online Web Evangelism Guide http://www.brigada.org/today/articles/web-evangelism.html
BuddhaNet http://www.buddhanet.net
Church of England: What it means to be an Anglican http://www.england.anglican.org/about/means.html
Ecunet http://www.ecunet.org
E-vangelism.com http://e-vangelism.com/
The First Church of Cyberspace http://www.godweb.org/
Gospel Communications Network http://www.gospelcom.net
Gospelcom's Online Evangelism Web Guide www.gospelcom.net/guide/
H-Judaic http://www.h-net.org/~judaic/
International Bible Society www.gospelcom.net/ibs
InterVarsity Christian Fellowship www.intervarsity.org/
Monastery of Christ in the Desert www.christdesert.org
Reapernet: Christianity with a Passion http://chat.reapernet.com/
Renaissance: Islamic Journal www.renaissance.com.pk
Technopagan Blessing
http://www.hyperreal.org/raves/spirit/technoshamanism/Technopagan_Blessing.html.
Technorealism http://technorealism.org

Toronto Airport Christian Fellowship http://www.tacf.org/
Vatican homepage http://www.vatican.va/
The Virtual Church of the Blind Chihuahua http://www.dogchurch.org/
Virtual Jerusalem http://www.virtualjerusalem.com/
Virtual Memorial Garden http://catless.ncl.ac.uk/VMG
The WebChurch - The WorldWide Virtual Church from Scotland http://www.webchurch.org
Who is Jesus? http://www.ccci.org/whoisjesus/
Zoroastrian Cybertemple http://www.zarathushtra.com/

index

General Editor: Steve Jones

Digital Formations is an essential source for critical, high-quality books on digital technologies and modern life. Volumes in the series break new ground by emphasizing multiple methodological and theoretical approaches to deeply probe the formation and reformation of lived experience as it is refracted through digital interaction. **Digital Formations** pushes forward our understanding of the intersections—and corresponding implications—between the digital technologies and everyday life. The series emphasizes critical studies in the context of emergent and existing digital technologies.

Other recent titles include:

Felicia Wu Song
 Virtual Communities: Bowling Alone, Online Together

Edited by Sharon Kleinman
 The Culture of Efficiency: Technology in Everyday Life

Edward Lee Lamoureux, Steven L. Baron, & Claire Stewart
 Intellectual Property Law and Interactive Media: Free for a Fee

Edited by Adrienne Russell & Nabil Echchaibi
 International Blogging: Identity, Politics and Networked Publics

Edited by Don Heider
 Living Virtually: Researching New Worlds

Edited by Judith Burnett, Peter Senker & Kathy Walker
 The Myths of Technology: Innovation and Inequality

Edited by Knut Lundby
 Digital Storytelling, Mediatized Stories: Self-representations in New Media

Theresa M. Senft
 Camgirls: Celebrity and Community in the Age of Social Networks

Edited by Chris Paterson & David Domingo
 Making Online News: The Ethnography of New Media Production

To order other books in this series please contact our Customer Service Department:
(800) 770-LANG (within the US)
 (212) 647-7706 (outside the US)
 (212) 647-7707 FAX

To find out more about the series or browse a full list of titles, please visit our website:
WWW.PETERLANG.COM